J. M. OLSON

Italian Renaissance Sculpture

171 illustrations, 20 in color

THAMES AND HUDSON

In memory of Ulrich Middeldorf,
and to Alexander, Allegra and Emma

*I am deeply grateful to James Draper, who read the manuscript of this
book, and to Laura Camins and Daphne Barbour who shared their
enthusiasm for Renaissance sculpture with me.*

*In the illustration captions, the measurements give height before width; a
single measurement indicates height, unless otherwise specified.*

Frontispiece: *1 Michelangelo* David *1501-04 (marble, 409 cm, 161 in)*

*First published in the United States in 1992 by
Thames and Hudson Inc., 500 Fifth Avenue,
New York, New York 10110*

Library of Congress Catalog Card Number 91–65310

Printed and bound in Singapore

Professor Roberta J. M. Olson
is A. Howard Meneely Professor of Art History
at Wheaton College, Massachusetts. She has taught Italian
Renaissance art history since 1974 in the United States and
Italy, has directed a number of research projects on artists of
this period and has published widely on the subject
of Italian art.

WORLD OF ART

This famous series
provides the widest available
range of illustrated books on art in all its aspects.
If you would like to receive a complete list
of titles in print please write to:
THAMES AND HUDSON
30 Bloomsbury Street, London WC1B 3QP
In the United States please write to:
THAMES AND HUDSON INC.
500 Fifth Avenue, New York, New York 10110

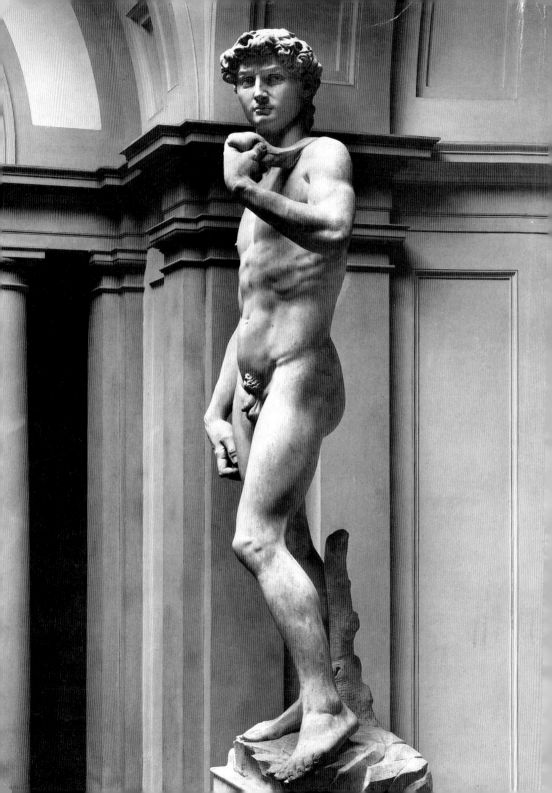

Contents

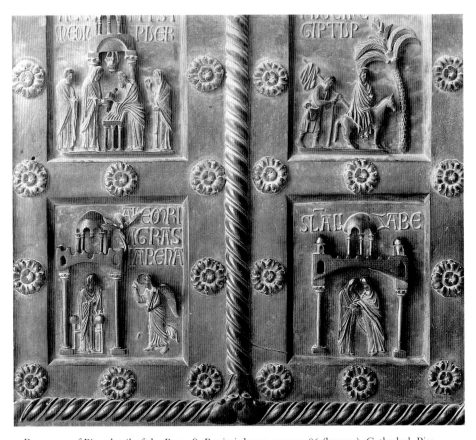

2 Bonannus of Pisa, detail of the Porta S. Ranieri doors, *c.* 1175–86 (bronze). Cathedral, Pisa

Setting the Scene

Michelangelo's *David* instantly signals to us the achievements of the 1
Italian Renaissance, a period in art which evokes a magical aura of
aesthetic heights. The Renaissance – meaning rebirth – was viewed by
its thinkers as a revival of a golden age of perfection envisioned in
antiquity. This complex, idealistic age, like the *David*, did not spring
full-grown from the head of Zeus but was part of a gradual evolution
that brought about a rebirth of both letters and the arts. In the visual
arts, the era can be likened to a verdant tree with two branches,
representing a return to nature and an emulation of Classical antiquity.
Sculpture played a pivotal role in the creation and self-definition of the
Renaissance. Despite the variety of works executed, sculptors focused
on two major problems: the freestanding figure and the representation
of three-dimensional space. This introduction to the subject examines
in a mainly chronological framework selected works of art from the
period in the context of contemporary economic, political, cultural and
intellectual trends. It takes several approaches to each work, highlight-
ing the most recent theories and discoveries.

To understand the sculpture of the Italian Renaissance, one must
consider its setting. Italy, cut off from northern Europe by the
formidable belt of the Alps, is surrounded on its three other sides by
water. This isolation determined the peninsula's unique cultural and
artistic development. In the Middle Ages and Renaissance, the term
'Italy' described not a nation but rather a collection of individual city
states, each with its own cultural and political characteristics as well as
its own distinctive foods and wines (Italy did not become a unified
country until 1870). Thus a knowledge of regional politics often
illuminates the meaning of individual monuments. Local sculptural
styles also developed, although sculptors tended to be peripatetic. Each
regional division was controlled by different powers in the feudal and
communal mixture that arose after the death of the Emperor Frederick
II in 1250. For example, northern Italy was split into four city powers,
three ruled by often tyrannical families: Milan, first under the Visconti
and then the Sforza; Verona under the Scaligeri; Padua under the
Carrara; and Venice, the exception, ruled as an individualistic republic

but in reality an oligarchy. In the south, Naples was under the French Angevins until the early fifteenth century and then the Spanish. Between 1309 and 1376, during the so-called Babylonian Captivity (when the Pope ruled from Avignon), Rome, which had been a place of great artistic activity, became a cultural backwater. At the same time in central Italy, Florence, an oligarchy whose Guelph sympathies allied it to the papacy, was surrounded by Ghibelline strongholds (Siena, Pisa and Arezzo) which sympathized with the heirs of Frederick II. These divisions reinforced local customs, tastes and linguistic dialects, encouraging civic pride during a period of great urban growth and economic prosperity. By the beginning of the fourteenth century (the Trecento), the three largest cities in Europe were Florence, Palermo and Venice, all with populations in excess of 100,000.

Despite its position as the chessboard of Europe, the Italian peninsula had a common denominator: a unified Roman cultural heritage and artistic patrimony. The area was infused by a Classical tradition more deeply rooted than in northern Europe, where the Roman occupation had been less thorough. In Italy, the antique existed as an artistic force in its own right, first slowing and then tempering the new international styles which filtered over the Alps with itinerant craftsmen: the Romanesque in the eleventh and twelfth centuries and the Gothic in the two subsequent centuries. These styles in Italy are therefore hybrids and must be qualified (for example, 'Italian Gothic'). The marked emphasis on the individuality of its artists also accentuated the singularity of Italian sculpture. Because of these factors, Italian Romanesque and Gothic sculpture already seem to possess characteristics of the Renaissance, raising the question of when it actually began.

The Middle Ages were punctuated by a series of earlier revivals usually centred round courts like those of Charlemagne and Frederick II. They were preludes to the true Renaissance and its humanism. The distinctive sensitivity towards the antique that occurred in Italy is understandable because even today wherever one walks one is bombarded by fragments of ancient sculpture, remains of buildings and inscriptions, reminders of Rome's grandeur. Fragments quarried from Roman edifices were frequently embedded (as *spoglia*) in structures like the Florentine Baptistry, so that pagan and Christian elements co-existed. As economic prosperity and urbanization demanded new construction, additional stone was needed, leading to the opening of quarries and in turn to the discovery and collection of many antiquities. It was ancient sculpture, as opposed to other media, that remained visible and most nearly intact to inspire the Renaissance. Therefore,

sculptors made the first and most natural connection to Graeco-Roman art, often working in locations rich with remnants of Classical civilization.

With the onslaught of the Crusades, the seafaring town of Pisa, originally founded as a Greek port, enjoyed expanding trade and a burgeoning economy. Out of civic pride a set of bronze doors was ordered in 1179 for the main entrance to the Cathedral (Duomo) from Bonannus of Pisa, a sculptor/architect, as was the custom during this period. Although these doors were destroyed in a fire of 1595, another set securely attributed to Bonannus for the Porta S. Ranieri escaped the fire and is still found at the back of the right transept facing the bell-tower (Campanile). (Several similar sets – modelled after those that embellished important buildings and sanctuaries of Greece and Rome – were executed in Italy in the twelfth century with the new wave of Byzantine influence.) Their twenty rectangular scenes narrating the Life of Christ are separated by bands punctuated with rosettes *all'antica* (after the antique). However, these doors manifest an unprecedented Western attitude in their inventive iconography and their new intellectual orientation. They also testify to the technical expertise of foundries at Pisa, which remained for several centuries a famous centre of bronze casting. The Porta S. Ranieri doors achieve their power through Bonannus's compositions. His figures fuse Byzantine and Romanesque models (via miniatures, ivories and goldsmith work) with a decidedly Western slant. The doors display his artistic independence and his iconography created *sui generis* in a manner that heralds the Renaissance. The rhythmic movement of the figures establishes patterns of light and shadow that add to the simple clarity of the scenes and facilitate a reading of the narrative. In addition, many of the elements are almost freestanding, bestowing palpability to the shallow reliefs. Traditional elements, such as the tree in the Flight into Egypt scene – which according to the Apocrypha offered its shade and fruit to the Child, thus exalting him and foreshadowing his martyrdom – have a charm and profundity beyond the usual schematic treatment. Moreover Bonannus gave an unusual emphasis to the written word: each scene is inscribed in Latin. In the Journey of the Magi, the artist's subtle use of symbolism is noteworthy: under the hillock on which the three gaze at the star, he placed diminutive scenes of the Temptation and Expulsion, the beginning of original sin from which the King of Kings would redeem Christians. These doors mark the inception of the prominent Pisan school which continues in the marble sculpture of Bonannus's successors, Nicola, Giovanni, Andrea and Nino Pisano.

The First Stage of the Renaissance

It is Nicola Pisano (active 1258–78), another sculptor/architect, whom Vasari in his *Vite* (*Lives*) credits with initiating the first of three stages of Renaissance sculpture. Nicola's first authenticated work, a signed pulpit for the Pisa Baptistry, justifies Vasari's choice. Dated 1260, it *3,4,12* fuses southern and Tuscan elements into a truly original vision, reinforcing the consensus on the artist's unknown birthplace: he was probably born in southern Italy (in two documents he is referred to as 'de Apulia') and may have either been trained in Pisa or worked for Frederick II before settling in Pisa. Precedents for Nicola's pulpit existed in the south from the previous century but they lacked the historiated (narrative) reliefs of the Tuscan tradition. Nicola's pulpit is indeed revolutionary: since it is freestanding it acts more like architectonic sculpture than a mere piece of liturgical furniture. Its shape is a function of its site. As a hexagon (symbolic of the Death of Christ), it echoes without being repetitive the adjacent earlier octagonal (symbolic of the Resurrection) baptismal font and harmonizes with the round shape (symbolic of rebirth, eternity and God) of the building. The pulpit's shape and the geometrical organization of its reliefs have been allied to the harmonious proportional ratios – associated since Pythagoras with the divine proportion of the cosmos – established by the contemporary Pisan mathematician Leonardo Fibonacci. In addition, the five reliefs (the sixth side was open for passage to the lectern) are separated by reddish brown Classicizing colonnettes. The classical manner in which they frame the white Carrara marble scenes leaves no doubt that Nicola was a talented architect and a sculptor of the first rank.

The pulpit is supported by a central column on a base with grotesque figures and animals – representing pagan elements subdued by Christianity – and by six external columns. Three of these have bases set on the backs of lions hovering over vanquished prey, a Romanesque motif symbolic of triumphant Christianity. The columns are crowned by Gothic, quasi-Corinthian foliated capitals whose deep carving and drill work is akin to late Roman techniques. They support archivolts with trilobe Romanesque arches with inlaid cusps. Nicola carved

3 Nicola Pisano, 'Fortitude', Pisa Baptistry pulpit, 1260 (56 cm, 22 in)

prophets and the Evangelists in the spandrels and six nearly freestanding figures (five virtues and St John the Baptist, relating to the site) between the reliefs. Appropriately for the Baptistry, the scenes emphasize Christ's infancy, revelation of divinity and sacrifice. They are: a continuous narrative with the Annunciation, Nativity and Annunciation to the Shepherds; the Adoration of the Magi depicted as the Three Ages of Man; the Presentation in the Temple; the Crucifixion; and the Last Judgment. Traces of pigment suggest that paint once increased the polychromy of the coloured marble, while the addition of black paste to some drill holes intensified the light and dark contrast of the carving.

Nicola's narrative panels are no less radical than the general layout of the pulpit. As was the Tuscan custom, figures dominate the scenes, but here they are unprecedented in their full height. In fact, the figures themselves create the space so that each panel resembles a Roman sarcophagus scene. Deeply undercut, they stand convincingly in front of each other. The weight of their features is heavy and their massive drapery both reveals their bodies and is separate from them. Their actions have a concentrated psychological realism and their forms are overtly sensuous. Unlike earlier sculptors who employed Classical motifs piecemeal like quotations, Nicola aimed at narrating the Life of Christ in a more integrated, naturalistic manner via a Classical style. While he borrowed from antiquity, he did so innovatively. For example, his massive Madonna is derived from the Phaedra on a sarcophagus in the Camposanto, Pisa. Her weighty form and Graeco-Roman head-dress as well as her heavy lips and chin are repeated throughout the pulpit with an Aristotelean unity of character. In both the Nativity, where she reclines like an Etruscan matron, and the 'Adoration', the figure is not copied but rather studied and then mixed creatively with borrowings from other sources. More directly inspired from figures on the Phaedra sarcophagus are the wizened heads of the expressionistic prophetess Anna and St Elizabeth in the Presentation in the Temple. This scene also contains another fascinating adaptation *all'antica*, the transformation of a Hellenistic aged Dionysos supported by a satyr into the old priest with an acolyte. (Michelangelo used this general prototype later for his *Bacchus*.) Nicola adapted to a Christian context the pagan form derived from a Roman copy of a Neo-Attic carved krater in the Composanto. His borrowing also had a civic dimension because the krater was believed to have been given to the city by Augustus, thus alluding to Pisa's origins and alliance to the Ghibellines.

The most extreme statement of Nicola's Classicism resides in his 'Fortitude', one of the cardinal virtues derived from Plato's *Republic*.

4 N. Pisano, 'Adoration of the Magi', Pisa Baptistry pulpit, 1260 (85 × 113 cm, 33½ × 45 in)

This statuette is considered the first modern representation of a heroic nude in the Classical manner. It departs from earlier depictions of Hercules in the sculptor's attitude towards the beauty of the nude body. The figure appears to derive from a Hercules like one on a sarcophagus in the Terme Museum, Rome, but the two are technically leagues apart. Nicola's is at once more classical and more finely carved. While the poses are almost identical, Nicola's figure – which has also been identified unconvincingly as Samson or Daniel in the Lion's Den – is assuredly a Classical Hercules which the sculptor substituted for the customary female personification of Fortitude, who holds a club and/or wears a lion skin as attributes of her strength. In its attitude to nudity and physical power, Michelangelo's *David* is its true heir. Although Nicola's 'Fortitude' is less than a metre tall, it seems more monumental until seen in context. The pose derives from one championed by Polyclitus and other sculptors of the fifth century BC, where the weight is borne on one leg. In contrast, the other leg remains relaxed, with the shoulders at an angle to the pelvis. Adopted by Renaissance artists to

lend convincing physicality to their figures, this shift in weight is called *contrapposto*

Nicola's inventive powers were not confined to his relationship with ancient art. One of his most human innovations is Charity on the Pisa pulpit. The child grasps Charity's first finger in such a naturalistic gesture of intimacy and loving trust that it must have been studied from life. His Charity is a fusion of French Gothic types depicting Misericordia (communal mercy) and of the antique, substituting a Classicizing nude putto for the usual beggar. The impact of Roman prototypes on Nicola's art lessens, in fact, as the pulpit reliefs evolve. They yield to more expressive human observations and richer detail. For example, in the Crucifixion the weight of the anatomically correct Christ is more convincing than in painted examples of Christ on contemporary giant crosses. Nicola also foreshortens Christ's halo and depicts the swooning Virgin with an unprecedented emotionalism appropriate to the subject. The final relief, the Last Judgment, betrays the influence of French Gothic sculpture, indicating the direction in which Nicola's art developed. Taken as a whole, the majestic panels offer a sophistication of technique and imagery that is rivalled only by Donatello and then Michelangelo. The didactic programme of this pulpit, like a major work of literature, is meant to be read on many

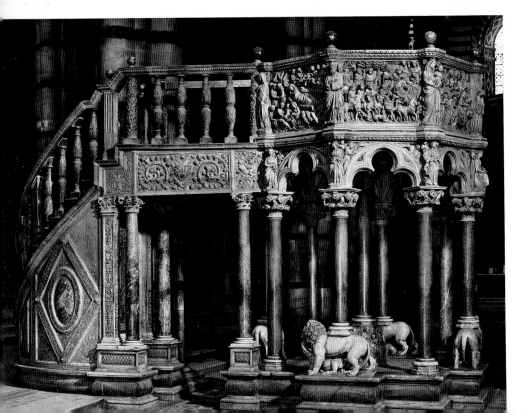

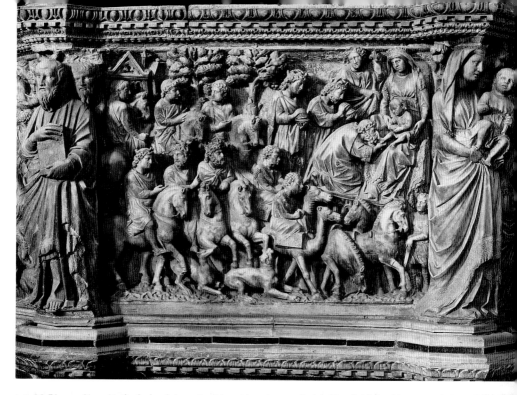

5, 6 N. Pisano, Siena Cathedral pulpit, 1265–8 (marble, 460 cm, 181 in). Detail: 'Adoration of the Magi' (85.1 × 97.2 cm, 33½ × 38¼ in)

levels. It has been suggested that the pulpit is related to the 'Domus Dei' sermon delivered in 1259 by the Pisan Archbishop Federico Visconti, who may have been adviser on the pulpit. Under the papacy of Urban IV (1261–4) the right to preach was extended from the exclusive province of the bishops to the mendicant orders. This profound change of relationship between clergy and laity led to an increase in pulpits.

It is believed that Nicola's workshop for the commission was small but probably included Arnolfo di Cambio and Nicola's son Giovanni. In the three subsequent Pisani pulpits changes occur with each commission that illuminate the genius of the father and the strength of the Italian workshop system. Presumably due to the success and fame of the Pisa pulpit, Nicola was commissioned in 1265 to sculpt another in Carrara marble for the Duomo of Siena. This second pulpit was 5,6 complete by 1268 and is far more ambitious than its Pisan predecessor; it is octagonal and therefore has seven historiated reliefs. The dark colonnettes framing the Pisa panels have been exchanged for figures in

white marble at the angles, allowing the narrative to flow while diminishing the classical containment. The richly carved cornice adds to the feeling of surface excitement and unity; it encourages a continuous scroll-like reading of the narratives, which is accentuated by a line of inlay above the lower cornice. The larger dimensions and layout of the Siena pulpit resulted from both practical and aesthetic considerations. The scenes of the Pisa Baptistry pulpit are clearly visible from any location within that small structure, but in the vast dark interior of the richly striated Sienese Cathedral it is difficult to view individual scenes. Nicola must have been aware of these limitations and planned his pulpit accordingly. In addition, the number of *dramatis personae* in each scene has been increased, necessitating a reduction in their scale. Thus the serene simplicity of Pisa has been exchanged for a richness of surface, motion and narrative. As at Pisa, the external columns rest alternately on the backs of lions (two males which devour their prey and two females which nurse cubs). The central column is surrounded not with grotesques but with figures of the liberal arts, a refinement in thought and form. Seven reliefs narrate the Life of Christ, but with significant changes. In the first scene, the Visitation is substituted for the Annunciation. In the second, the Journey of the 6 Magi is added to the simple 'Adoration'. It is replete with a black magus, an entourage including mastiffs, and four trees to suggest a landscape. A new scene, the Massacre of the Innocents, surely by Giovanni, is introduced. Finally, the Last Judgment represents the Damned on the left of Christ and the Elect on the right. In 1329 the columns were replaced and in the sixteenth century stairs were added and the pulpit moved to its present location, raised on a base to afford greater visibility.

These significant differences arise from three factors. The first is an infusion of French Gothic influence, seen in the beautiful Christ the Redeemer as well as in the decorative drapery and the proportions. Nicola was exposed to French Gothic ideas partly from contact with French ivories. Since a change in style often goes hand-in-hand with a 3 change in imagery, the Classical figure of Hercules at Pisa is replaced by a more traditional female virtue. The impact of the native aesthetic of Siena is the second factor. Whereas Pisa had Classical connections, Siena, which also traced its origins back to Rome, was interested in narrative, decoration and landscape. In the Siena pulpit, Nicola catered to local taste. The third factor is the extensive participation of Giovanni and assistants. A new composition for the narrative panels also appears in Siena. Rows of figures are set above each other to suggest depth and create a dense *horror vacui*. This compositional device reveals that

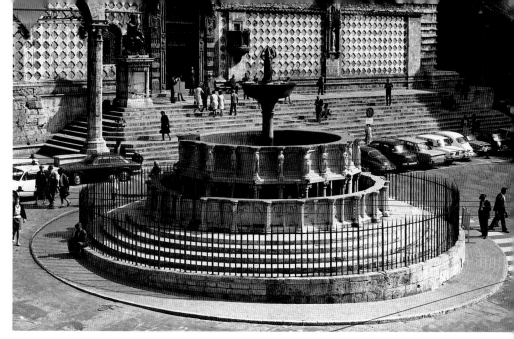

7 N. Pisano and workshop *Fonte Maggiore* finished 1278 (marble). Perugia

Nicola had looked at later Roman sarcophagi, which also stimulated Giovanni. The increased surface pattern, the thin somatic types, the greater amount and depth of the drilling and the 'bridge' (a small piece of stone connecting heads to the relief) all signal late Roman sources. So too the increased emotion, violence and linear drapery betray a study of these precedents, coupled with a freedom of expression most graphically embodied in the horror of the Damned and in the pathos of wanton slaughter in the 'Massacre of the Innocents'. By comparing the Pisa and Siena pulpits it is clear that Nicola developed rapidly, discovering that the Gothic language opened new expressive avenues. His son Giovanni (*c.* 1240/50–*c.* 1314), a contemporary of Dante and Giotto, was even more involved with the Gothic. It has been suggested that he travelled to Paris sometime between 1270 and 1275, although French ivories could account for his style. Different from his father, Giovanni focused on emotion, movement and the interplay of light and shadow, which he observed in both French Gothic and late Roman sculpture.

The last known monument on which Nicola Pisano worked is the *Fonte Maggiore* for the Umbrian town of Perugia. It was a collaboration among father, son and engineers for the hydraulics. The Pisani and their

7

17

workshop began it in 1277 and completed it in little over a year, although the planning and construction of this civic monument in the piazza in front of the town hall date back to 1254, when repairs were initiated on its subterranean aqueduct. Commissioned by the city fathers, the fountain carries political and allegorical allusions to one of the basic rights of every Roman citizen, access to free water. Thus it reflects the heritage and aspirations of the Guelph commune of Perugia (first an Etruscan, then a Roman city) during the dissolution of Frederick II's empire and the decline of the Ghibelline cause. The fountain, termed a 'Perugian encyclopaedia', is oriented on the points of the compass and serves as the hub of the city. It is executed in a combination of bronze and marble, recommended by ancient authors like Pliny. Like the two pulpits, the fountain is polygonal, although architectural elements dominate the sculpture. It is constructed on three levels and rests on top of concentric rings of steps to compensate for its irregular setting. The first level consists of a basin with 25 sides, each face with 2 upright reliefs (including 12 Labours of the Months, liberal arts, animals symbolic of Perugia, Romulus and Remus – the founders of Rome – Aesop's fables and scenes from Genesis). External and internal columns support the smaller basin of 12 sides whose bronze protomes, animal heads resembling Etruscan bronzes, serve as water spouts. The angles of this basin are decorated with 24 figures, representing civic and historic personages and personifications; some are religious and others secular, while portraits of leaders of the commune are progressively included. The third level consists of a simple bronze basin, dated 1277 and inscribed *RVBEVS* (probably the bronze founder). Crowning the fountain are 3 bronze caryatids who carry vases on their heads *all'antica*.

The fountain has been reconstructed several times and the positions of certain panels have been shifted and the surfaces of many have weathered badly. From what remains, however, it is clear that its meaning was civic, communal and Christian, referring to Perugia's ancient heritage and desired affluence. Still functioning today, it extols work, history and learning (the University was founded in 1307) and enshrines the ideal union of the church and state. Thus it is truly a Renaissance work of art and prophetic of later fountains. According to Vasari, after its completion Nicola returned to Pisa, where during his last years he worked on the huge, expressive half-length figures for the exterior of the Baptistry, which are very different from his early work. Nicola's approach to sculpture ultimately broke the spell of abstract symbolism which had governed earlier periods, suggesting a new attitude that Donatello and Michelangelo inherited.

The first independent work of Nicola's son dates from 1284 when Giovanni was employed as an architect/sculptor on the Cathedral of Siena and became a citizen of that city, perhaps indicating not only his principal place of employment until about 1295 but also his aesthetic sympathies. As Capomaestro (master builder) for Siena, he designed the earliest and most elaborate of the great 'Italian Gothic' cathedral facades, of which only the lower part was executed. The sculptures (removed to the museum for protection) include Old Testament prophets, sibyls and ancient philosophers so ravaged by the elements that they are only ghosts of the originals. Their deep drilling and craning necks are perhaps even more evocative and powerful in this deteriorated state. Such exaggeration was necessary to make the highly placed statues visible from below (unlike on French cathedrals where they were linked to portals).

From Vasari, we learn that the commission for a third Pisano pulpit, for S. Andrea in Pistoia, was awarded to Giovanni around 1297. The *8,9* Latin inscription beneath the pulpit's narrative reliefs gives the name of its patron, Canon Arnoldus, and the date of its completion, 1301. Probably because the church is a small Romanesque building, Giovanni returned to the hexagonal format of the Pisa Baptistry pulpit, although its Gothic character sets it apart from the earlier work. Not only are the cusps of the archivolt pointed Gothic forms but also the figures are Gothic, contributing a vertical thrust. As at Siena, angle figures separate the narrative scenes. There are also innovative variations on the Pisano pulpit formula. For example, one of the two supporting lionesses on the base nurses cubs and pauses over a rabbit, while a third has been replaced by an older, bearded atlantid figure turning in extreme *contrapposto*. The five reliefs depict: the Annunciation, Nativity and Annunciation to the Shepherds; the Adoration, Dream of the Magi and Angel warning Joseph; the 'Massacre of the *9* Innocents'; the Crucifixion; and the Last Judgment. They demonstrate an increased interest in anecdotal detail and narrative enrichment, as in the addition of two thieves to the Crucifixion or the maid who tests the water before plunging the clearly newborn babe into the basin. At the angles of the archivolts between prophets are six sibyls with attendant genii whispering in their ears, a motif also used by Michelangelo on the Sistine Chapel ceiling. It is in the style of the relief and the figures with more expressive gestures, angular forms, diagonal rhythms, deep undercutting and emphasis on heavy shadows that one feels Giovanni has found his mature stride. The influence of French ivories is everywhere evident. There are also traces of gilding and inlaid vitreous paste with patterns of quatrefoils, the ubiquitous Gothic form. The

reliefs were carved quickly and surely with great freedom and abrupt plunges into darkness. Such virtuoso technique generalized and distorted the figures' expressions and left gouges and the raw marks of the chisel. For the first time Giovanni carved the reliefs tilting towards the viewer to achieve greater visibility. The expressive power of his art reaches a feverish pathos in the 'Massacre of the Innocents'. We witness infants yanked between soldiers and protective mothers, while other mothers, with swollen breasts, mourn their slain babes or plead for clemency from Herod. The anguish of suffering at the hands of brutal butchers and a cruel tyrant transcends the specific incident to become a universal polemic against injustice.

Records show that in 1298 Giovanni was documented as Capomaestro of Pisa Cathedral, where he was working on a number of projects including the Campanile, taking soundings in preparation for correcting its lean. In 1302, after the completion of the Pistoia pulpit, he was commissioned by the head of Pisa Cathedral, Burgundio di Tado, to

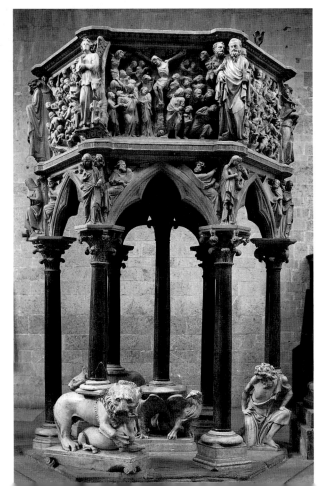

8, 9 Giovanni Pisano, pulpit in S. Andrea, Pistoia, 1301 (marble, 455 cm, 179 in). Detail: 'Massacre of the Innocents' (84 × 102 cm, 33 × 40⅛ in)

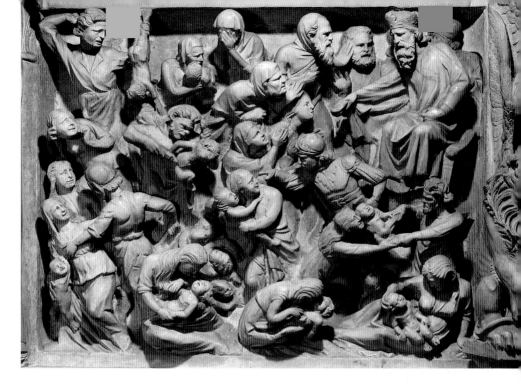

execute yet another pulpit in Carrara marble. It was installed in the right choir but damaged by a fire in 1595 and dismantled. (Most of the fragments were gathered into a problematic reconstruction in 1926, while others are dispersed in museums around the world.) In this last and most ambitious of the four Pisano pulpits, Giovanni reverted to an octagon as had his father in Siena Cathedral. This decision was again at least partly determined by the size of the building. Giovanni further modified the shape by including a platform at the top of the stairs, which allowed for two additional reliefs. The pulpit consequently has 9 historiated panels, 2 flat ones on the platform and 7 on the main body of the pulpit in a new convex shape. This convexity gives a circular impression to the monument. The narratives read like a cohesive, unrolled scroll, aided by the heavy cornice which helps to propel the viewer's eye. Giovanni, a gifted raconteur, increased the superimposition of episodes and created variations on the standard Pisani narratives. He also introduced two new subjects – one with three episodes in the life of John the Baptist, probably derived from the popular *Meditationes de vita Christi* (*Meditations on the Life of Christ*) of Pseudo-Bonaventura, and another depicting the Betrayal, Mocking and Flagellation, as well as Christ before Caiaphas.

No systematic study has distinguished the many hands at work on the pulpit. While the reliefs are tilted towards the spectator as at Pistoia, there is less stylistic unity and decorative elements seem more profuse. The undercutting is still deeper, so that in places, heads are freestanding and the background translucent in daylight. There are also unusual proportional dissimilarities among the figures. The pointed Gothic cusps of the archivolts have been replaced by double scrolled volutes which do not meet in the centre below the reclining prophets. These dynamic vaguely Classicizing forms lend an unresolved quality to that section of the pulpit. The lower supports, which may not be correctly reconstructed, are the most interesting elements and include several innovations which grew out of the atlantid of the Pistoia pulpit. For example, the most complex one is crowned by Ecclesia or Pisa, shown with two suckling babes at her breasts, like later Charity figures. She stands on a base with the four cardinal virtues: the female personification of Fortitude holds a lion and Prudence, depicted as a *Venus pudica*, covers her genitals and breasts. In their heavy facial types and attitudes one can sense that Giovanni has fallen under the sway of his father's nearby Baptistry pulpit and the antiquities of Pisa. This influence also appears in one of the two single supporting figures, the older anguished Hercules which, in comparison with the Herculean 'Fortitude' on the Baptistry pulpit, reveals how different Giovanni's style was from that of his father.

During his final work on the Pisa Cathedral pulpit, Giovanni Pisano received a commission for a *Madonna and Child* from Enrico Scrovegni. It was designed for an unknown position in the family chapel attached to Scrovegni's palace in Padua. Today it stands on the altar before Scrovegni's tomb, flanked by two wingless acolyte angels. The chapel was constructed to expiate the sins of the patron and his father, whose vast fortune was gained from usury (inspiring Dante to place him in Hell in the *Divina Commedia*). This regal group is similar to others executed by Giovanni. While the Paduan Madonna wears a Gothic crown, she seems more majestic, tempered by antiquity and less influenced by French Gothic forms. She supports the Child on her hip as she turns in *contrapposto*, her garment clearly separate from her body. The Child instinctively searches for her breast, and the rapt gaze between the two rivets them in an intimate moment that preserves the Madonna's realization of her son's death. The columnar quality of her drapery and the reliance on profiles add a Classical note similar to the figures in Giotto's frescoes in the chapel, painted at the same time. Giotto's sculptural figures are so close to Giovanni's that it is tempting to conclude the two met, as Vasari contends. Unfortunately, there is no

10 G. Pisano, Pisa Cathedral pulpit, 1302–11 (marble, 461 cm, 181½ in)

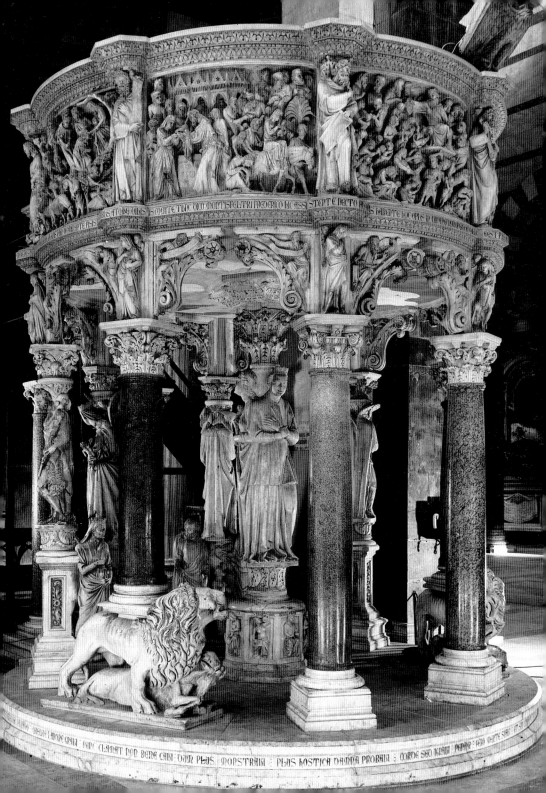

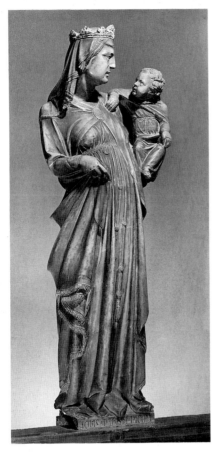

11 G. Pisano *Madonna and Child* 1305–06 (marble, 129 cm, 50¾ in). Scrovegni Chapel, Padua

12 N. Pisano, Pisa Baptistry pulpit, 1260 (marble, 465 cm, 183 in)

proof of this attractive theory and, indeed, Giovanni may have executed his work in Classicizing Pisa.

Two of the last works by Giovanni are related to the Hohenstaufen Emperor Henry VII, who visited Pisa in 1312. To celebrate an alliance with Pisa (1310), he commissioned a group for the tympanum over the Porta S. Ranieri, which consisted of the Virgin and Child, the personification of Pisa and the emperor (now lost). It was followed by a still more significant work, the tomb of Henry's wife, Margaret of Brabant, who had died at Genoa in 1311. Originally in the church of S. Francesco di Castelletto, it was destroyed when the building was demolished in 1798 during Napoleon's ecclesiastical suppression. Only fragments remain of this lost work, the sole recorded sepulchral monument by Giovanni, which could have told us much about his late relationship with French Gothic. The most eloquent fragment depicts

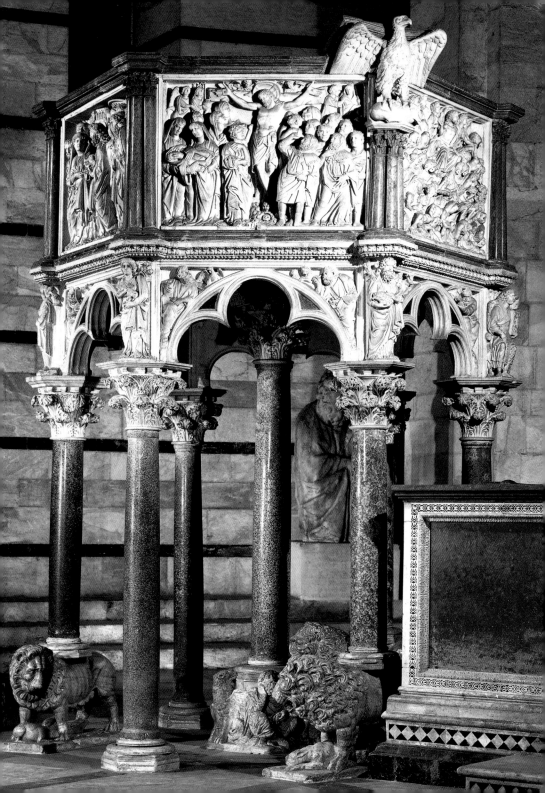

the Resurrection of the Empress, raised up to a new life by angels, which was patterned on the French theme of the awakening of the Virgin.

Arnolfo di Cambio (c. 1245–c. 1310), a contemporary of Giovanni, was Nicola's chief assistant on the Siena pulpit. After its completion in 1268, he worked on the Pisano shrine of St Dominic in S. Domenico, Bologna, leaving the shop to work independently in Perugia and Rome around 1270. His sculpture fuses the art of Nicola, the antique and the traditions of medieval Rome in a distinctive manner. Arnolfo played a seminal role in creating the *trecento* sepulchral monument. A case in point is the very mutilated and badly reconstructed tomb of the French cardinal De Braye, who died in 1282. This tomb was moved and, in its present form, lacks a unifying Gothic architectural tabernacle. Its majestic, enthroned Madonna, taken from a Classical goddess, presides over the heavenly realm. Below, flanking the central inscription, are two saints, one of whom (probably St Mark, the deceased's patron saint) presents the kneeling cardinal to the Virgin, as in an innovatively arranged eschatological *tableau vivant*. Arnolfo has monumentalized the funeral portrait, taken from the French tradition, wherein the deceased is also shown alive. Directly below is the tomb chamber whose side curtains are being drawn by two deacons/angels to

13,14

13

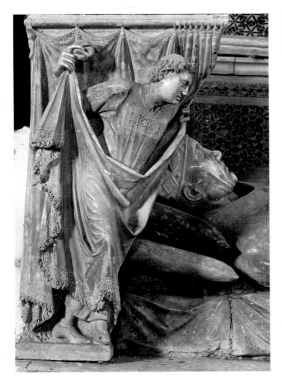

13, 14 Arnolfo di Cambio *Tomb of Cardinal de Braye* after 1282 (marble). Detail: deacon/angel pulling back a curtain (c. 63.3 cm, 25 in). S. Domenico, Orvieto

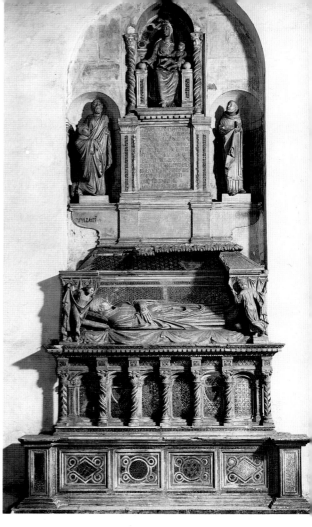

reveal the recumbent effigy. This dynamic duo – one shown from the front almost in a dancing pose and the other from the back in typical Italian fashion to balance and enliven the composition – is the most novel feature, yet they descend from ancient models. Below this area is a sarcophagus (not a recycled antique one as in other contemporary tombs) with columns and a base heavily decorated in cosmati work (polychromatic mosaic inlay named after a Roman family associated with its inception and popularity), a feature running like a leitmotif through the monument.

15 (p. 28) Andrea Pisano, Florence Baptistry south doors, 'Life of St John the Baptist', 1330–36 (gilded bronze, 486 × 280 cm, 191⅜ × 110¼ in)

16 (p. 29) Ghiberti, Florence Baptistry north doors, 'Life of Christ', 1403–24 (gilded bronze, 457 × 251 cm, 180 × 98⅞ in)

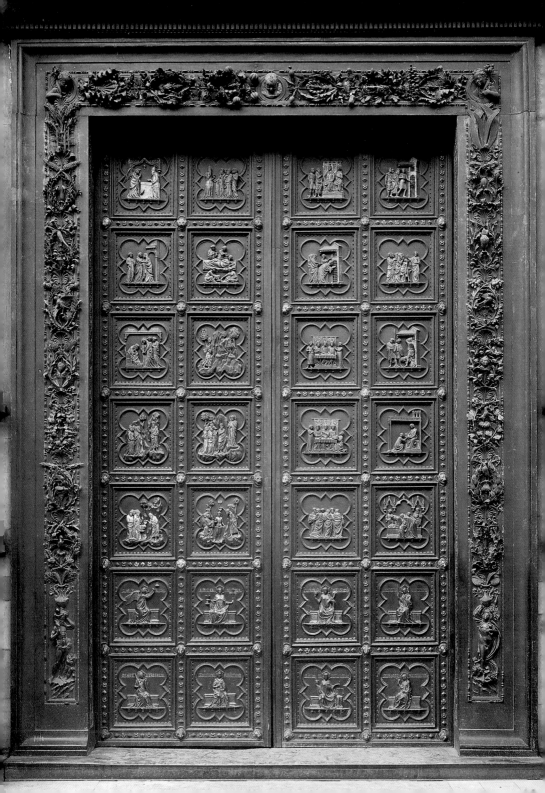

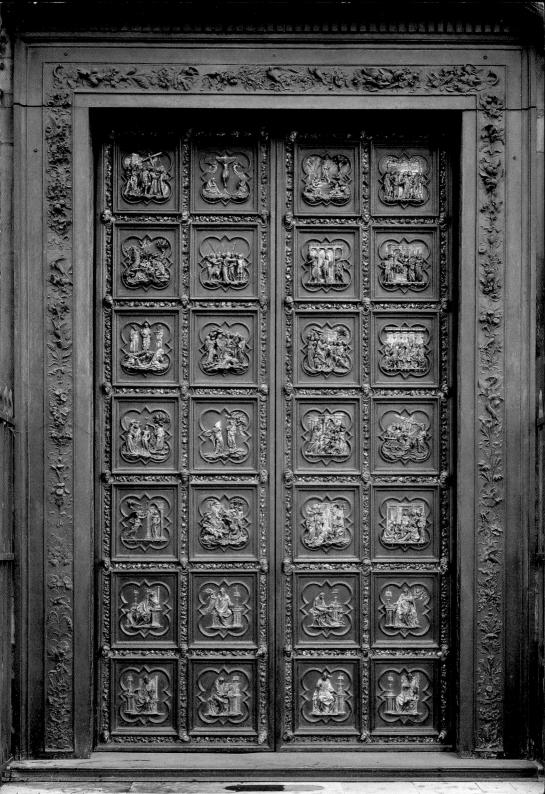

After returning to Rome, Arnolfo executed many works, including two celebrated ciboria for S. Paolo fuori le Mura and S. Cecilia in Trastevere, tombs and the famous bronze of St Peter in the basilica of the same name. Since architecture takes the dominant part in all Arnolfo's work, he is best remembered as an architect. In 1294, he was called in to consult on Florence Cathedral and returned in 1296, when he designed and served as Capomaestro of the new structure, built on top of the church of S. Reparata. (He also designed other churches in Florence and is credited with Orvieto Cathedral and the Palazzo Vecchio of Florence.) One of his duties as Capomaestro was to supervise the sculpture programme. His *Madonna and Child*, for the lunette over the central portal of Florence Cathedral (as shown in a sixteenth-century drawing), was flanked by two patron saints, Reparata and Zenobius. Renaissance descriptions praise the veracity of the Virgin's shining glass eyes with their painted pupils. Her massive body and crisp folds of Classicizing drapery once again relate to Roman models. The work's blocky planes and austere monumentality, together with the slight tender smile, constitute Arnolfo's original style. He also carved groups over the two side portals of the western facade: the Dormition of the Virgin, one of the most moving Italian sculptures of the period (now destroyed but preserved in a cast), and the reclining Virgin of the Nativity, both of which echoed the grandeur of the central portal. He created these figures at the same moment when Giovanni Pisano was working on his figures for the Cathedral of Siena, Florence's arch rival. In Arnolfo's austere art, Gothic traits are held in check by Classical reminiscences and its serene and static abstraction is the antithesis of the movement and emotion of Giovanni's figures on Siena Cathedral.

When Arnolfo died he left no major followers, whereas Giovanni left many, including the talented Tino da Camaino (*c.* 1280/5–1337). A native of Siena and son of the sculptor Camaino di Crescentino, he first worked under Giovanni on the Pistoia pulpit and succeeded him as Capomaestro at Pisa in 1315. His works are characterized by solidity and broad planes – in contrast to the emotion and grace of Giovanni – traits indebted to the antique, Nicola and Arnolfo. Tino also endowed his broad figures with a certain sweetness and slightly slanted eyes, stylistic hallmarks. In 1315, he received the commission for the funeral monument of the Emperor Henry VII (died 1313). As Tino left Pisa before it was completed, its final form is uncertain. Today it is divided between the Cathedral (the sarcophagus and effigy) and the Campo-santo (the seated figure of Henry and four councillors by his studio). A fifth head has been discovered, suggesting that there were six flanking

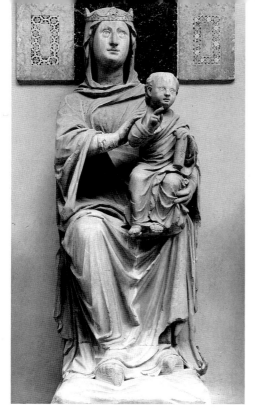
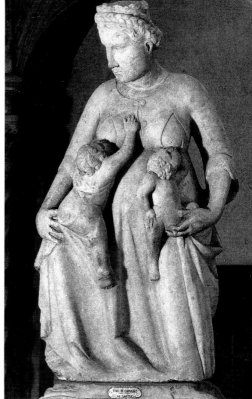

17 Arnolfo di Cambio *Madonna and Child, c.* 1296–1302 (marble, 173 cm, 68 in)

18 Tino da Camaino *Charity, c.* 1321 (marble, 136 cm, 53½ in)

figures arranged as a kind of council. This monument represented Henry as a Roman emperor to a Ghibelline city which hoped to become part of a New Rome, a statement of political propaganda which had not been equalled since Roman times. Dante celebrated Henry in his *Paradiso*, Canto XXX, as a representative of good government, who would organize Italy according to justice and mercy.

Although the date of the massive *Charity*, found in the environs of *18* Florence, is still debated, it probably derives from Tino's residence there. While the work is remarkably like his unusual seated effigy of Bishop Orso, from that cleric's tomb, its original context and purpose remain a mystery. The heroic figure, an earth-mother type, is one of the first portrayals of Charity nursing; it represents the outcome of a complex evolution of the image that sprang from the *trecento* Pisano school. Shallowly carved in a plane and with an unfinished back, it was probably meant for a niche. Her casual posture, like contemporary

images of the Madonna of Humility, has never been properly ascertained, and it is usually stated that she is sitting. However, her right knee is up (traces of a damaged foot peek out of the drapery) but is not correctly foreshortened and she kneels on the left. In 1323, Tino departed for Naples to work for Robert of Anjou until his death in 1337, taking with him to southern Italy the sculptural traditions of Tuscany. (There he met the Sienese painter Pietro Lorenzetti, as well as Giotto, who was court painter.) Tino's main contribution was in the field of sepulchral monuments. Some of these are noted for their unorthodox iconography, like the earlier one of Bishop Orso.

In the first quarter of the fourteenth century in the north there emerged with the Scaligeri tombs at Verona a significant secular Renaissance image – the large-scale equestrian sculpture. Earlier works had prepared the way for these freestanding monuments: for instance, the three-quarters life-size relief (1233) of the *podestà* (executive magistrate) Oldrado da Tresseno – attributed to the circle of Benedetto Antelami – in Milan. In many ways this equestrian ran parallel to the appearance of the *dolce stil nuovo* (the 'sweet new style' of Dante and other poets) in literature; as that anticipated humanism, so this sculpture foreshadowed one of the noteworthy themes of the Renaissance. Originally the Graeco-Roman equestrian was secular in nature; the most famous example known to the Renaissance was the *Marcus Aurelius*, mistakenly thought to represent Constantine, the first Christian Roman emperor, and thus saved. During the Middle Ages a man on horseback often depicted the vice of pride, but more frequently a Christian saint or a Labour of the Month. At the beginning of the Duecento, the equestrian statue was re-secularized, as in the Oldrado work, to evoke civic liberties and the cult of the hero, so important to the Renaisssance. At this time, equestrians were also carved small-scale in narrative funerary reliefs, portraying the deceased galloping into battle, as on Gothic seals.

An unbroken evolution of equestrian statues in a funerary context occurred in *trecento* Verona. It started conservatively with a small relief on the sarcophagus of Alberto I della Scala (died 1301) inside S. M. Antica. With Giovanni da Campione's (active 1340–60) outdoor tomb of Cangrande della Scala (died 1329) – a conglomerate structure crowning the portal of the church – the equestrian became freestanding and life-size (a copy has replaced the original, now in the Museo del Castelvecchio). Cangrande – in full armour, his winged helmet thrown back and his sword held aloft – in unison with his caparisoned steed turns his head 'full of good cheer', according to a source, proclaiming the triumph of individuality. His look of self-satisfaction and 'lordly

insouciance', as one art historian has phrased it, are blatant and his slightly awkward smile reminds one of Archaic Greek figures. This work, not without Germanic influence, spawned a northern Italian tradition for equestrian monuments; Cangrande's successors were also honoured with nearby tombs whose equestrian images lack the vigorous impertinence of Cangrande. Bernabò Visconti (died 1385), the iron-fisted despot of Milan who married Regina della Scala of Verona, forged both a political and aesthetic alliance between the two cities. He commissioned from Bonino da Campione a six-metre high equestrian monument (which remained unfinished), originally placed behind the altar of the now demolished church of S. Giovanni in Conca, Milan. The horse and intensely fierce rider, which leaves no doubt as to who controlled Milan, dates from *c.* 1363 according to a chronicler's description, while the sarcophagus dates from Visconti's death.

Trained in Siena where he worked on the city's Cathedral until 1308, the sculptor/architect Lorenzo Maitani (*c.* 1270–1330) became the 'universalis caput magister' of the Cathedral at Orvieto in 1310. He retained the post until his death and was granted citizenship in that former Etruscan city. Later, it seems, he also supervised the sculpture of the lower facade, although he is recorded as executing only one of the four large bronze symbols of the Evangelists, the eagle of John. The

19 Giovanni da Campione *Tomb of Cangrande della Scala, c.* 1333 (marble). S. M. Antica, Verona (detail)

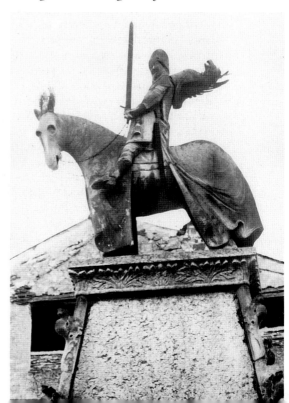

four massive piers of the facade, richly decorated in low relief, are also believed to have been executed under his supervision. Their unusual placement relates to a local tradition, but lurking in the background is the source for their continuous vertical narrative – Roman columns like those of Trajan and Marcus Aurelius. With these elaborate reliefs that read like a visual Bible, the decoration of Orvieto Cathedral far surpasses in complexity both the Florentine and Sienese cathedrals, although scale is sacrificed in the process. The piers narrate from left to right: scenes from Genesis; the Tree of Jesse and Prophecies of Redemption; prophets and the Life of Christ; and the Last Judgment and Paradise. The two inner piers are more conservative and schematic than the outer pair, suggesting that they were executed by a different sculptor. Only the lower scenes on all four piers are finished; they are also more densely populated and deeply carved because they are closest to the viewer. Many of the figures reveal Maitani's debt to G. Pisano, while the unifying vine reminds one, especially in the two outer piers, of manuscript illumination and the art of Siena. So too the exquisite Gothic proportions of some of Maitani's figures, like the graceful angels of the Creation, resemble the elegant figures of the Sienese painter Simone Martini. The interest in pictorial landscape also recalls Maitani's native city. In the lower region of the fourth pier, the influence of late Roman sarcophagi appears in the grotesque expressions and vigorous postures of the chaotic Raising of the Damned. It is no coincidence that these terrifying scenes were relegated to the most accessible register, didactically encouraging conversion, repentance or stricter religious observance.

In 1329, a pair of bronze doors was commissioned for the Florentine Baptistry by the Arte di Calimala (Guild of Cloth Importers), responsible for supervising the building. (The first mention of bronze doors occurs in 1322, when Tino da Camaino was in charge of wooden doors covered with metal.) Bronze casting was a specialized activity, and no one in Florence was capable of the task. Therefore, the Guild selected Andrea d'Ugolino, known as Andrea Pisano (c. 1290–1348?), from Pontedera near Pisa, renowned for its bronze tradition. The doors for the Baptistry, believed to have been a Roman temple of Mars, were commissioned in emulation of ancient doors and were influenced by the scheme and monumentality of those made by Bonannus. The Guild had dispatched a goldsmith to Pisa to draw the doors and then to Venice to view the bronze doors of S. Marco. Andrea forged his new design from these precedents. He signed and dated the doors 1330 (they were not hung until 1336), showing that he was proud of his identity, art and native city, and was thus not an anonymous craftsman in the medieval

34

20 Lorenzo Maitani, Orvieto Cathedral facade, detail from left pier: scenes from Genesis, 1310–30 (marble)

tradition. Little is known of Andrea's background: he probably trained as a goldsmith, according to documents terming him a 'worker in gold'. This conclusion is reinforced by the sensitivity to decorative, miniature detail on the doors. Andrea participated in the revival of bronze on a grand scale, which reached maturity in the second stage of the Renaissance. Unlike earlier bronze doors elsewhere, Andrea's were cast in the ancient *cire perdue* (lost wax) method, like the caryatids of the Pisano, although parts were cast separately and then assembled. The gilding of the setting and figures for contrast was a technical innovation.

The doors (consisting of twenty-eight rectangular panels) were destined for the south portal of the Baptistry, the most frequented entrance. Since they were always open, they were meant to be read separately, starting at the upper left corner like the page of a book. At the four corners of each scene are lions' heads (the *Marzocco*, symbol of the Florentine *popolo*) with bands of alternating rosettes and studs between. These decorative details unify the doors and are echoed in the dentilated mouldings which enclose the Gothic quatrefoils, surely

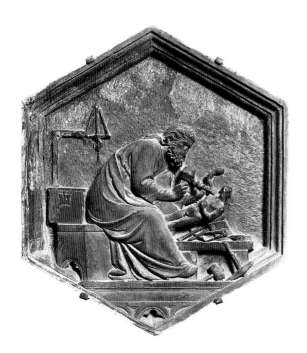

21 A. Pisano *Sculpture* 1336–43 (marble,
83 × 69 cm, 32⅝ × 27⅛ in). Campanile,
Florence

derived from French metalwork but also used by other artists such as Giotto. Each door contains ten scenes in the upper section from the Life of St John the Baptist, the patron saint of Florence to whom the Baptistry is dedicated. The stage-like, abbreviated settings are placed on projecting platforms, and the space, defined almost exclusively by the figures, resembles that painted by Giotto in his scenes in the Peruzzi Chapel, S. Croce. Much admired, Andrea's doors became a symbol of the glory of Florence and were the model for the next set.

The implied connection with Giotto is explicit in Andrea's second commission, the sculpture of the Campanile, begun by Giotto in 1334, diagonally opposite the south portal of the Baptistry. It is believed that the Genesis scenes were installed by Giotto's death in 1337, when Andrea became Capomaestro. He subsequently completed the first zone of hexagonal reliefs, working on the large freestanding figures for the upper parts until his departure for Pisa around 1343. The programme is a visual scholastic *summa* of encyclopaedic content. It places an unusual emphasis on the concept of work, one of the primary ways medieval and Renaissance people defined their existence, but in a marked departure from the usual medieval context of the Labours of the Months. Andrea's scheme appears to reflect a belief in the value of work, which eventually led to the strong Florentine profit motive and increasing economic prosperity. Florence has been credited with being

36

one of the first capitalist societies. As Andrea matured, he exhibited a greater interest in the aesthetic qualities of Graeco-Roman art, coinciding with evidence in Giovanni Villani's contemporary *Chronicle* that members of the upper bourgeoisie who controlled the Campanile project were more conscious of their Roman past. The representation of *Sculpture* marks a turning point in Andrea's stylistic evolution. It is 21 more monumental than the preceding reliefs, with its sculptor placed against a neutral but coherent background. This Classical trait is echoed in the figure he is carving, an 'antique' male nude in the round. Tools of the sculptor's trade are casually depicted – the hammer, drill, compass and, significantly, a book. Parts of the cycle include for the first time pagan figures without Christian clothing, like Hercules, Daedalus and Gionitus, the inventor of astronomy. A number of these are based on ancient prototypes, while others herald attitudes towards the sensuousness of the human body and nature that are not prevalent until the next century.

Andrea also created independent works and his son Nino, who started his career in Andrea's *bottega*, carried on the family tradition, specializing in lyrical Madonna and Child sculptures. Although Nino began within the Classicizing style of his father, his art increasingly assimilated northern influences, probably from ivories whose delicate smoothness he translated into his marbles. Nino's brother Tommaso, a less gifted sculptor, ended the so-called Pisan school which Nicola Pisano had so brilliantly initiated.

By the early 1340s the political and economic climate in Florence had deteriorated with the collapse of the great banking houses, political unrest, failure of the crops and the spread over Europe of the Black Death. It is estimated that the severest epidemic in 1348 decimated between forty and sixty per cent of the populations of Siena and Florence. Siena never recovered economically or artistically from this devastating catastrophe that we in the age of antibiotics cannot quite fathom. It engendered a reactionary, pessimistic atmosphere of religious pietism and fanaticism that emphasized dogma. People believed that they were being punished for their worldliness. These drastic changes had a dramatic impact on art. Since the economy was severely depressed, there were fewer commissions and substantially fewer sculptural ones, which tended to be very costly. Those ordered were more conservative, very religious in content, hieratic, frontal and emblematic, marking a retreat from earlier ideas. The style of this period has been termed 'The Black Death Style', but it also quietly continued older traditions in decorative detailing and patterning. Working in this ambience was Andrea di Cione (active 1343–68),

known as Orcagna – a painter, sculptor and architect whom Vasari claims was trained by A. Pisano. He was commissioned to execute the only significant, large-scale sculpture of the time in Florence, the mammoth tabernacle for Or San Michele (the former grain market which had become an oratory below and a meeting hall for the market above). This Gothic marble structure, rather like a miniature church, was a religious and civic edifice built to house Bernardo Daddi's repainting of a lost thaumaturgic image of the Virgin and Child. The painting engendered a cult in Florence, replete with a confraternity to oversee its functions, and exerted a magnetic pull for pilgrims after the plague's scourge. Hexagonal reliefs of the virtues and octagonal reliefs of the Life of the Virgin alternate on its base. The programme culminates in the large relief on the back, the 'Dormition and Assumption of the Virgin', where the work is signed and dated 1359. The two scenes, treated as one, are separated by the horizontal band of the tomb. This rocky ledge also marks a dichotomy in contemporary attitudes towards the earthly and the spiritual. The Death and Funeral of the Virgin take place on earth and are physical, but three-dimensional space is suggested only by the histrionic figures who crowd round the Virgin laid out on her sarcophagus. In the middle stands Christ holding a child symbolic of the Virgin's soul, flanked by two angels with twisted tapers like those in the services for the dead of the confraternity. The mourners convey a pathos with which most survivors of the Black Death could identify. Likewise, they would associate with two individuals in *trecento* dress at the right, one of which is reputed to be a portrait of the artist. Above in the flat, otherworldly realm, the Virgin levitates within a *mandorla* (almond) indicating spirituality and bestows her girdle on the kneeling St Thomas, probably reflecting one of the confraternity's lauds dedicated to the Assumption. Orcagna's tabernacle is encrusted with precious lapis, gold and glass inlay that creates a brilliant, shining polychromy; it is especially dense in the celestial realm, rendering the area still flatter. The elaborate decoration is equivalent to the rich brocades in contemporary painting, a taste which blossomed with the International Gothic style.

As the Florentine economy began to recover at the end of the Trecento, several projects ended the hiatus in large sculptural commissions: the closing of the arches of Or San Michele; the construction of the Loggia dei Signori or Lanzi; and the resuscitation of the facade sculpture on the Cathedral. An important part of the last project was the decoration of the lower region of the Porta della Mandorla, whose first phase lasted from 1391 until around 1400. The acanthus leaves and the small nude female and male figures, identified as

22

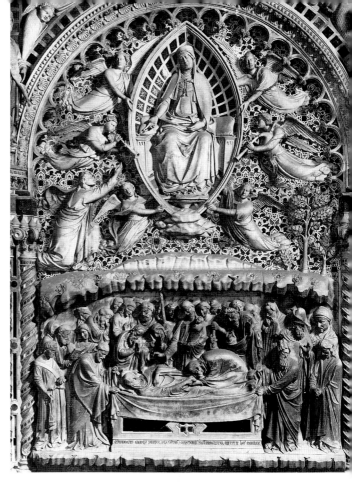

22 Andrea Orcagna, 'Dormition and Assumption of the Virgin', *c.* 1352–9 (marble, lapis lazuli, gold and glass inlay). Tabernacle, Or San Michele, Florence

Abundance and Hercules, in the decorative border are the first tentative re-introduction of Classical motifs on a public building. Hercules, a civic hero and protector of Florence, expressed *virtù*, a quality prized by Renaissance humanists. It is no coincidence that the humanist Chancellor of Florence, Coluccio Salutati, was writing his treatise on the Labours of Hercules at the same time. Hercules was the ideal Renaissance person, for he perfected himself to gain Olympian status. Following the Campanile relief by A. Pisano, this Hercules heralds a new age.

At the same time in Venice, a mercantile city with a special relationship to the sea and prone to influences from all points of the compass, the brothers Jacobello (died *c.* 1409) and Pierpaolo (died *c.* 1403) dalle Masegne were active. Although they appear to have been

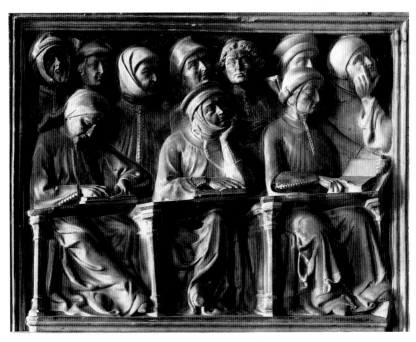

23 Jacobello and Pierpaolo dalle Masegne 'Students', *Tomb of Giovanni da Legnano*, 1383–6 (marble, 63.3 × 76.5 cm, 24⅞ × 30⅛ in)

trained in Venice under the lingering influence of Nino Pisano's grace, they made their reputations in Emilia. Between 1391 and 1395, they were working in tandem to embellish the interior of S. Marco with a monumental choir screen. The styles of the two brothers remain to be sorted out satisfactorily, although their figures betray a strong Germanic influence, which could be expected in Venice. It is apparent in the generalized figures and the hard, almost metallic quality of their drapery. As with most sculptors, the Dalle Masegne were itinerant and subsequently worked in Mantua, Bologna and Milan, sometimes separately. One of their finest works is a relief formerly in the church of S. Domenico, Bologna. It is from the tomb of Giovanni da Legnano, a professor at the famed University. Often attributed to Jacobello, it shows a class of students with great naturalism and animation.

23

The Mature Renaissance: Beginning the Second Stage

There was one moment at the start of the Quattrocento in Florence when all the elements necessary to the Renaissance coalesced. In the winter of 1400–01, the Arte di Calimala held a competition in the ancient mode for the second set of Baptistry doors. They were destined for the important east portal facing the Cathedral and were to be modelled on those of A. Pisano. The competition was entered by seven Tuscans: Filippo Brunelleschi, Lorenzo Ghiberti, Jacopo della Quercia, Simone da Colle, Niccolò d'Arezzo, Niccolò di Pietro Lamberti and Francesco di Valdambrino, who submitted designs for the 'Sacrifice of Isaac', the Old Testament typological prefiguration of the Crucifixion. Although a second set had been planned in the Trecento, it took an economic recovery and a feeling of optimism after deliverance from another outbreak of plague in 1400 to set the work in motion during a period of intense patriotism and a lull in the war with Milan. Competition with the Arte della Lana (Guild of Woolworkers), which was embellishing the portals of the Cathedral, no doubt added fuel to the fire of patronage to create the correct matrix. (Art in Florence was commissioned mainly by seven major guilds; only as the century progressed did individual patronage evolve on a large scale.) These events coincided with the beginnings of humanism, a more objective and comprehensive revival of Greek and Roman culture than previously experienced. The development of humanism was inextricably linked to an interest in the Roman legal system and to scholars translating texts. As knowledge of Latin and Greek literature spread, people began to look to the Classical past for artistic, literary, political and heroic models. Rome became the inspiration, not in rhetoric only, for an idealistic renewal, a way of bettering life on this earth. Florence viewed itself as a leader in the humanist movement and Florentines believed their republican city, originally founded as a Roman colony, was the new republican Rome.

Today only two of the competition panels are known, those of Brunelleschi (1377–1446) and Ghiberti (1378–1455): either preliminary *24,25* drawings or models eliminated all but these or the other bronze panels were melted down because they were not deemed worth keeping. In

November 1403 the virtually unknown Ghiberti, declared the victor by a narrow margin over the more experienced Brunelleschi, was given the contract. Although both reliefs broke away from the current static compositional formulae and both used the prescribed number of figures in a Gothic quatrefoil format, they differ radically, revealing *24* two distinct artistic personalities. Brunelleschi's dramatic, realistic *25* depiction is arranged in two horizontal levels, while Ghiberti's is subtly organized by gently interwoven diagonals. Even though Brunelleschi's contains noteworthy achievements – the quotation of the famous thorn-puller (*Spinario*) from antiquity, the extreme *contrapposto* in the figure at the right, the angel grasping Abraham's arm to stop the sacrifice and the tortured pose of the nude Isaac – he filled the protuberances of the quatrefoil rather mechanically. Most importantly he failed to integrate his figures, thus making his narrative abrupt and jerky. By contrast, Ghiberti's depiction is unified pictorially and optically with light and landscape playing important parts in his exquisitely chased panel. There is also a graceful flow between the Gothic proportioned figures and the Isaac embodies the idealism so fundamental to Classical art. Moreover, Ghiberti presents the narrative with a seductive ease that belies the complexities of his composition, overlaid with decorative charm and anecdotal details (the worn saddle of the donkey, the lizard, the elaborately tooled borders of the cloaks). It is no wonder that the judges selected Ghiberti's relief. But the strongest argument in favour of his entry for the parsimonious Florentines was, no doubt, its cheaper, superior technique. It is hollow-cast in one piece (except for Isaac, Abraham's left hand and a rock) in the lost-wax method, whereas Brunelleschi's is solid-cast with soldered pieces (he would have required six hundred more Florentine pounds of bronze than Ghiberti). This awkward method appears in his less integrated though more powerful design. Overall, Ghiberti's relief was visually and monetarily sounder. It was never incorporated into the doors, whose subject was changed before he began work.

16,26 The theme for Ghiberti's first doors was the Life of Christ in 20 scenes with the 8 lower panels containing the Evangelists and Fathers of the Church. As these doors were kept shut, except on feast days, the scenes read from the bottom across both wings. The 28 back panels, each with a lion inside a roundel in low relief, repeat the divisions on the front. The first panels executed reveal that Ghiberti tried to harmonize his compositions with the Gothic quatrefoil, unlike A. Pisano who echoed the outer square form. The slender, lyrical figures approximate those of International Gothic painters like Lorenzo Monaco and Gentile da Fabriano. Their draperies establish patterns of fluid elegance which

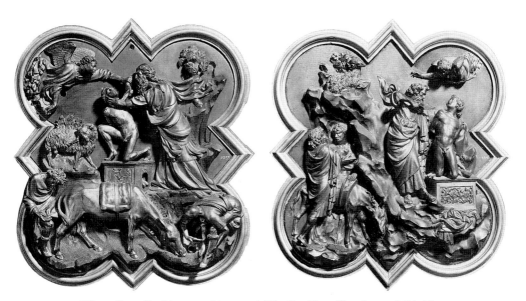

24 Filippo Brunelleschi, competition panel, 'The Sacrifice of Isaac', 1401 (gilded bronze, 53.3 × 44.5 cm, 21¼ × 17½ in)

25 Lorenzo Ghiberti, competition panel, 'The Sacrifice of Isaac', 1401 (gilded bronze, 53.3 × 44.5 cm, 21¼ × 17½ in)

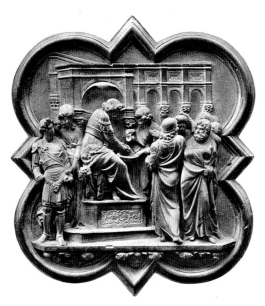

26 Ghiberti, 'Pilate washing his Hands', Florence Baptistry north doors, 1403–24

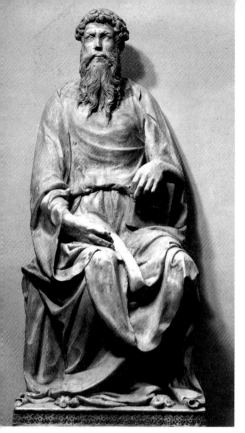 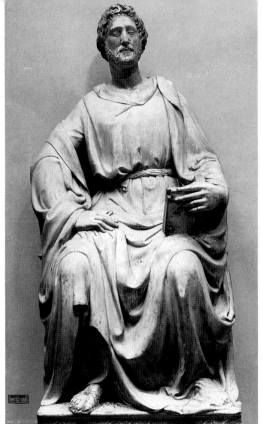

contribute a rhythmic unity to the design. Before Masaccio, International Gothic was the progressive trend in Florentine painting, introducing naturalism beneath its decorative veneer. But Ghiberti cannot be considered simply an International Gothic artist: as his work progressed, his compositions became more complex and his forms began to fight with the quatrefoil. Since he included ever more ambitious architectural and geometrical elements, his compositions evolved towards the new rectilinear Renaissance format. He finished each relief step by step, chasing them over-zealously with the precision of a goldsmith as if they were delicate jewels. The inner framing bands of foliage (as opposed to Pisano's studs and rosettes) testify to the sculptor's love of luxuriant nature; they are punctuated with quatrefoils out of which project heads of prophets instead of Pisano's lions' heads. A further contract of 1407 suggests that Ghiberti had fallen behind in his work, although by 1416 most of the panels appear to have been designed. The decision partly to gild the doors was made in 1423 and

27 Donatello *St John* 1408–15 (marble, 210 cm, 82⅝ in)

28 Nanni di Banco *St Luke* 1408–15 (marble, 208 cm, 82 in)

29 Donatello *David* 1412–16 (marble, 191 cm, 75⅛ in)

they were hung in 1424. During this time, Ghiberti's workshop was a training ground for a new generation of artists (to name a few, Donatello, Michelozzo, Uccello and Masolino). This first set of doors spanned the first half of Ghiberti's career and was only one of many commissions. He also worked in other media – paint, stained glass, precious metals, wood and architecture – Florentine artists being trained as versatile designers, leading Vasari to hold that *disegno* (drawing or design) was the secret of their success.

Ghiberti wrote his *Commentarii* (*c.* 1447–8) on the Vitruvian model; it attempted to give a theoretical basis for his own art, to add to the knowledge about art and to aggrandize his accomplishments. By this very act, he demonstrated that art was an intellectual endeavour, not a manual craft. Although his rather immodest autobiography – he was the only *quattrocento* artist to have written one – forms the core of the book, he constantly refers to antiquity and nature and mixes discussions of ancient art and Gothic forms, just as the two are fused in his art.

45

Written to instruct artists, it is, for all its biases, one of the main source books for art of the period.

The decade of 1410–20 was a turning point in Florentine sculpture. There was great rivalry and cross-fertilization, and sculptors switched between Gothic and Classicizing styles depending on the commission. The criterion was a convincing portrayal of visual reality, a triumph of naturalism that would have reverberations throughout the Italian peninsula. In the same years as the execution of Ghiberti's first doors, other major sculptors emerged working on projects allied to the Cathedral, such as the four Evangelists for niches flanking the central portal. These involved the challenge of the life-size seated figure: to address not only the potential for movement and thought but also the foreshortened lap. In 1408, the commission was split among three 27,28 sculptors – Donatello (*St John*), Nanni di Banco (*St Luke*) and Niccolò Lamberti (*St Mark*). The *St Matthew* was offered as the prize in a competition, an idea soon discarded because none of the originals were completed; consequently it was commissioned from Bernardo Ciuffagni. These statues were meant to be seen from below, and several bear traces of patination, suggesting that they were painted. Donatello (Donato di Niccolò di Betto Bardi, *c.* 1386–1466) seems to have optically adjusted his figure to compensate for its high position, as he frequently did in other works (although this optical theory has been challenged). He elongated the head, torso and neck (in harmony with *trecento* proportions) – the last cleverly concealed by a beard – and enlarged the head and hands for expressive power. Typical of Donatello, the figure when seen from below was foreshortened and in a pyramidal shape, lending it stability and universality. The enlarged coiffure casts the furrowed brow and eyes, uplifted to God, in dramatic shadow. The resulting aura of keen intelligence inspired Michelange- 131 lo's *Moses*. While the influence of ancient sculpture on Donatello's figure is not overt, it is noticeable in the face of Nanni di Banco's (*c.* 1374–1421) *St Luke*, modelled on Roman senator types. Nanni calculated that his figure would be viewed from below but he neither disguised the elongated neck nor made Donatello's proportional adjustments. Beside the exaggerated and intensely alert *St John*, the *St Luke* looks normative and calm. Both are noble and powerful in comparison with the lifeless, formulaic pieces by Lamberti and Ciuffagni. Lamberti, indeed, who had recently lost his position as master sculptor on the Cathedral, was paid less for his *St Mark*, precipitating his departure for Venice.

In 1408 Nanni and Donatello were commissioned to execute life-size prophets for buttresses of the Cathedral. Then between 1408 and 1412

30 Nanni di Banco *Assumption of the Virgin* 1414–21 (marble). Porta della Mandorla, Cathedral, Florence

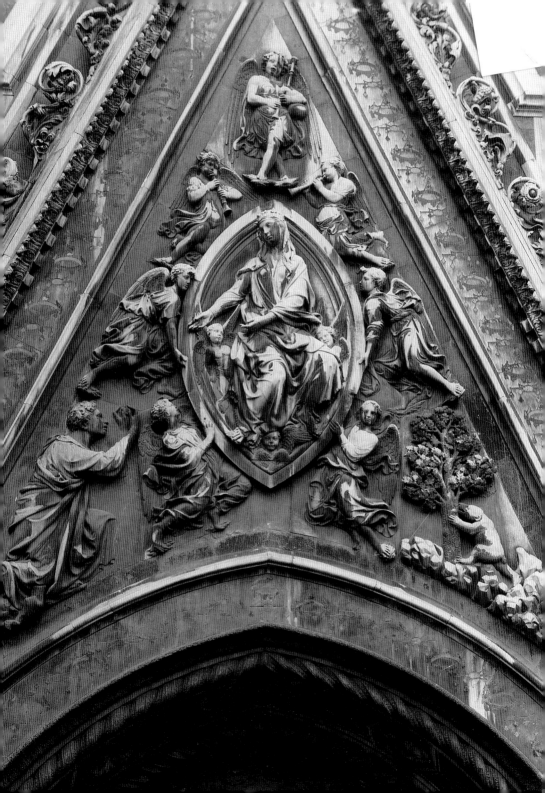

29 Donatello's *David* was commissioned for the building. By 1416 it was in the Palazzo della Signoria, having been sold to the city and converted from an Old Testament figure into a partly secular civic hero. The drapery was probably recut at this time to reveal the youth's leg. Some anomalies – the long neck and jarring but interesting proportions – may result from its juvenile status. It is in Goliath's head that we see intimations of Donatello's psychological realism and expressive power. This *David*, one of the early cases in monumental sculpture where he is portrayed as a youth (as in the Bible), teeters between the Gothic and Renaissance worlds. Its swaggering posture, not true *contrapposto*, and voluminous cloak owe something to Donatello's apprenticeship in Ghiberti's shop. The idealized head, loosely based on the antique

35 'Antinous' type, anticipates his *St George* and ultimately Michelangelo's

1 *David*. The uncut eyes contrast with the treatment of the eyes in his other early sculptures, leading to speculation that they were at one time painted. The unusual iconography indicates the direction in which Donatello's imagination developed. David stands over Goliath's head in the pose established in antiquity for the victor-over-vanquished. His head is encircled by amaranth blossoms (also identified as ivy), alluding to the never-fading fame of heroes. Once, a metal or leather thong connected the pouch containing the stone with one of David's hands. He represents the divinely inspired, young and vulnerable hero who saved his people from the tyrant. Donatello's *David* is the first in a long line of sculptures portraying heroes who blend civic and religious values.

From 1414 until his death, Nanni di Banco continued his work on the

30 Cathedral in the Porta della Mandorla tympanum with his *Assumption of the Virgin*. The ecstatic spiritualism of the subject coupled with Orcagna's example encouraged Nanni to adopt a style that included Gothic elements such as wind-swept drapery, which is, however, weightier than in most Gothic works. The elongated proportions of the Queen of Heaven are Gothic but her heavy body, in *contrapposto*, is Renaissance. In addition, the struggle of the four adolescent angels to sustain the physical weight of the mandorla is unprecedented, while the putti clearly derive from a study of ancient types. The musician angels and bear searching for honey (a metaphor of the soul seeking salvation) joyously echo the sentiment of St Thomas about to receive the Virgin's girdle. They are carved in a lyrical style that Luca della Robbia (who may have completed this work at Nanni's death), Filippo Lippi and Botticelli continued. Here, plastic form and linear design are held in equilibrium. The background was once painted blue and gilded by Bicci di Lorenzo, while the Virgin held both a lily and a girdle.

48

One of the greatest sculptural programmes in the early Quattrocento was the exterior decoration of Or San Michele, a building which joined civic and religious functions. In the Trecento each guild had been assigned the task of filling one niche with a freestanding statue of its patron saint. Only a few guilds complied, forcing the city council in 1406 to set a ten-year deadline for these obligations, which precipitated a spate of commissions. It is therefore one of the best places to observe the evolution of the freestanding figure. In this public arena sculptors competed to create figures seen from below that interacted with the spectator in the street, emulating the accessibility of ancient statuary.

In 1409 Lamberti received the contract for a St Mark, the patron of the Arte dei Linaioli (Guild of Linen Drapers), but two years later a committee selected Donatello to carve the figure. With his knowledge *31* of antiquity, partly gained from a conjectured trip to Rome with Brunelleschi, and his interest in *contrapposto*, Donatello emphasized the weight-bearing leg by vertical drapery folds resembling the flutes of a Doric column. In contrast, the free leg protrudes from the niche. As with *St John*, Donatello enlarged the head and hands and elongated the *27* torso for optical compensation. *St Mark*, ironically, drowns in his voluminous drapery but his latently powerful body seems separate from his clothing (once partly gilded). He stands on a pillow, traditionally symbolic of holiness, perhaps to demonstrate his massive weight. Because *St Mark* exudes the high moral purpose and *virtù* celebrated by the humanists, many have singled it out as the first unequivocally Renaissance sculpture. Certainly, it broke from the prevailing delicate International Gothic style and helped to usher in the new Renaissance world.

Nanni sculpted the most singular contribution to the niches, the so-called *Quattro Santi Coronati*, for his own guild, the Arte dei Maestri di *32* Pietra e Legname (Guild of the Stone and Woodcutters). The life-size figures arranged in a semi-circle represent Claudius, Castor, Symphorian and Nicostratus, four Christian sculptors who refused to execute a statue of Aesculapius for the Emperor Diocletian; they were confused with Christian soldiers who were martyred for not venerating the Emperor and were worshipped as the *Quattro Santi Coronati*. More than the *St Luke*, these figures confirm that Nanni was heavily influenced by Roman sculpture. Like actors in togas they brought antiquity to life, almost as contemporary *tableaux vivants* and *sacre rappresentazioni* made religious stories real. The figure on the right, who gestures to his companions and addresses them, introduces a narrative element, while they evince a unity of emotion. Their volumetric forms impressed other artists, especially Masaccio (his Brancacci Chapel frescoes).

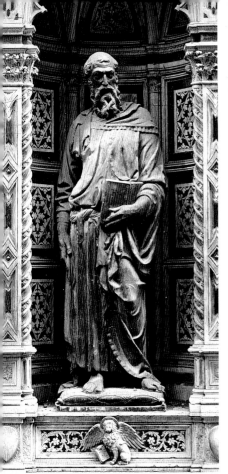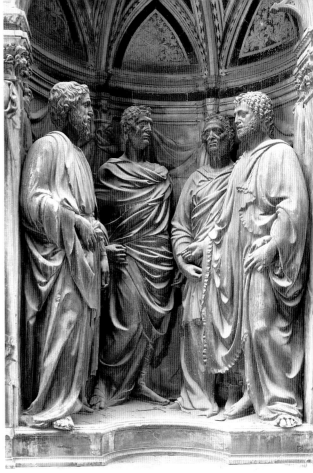

31 Donatello *St Mark* 1411–3 (marble, 236 cm, 92⅞ in). Or San Michele, Florence

32, 33 Nanni di Banco *Quattro Santi Coronati*, *c*. 1408–13 (marble, *c*. 185 cm, 72⅞ in).
Detail, relief below niche: 'Sculptors at Work'. Or San Michele, Florence

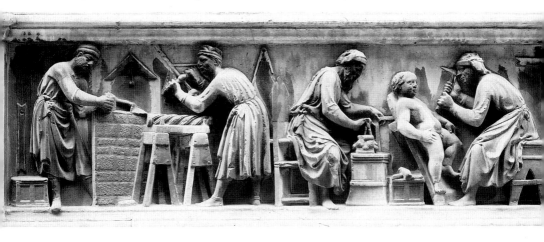

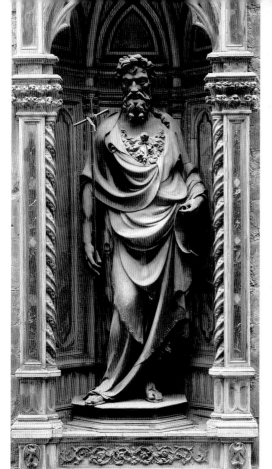

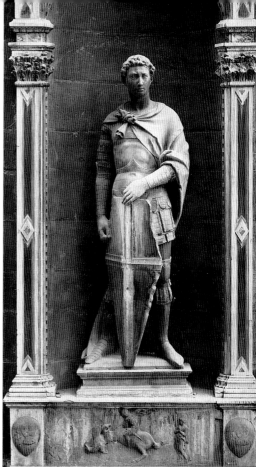

34 Ghiberti *St John the Baptist* 1412–16 (bronze, 254 cm, 100 in). Or San Michele, Florence

35, 36 Donatello *St George*, *c.* 1415–17 (marble, 209 cm, 82¼ in with base). Detail, relief below niche: 'St George and the Dragon' (39 × 120 cm, 15⅜ × 47¼ in). Or San Michele, Florence

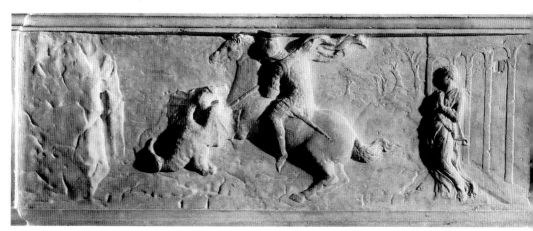

St John in the Tribute Money is based on Nanni's gesturing figure, including his corkscrew curls. In the relief below, three men labour at guild tasks (building a wall, carving a spiral column, measuring a capital), while a fourth, perhaps a self-portrait, works on either a nude putto *all'antica* (most likely) or a Christ Child.

In 1412 Ghiberti entered the Or San Michele arena with the first bronze and his first large-scale figure, *St John the Baptist*, for the Arte di Calimala. The signed work, cast in one piece, was so difficult to execute that the guild stipulated it be undertaken at the sculptor's risk. It was highly chased, which, with the cascades of decorative drapery masking rather than revealing the body, made it resemble a precious statuette. Although *St John* appears to epitomize the International Gothic style, his scroll is inscribed with what is thought to be an early example of humanist script. A comparison between it and Donatello's *St Mark* reveals that both artists studied the antique for different ends: Donatello to exploit Roman realism for dramatic expression and emotion, Ghiberti to achieve serene and graceful figures.

Donatello's reply to Ghiberti's bronze essay was his marble *St George* for the Arte dei Corazzai (Armourer's Guild). He continued to explore the youthful hero in this embodiment of courtly chivalric virtue; the work may also be related to Roman military *stelai* with figures in armour bearing lances. It has been argued that *St George* originally had bronze accoutrements (a helmet or wreath and a sword or lance). Evidence includes holes in his head with remnants of metal, attachments for a sword sheath and a niche too tall for the existing statue. *St George* stands in slight *contrapposto*, relaxed but alert. His pivoted shield, a brilliant compositional touch, suggests that he could move in any direction. His furrowed brow and heavy curls stress his concentration, an idea not lost on Michelangelo for his *David*. What is revolutionary is the flattened relief (*rilievo schiacciato* or *stiacciato*) in the panel below. (Florentines still eat a flattened bread called *schiacciata*.) Here Donatello created atmospheric perspective, optically conceived, by a diminishing level of relief and an undulating surface. At its extreme only a faint line is etched on the surface, as in the trees in the background. Such perspective was produced in painting only by Masaccio in the Brancacci Chapel ten years later. In the building at the right, Donatello introduced orthogonals (lines perpendicular to the picture plane), the basic components of one-point or linear perspective, which Brunelleschi perfected around 1420. It led to two related experiments in the late 1420s: the *Ascension and Christ giving the Keys to St Peter* (London – which probably once decorated the altar of the Brancacci Chapel,

complementing Masaccio's Tribute Money fresco) and the *Assumption of the Virgin*, part of the Brancacci monument in S. Angelo a Nilo, Naples.

Gradually, other niches of Or San Michele were filled. Ghiberti's bronze *St Matthew* for the Arte del Cambio (Banker's Guild) shows a study of Nanni's and Donatello's figures as well as ancient sculpture; it is a Renaissance work purged of most International Gothic excesses. The effects of Ghiberti's trip to Rome appear in the more successful application in his *St Matthew* of his decorative style to a Roman philosopher type (the Roman copy of a Greek original *c.* 340 BC of Sophocles in the Vatican Museums). Between 1426 and 1428 he worked on his bland *St Stephen* for the Arte della Lana. Donatello contributed a technically innovative fire-gilt bronze (its drapery cast from actual cloth), his *St Louis* for the Parte Guelfa in 1423, whose architectural niche shows a keen appreciation of Brunelleschi's *83* architecture and an inventive melange of Classical motifs. The niche also continues Donatello's optical experiments – in the kinetic heads at the corners of the base, each with one eye-socket empty and the other filled, carved illusionistically to accommodate the changing point of view of a passer-by. Thus in the second decade, sculpture was the most experimental, exciting medium in Florence.

Jacopo di Pietro called Jacopo della Quercia (*c.* 1374–1438), the greatest Sienese sculptor of the first part of the century and the son of a goldsmith and woodcarver, was one of the unsuccessful participants in the 1401 competition. Throughout his career he was itinerant: in Lucca he sculpted the Trenta Altar in S. Frediano (1416–22, a translation into stone of a Gothic, painted pentaptych) and the freestanding *Tomb of* *37* *Ilaria del Carretto* (Cathedral of S. Martino). Ilaria del Carretto, who died aged twenty-six after giving birth to her second child in 1405, was the second wife of Paolo Guinigi, the local merchant tyrant. Her tomb, indebted to French precedents, was partially destroyed by the Lucchese in 1430 after Guinigi's expulsion and has been moved at least twice (it was originally in S. Francesco in the Guinigi Chapel). What remains is a sarcophagus and an effigy, strongly influenced by northern types and courtly costumes – not surprising given Guinigi's commercial links with Burgundy and France. A dog, symbol of fidelity, looks up expectantly at his mistress from her feet. Ilaria seems to be sleeping with her hands over her swollen abdomen to remind us of the cause of her death. Her breasts fall to either side naturalistically, underlining the fact that her flesh is of this world. This striking effigy evokes compassion and the refined carving romantically heightens the tragedy. An equilibrium between Gothic and Classical elements enlivens art at this

period. Whereas the costume of the luminous effigy in the local Carrara marble belongs somewhat to the Gothic world, the sarcophagus (on which, perhaps, Francesco di Valdambrino assisted) is decorated with almost shockingly archaeological putti in *contrapposto* who carry heavy garlands. Drawn almost exactly from a type of early Roman imperial sarcophagus, it may represent a novel twist on the *trecento* tradition of incorporating actual sarcophagi into Christian tombs; perhaps because no sarcophagus was available, a new one was carved. It is the first instance when putti, Roman funerary genii, were used on such a large scale. Putti became so ubiquitous in the Quattrocento that it has been called 'the age of the putto'. These putti are especially poignant because they can hardly help but emphasize the cause of Ilaria's demise. It is probable that the sarcophagus and effigy were once separated by perhaps a trapezoid band with an epitaph. When Vasari saw the tomb, he described this middle section as a casket. Such a bridge would harmonize the dimensions of the two areas and balance the heavy, dentilated moulding of the sarcophagus. The monument may also have had an architectural setting with a canopy.

38 The individualized style and peculiarly sensuous plasticity of Jacopo's draperies appear in the very damaged figures from the *Fonte Gaia*, the Sienese fountain commissioned (*c.* 1408) for the sloping, fan-shaped Piazza del Campo on the site of a *trecento* fountain. Two

37 Jacopo della Quercia *Tomb of Ilaria del Carretto* 1406/8–13 (marble, sarcophagus 244 × 88 × 66.5 cm, 96 × 34⅝ × 26 in; effigy 204 × 69 cm, 80¾ × 27⅛ in). Cathedral, Lucca

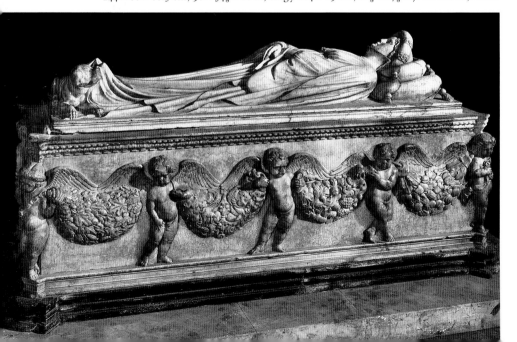

38 Jacopo della Quercia *Acca Laurentia*,
c. 1414–19 (marble, 162 cm, 63¾ in)

drawings preserve some of its original features which were altered
during its execution (*c.* 1414–19). In the nineteenth century, a
replacement was installed and the dismembered pieces moved. The
large fountain included allusions to the city's Roman history and
Christian virtues, culminating in the central Madonna and Child (Siena
was called the *Civitas Virginis* and the Virgin was its patron), echoing
the ethos of good government in the frescoes inside the Palazzo. While
most of the sculpture was in relief, two freestanding figures formed part
of the Roman iconography – *Acca Laurentia*, the goatherd's wife who 38
cared for the young Romulus and Remus, the mythical founders of
Rome, and Rhea Silvia, their mother (perhaps carved by F. di
Valdambrino). The well-preserved *Acca Laurentia* derives from a

39 Jacopo della Quercia,
'Temptation', 1425–38
(marble, 82 × 68 cm,
$33\frac{1}{4}$ × $26\frac{3}{4}$ in). Portal, S.
Petronio, Bologna

40 Jacopo della Quercia
Annunciation, c. 1421–6
(painted wood, 175 cm,
$68\frac{7}{8}$ in)

Roman Venus and has Jacopo's characteristic fleshiness and heavy drapery. The group is psychologically integrated, for as she holds one of the chubby boys who pushes at her breast, the other jumps up to attract her attention. She looks at him with almond-shaped eyes and a smile that suggests life. So successful was the fountain that the sculptor earned the nickname 'Jacopo della Fonte'.

Jacopo's next major project was the portal of S. Petronio, Bologna, where he worked sporadically until his death. The modified contract included ten Genesis scenes for the pilasters by the doors, including the 39 'Temptation'. Here landscape is rendered in a simplified *rilievo schiacciato* so that the overpowering figures create the space. Their heroic bodies look back to N. Pisano and influenced Michelangelo who, in fact, was drawn to them while in Bologna. The psychological insight manifested through the gestures is astounding. The serpent, with a female's head (a symbol of Deceit, ultimately derived from a medieval fertility symbol), beguiles Eve to eat the fig (a complex symbol also alluding to female genitalia) from the tree of the

knowledge of good and evil. With one hand Eve pushes the temptress away, but with the other selects a fig, thus revealing her ambivalence about sin, an attitude not usually depicted. Adam, whose musculature testifies to Jacopo's knowledge of anatomy, is atypically represented as an active participant in the Fall. He turns his head over his shoulder to ask Eve for the fig, holding out his right hand behind his body and reflexively moving the other to cover his genitals, prefiguring his fall.

To Jacopo are assigned a number of wooden polychrome works such
as the lyrical *Annunciation* in the Collegiata, San Gimignano. The
heavily repainted pair was originally polychromed by the specialist
Martino del Bartolommeo. The Virgin once wore a crown, the angel
held an olive branch. They may also have worn actual garments
because, like their counterparts in wax, wooden figures were often
embellished with actual accoutrements, blurring the distinction
between art and life. With its love of colour, Siena retained a strong
taste for wooden sculpture, whose heyday had been during the
Romanesque. Jacopo was aware of the medium's limitations and
approached it differently because there were no ancient prototypes for
most subjects executed in wood. Vasari informs us that he executed a
wooden equestrian statue which, unfortunately, no longer exists.
Wooden polychrome sculpture flourished from the twelfth century
throughout Italy, influenced by currents from France and Germany. It
was less costly than marble and bronze and was distinguished by
different plastic solutions and polychromy. The iconographical range
was narrower, the most popular subjects being the Crucifix and the
Madonna and Child. Our knowledge of the form is limited by its
scarcity, the losses caused by susceptibility to worms, moisture and fire.
It had almost disappeared in Tuscany by the 1450s except in Siena and
the countryside and except for crucifixes, where its expressive possibili-
ties and light weight were especially suitable for portable cult objects.

Some years before Jacopo's *Annunciation*, Donatello began a series of
prophets to fill niches high on the Florence Campanile. These prophets
without attributes were commissioned as generic types, listed as, for
example, 'beardless prophet'. Several were simply taken from the
Cathedral facade and re-used. The notable exception is one of the five
mentioned in the documents with Donatello's name, the *Abraham and
Isaac*, commissioned jointly from Donatello and Nanni di Bartolo (but
believed to be only by Donatello) in 1421 and completed in seven
months. Using the victor-over-vanquished scheme, Donatello amalga-
mated the poses of Isaac in Brunelleschi's and Ghiberti's competition
reliefs. Abraham is positioned above his son, his eyes riveted on the
angel whose implied presence outside the niche (foreshadowing
developments in the seventeenth century) has stopped the ritual
slaughter. This forward-looking image contains reciprocal *contrapposto*
and distortions to compensate partly for the high position. Donatello
heightened the emotion by his energetic treatment of Abraham's beard
(a tactic followed by Michelangelo on his *Moses*). Donatello's prophets
were all individualized, as in the one usually identified as Habakkuk.
Since the sixteenth century, the figure has been called 'Lo Zuccone'

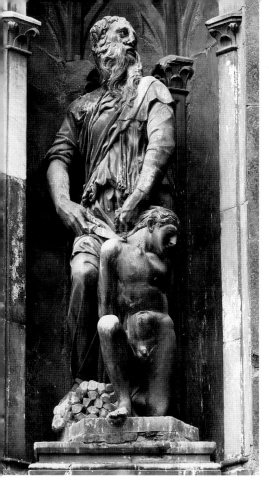
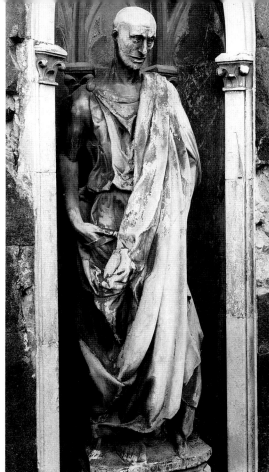

41 Donatello *Abraham and Isaac* 1421 (marble, 188 cm, 74 in)

42 Donatello *Habakkuk?* ('Lo Zuccone') before 1436 (marble, 195 cm, 76¼ in)

(Big Squash) because of his baldness. It has also been suggested that he represents Elisha wearing the two-part mantle of Elijah (as recorded in II Kings 2:9–13; 23–24). While the crude features are boldly chiselled – the broad slash for the figure's mouth – they appear life-like from a distance. Such verism transcends the Roman portraiture of the third century AD that Donatello had digested. The figure looks downward, his lips open as though prophesying. In fact, Vasari says that Donatello exclaimed while carving it, 'Speak, speak or may dysentery seize you.' No work could be further from Ghiberti's elegance.

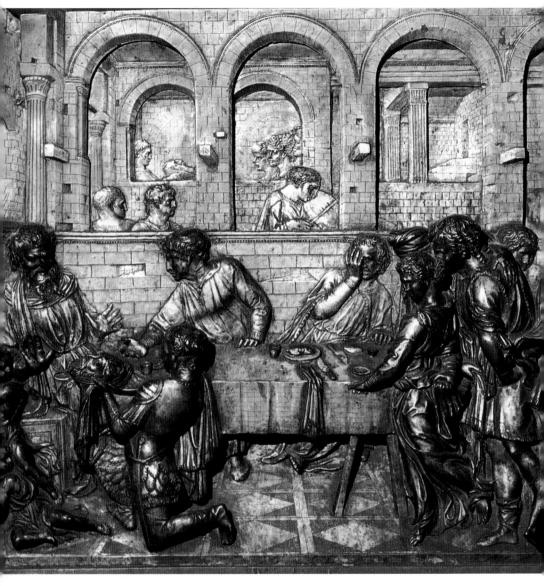

43 Donatello, 'Feast of Herod', 1423–7 (gilded bronze, 60 × 60 cm, $23\frac{5}{8}$ × $23\frac{5}{8}$ in). Font, Baptistry, Siena

The Spread of the Renaissance

By 1420 the new Renaissance ideals were becoming known outside Florence, disseminated by the artists who had introduced them.

SIENA

The font in the Baptistry had been commissioned in 1416. Its conception seems to belong to Ghiberti, who supervised its hexagonal marble base with gilded bronze reliefs narrating the life of John the Baptist. (Jacopo della Quercia probably designed the upper marble ciborium after 1428.) Ghiberti executed two of the most prized reliefs: the earlier Baptism of Christ, set in a landscape, and the more elaborate St John Preaching, based on Roman formulaic imperial scenes, such as those on the Arch of Constantine. Their formats gave Ghiberti, chafing under the constraints of the Baptistry quatrefoils, the opportunity to explore the new Renaissance rectangle and to apply the innovations in Donatello's *St George* relief. In 1423 the 'Feast of Herod' relief, 43 originally commissioned from Jacopo della Quercia, busy on the *Fonte Gaia*, was re-assigned to Donatello. While incorporating antique elements so subtly that their exact sources are untraceable (except one head in the middle ground from a Roman coin), he created a continuous narrative within a revolutionary one-point perspective system articulated by an architectural setting, to be viewed from above. He adopted the system (which just misses having a single vanishing point) from Brunelleschi, who is credited with its invention around 1420 by the mathematician Antonio Manetti in his biography of Brunelleschi. The relief also adapts *rilievo schiacciato* to bronze. The complex space has three levels: foreground with two figures nearly in the round; intermediary with the youth playing an ancestor of the violin; and background where a servant with the head of St John on a salver meets Herodias and her two attendants. In order to represent this space, Donatello used several devices: the tiled floor with its orthogonals and transversals; the four protruding beams to echo the orthogonals; the wall behind Herod where two bricks were 'removed' to create microcosmic diagrams of perspective space; the levels of relief; and the diminution in size. This elaborate mathematical formula was

saved from being perceived as a dry method by a variety of textures. In the narrative, Salome has just finished her last pirouette. With a group of spectators, she gazes in horror at the head being presented to Herod, while Herodias is implicated as the true villain by Donatello: she is separated from the others by a spatial gulf created by the man recoiling. Framed in the central arch, the youthful musician is the only lyrical interlude in this tragedy. Donatello also executed independent figures for the font and a rejected bronze door for the tabernacle.

Jacopo della Quercia executed his scene of Zacharias in the Temple only in 1428, after the completion of Donatello's relief. Although he superficially imitated the brickwork of Donatello's setting, it is the figures and their billowing drapery which establish the space. Other sculptors worked on the font, making it a prime example of positive competition and harmonious collaboration.

FLORENCE

Ghiberti applied his Sienese experiments in the rectangular format to his second set of doors for the Baptistry. Another contract was drawn up less than a year after the first set was hung on the east side (later moved to the north). Work on these doors continued until they were hung on the east in 1452. Vasari said they were called the *Porta del Paradiso* ('Door of Paradise') by Michelangelo but the term seems to have been in common use. Since they faced the Cathedral, they were aligned with the altar where mass, the way to salvation and thus Paradise, was celebrated. The first plan consisted of 28 panels, 20 with Old Testament narratives and 8 with prophets. Being busy with other commissions, Ghiberti probably did not begin until 1429, when he cast simple circular backs to harmonize with the earlier doors. The adviser was Leonardo Bruni, the humanist and later chancellor of the city. Objections to Bruni's conservative programme were voiced by Ghiberti and the humanists Ambrogio Traversari and Niccolò Niccoli (who carried his humanism so far that he dressed in Roman togas and ate from ancient dishes). In his autobiography, Ghiberti implies that he himself was responsible for the change to the second format of 10 rectangular panels (with the prophets and prophetesses relegated to the lateral friezes separated by heads in roundels – two at eye level represent the sculptor and his son Vittorio). At the very least, Ghiberti was instrumental in the alteration, tangible evidence of the increasing status of artists. This plan, wholly Renaissance, draws heavily on patristic sources (such as Origen and Ambrose) and the Hebrew Talmud and reflects Traversari's interests (Ghiberti included Traversari's portrait in the right foreground of the Meeting of Solomon and Sheba).

44,45

In the first panel Ghiberti combined four separate Genesis scenes from the Bruni programme into four *effetti* (episodes): the Creation of Adam, Creation of Eve, Temptation and Expulsion. His willingness to change is a mark of his genius. The doors reveal that his technical expertise had developed. Documents prove that the ten reliefs were all cast by 1436–7, indicating a highly organized shop resembling a small factory. These reliefs were not as meticulously chased as the first but they were entirely gilded, proclaiming the wealth of the guild. Ghiberti altered their shape, which in profile is a truncated trapezoid, wider at the bottom for more three-dimensional foreground figures. (Copies are in place and the originals are displayed in the museum behind the Cathedral.)

The more pictorial 'Doors of Paradise' present a fully developed Renaissance statement in relief. They are rectangular and the influence of antiquity is more pronounced, certainly as a result of Ghiberti's second trip to Rome around 1429–30: Eve poses like a *Venus pudica*. In the Abraham and Isaac scene, he adopted Brunelleschi's device of the angel stopping the hand of Abraham, an acknowledgment of his rival's superior composition in one aspect. Ghiberti was aware of architectural trends, such as Brunelleschi's round church (the ideal of theorists), S. M. degli Angeli, begun in 1434 and reflected in his round building in the Joseph panel. He also used linear perspective in several scenes, leading to speculation about his relationship to Leon Battista Alberti, who returned to Florence in 1434 and who published his treatise *On Painting* (1435 in Latin and 1436 in Italian) during the execution of the doors. Alberti's articulation of the new perspective disseminated Brunelleschi's graphic system. The narrative and perspective of the late Meeting of Solomon and Sheba is more lucid and unified than in earlier scenes. This 'marriage' scene has been interpreted as symbolizing the projected reconciliation of the Greek and Latin churches, with which Traversari was closely associated. The Council of Ferrara and Florence (1438–9), promoted by the Medici, also had that goal on its agenda and the central building in the relief resembles Florence Cathedral.

Some of the most charming features of the doors are the decorated jambs and interior borders. Growing out of the borders of the north doors, they summarize Ghiberti's expertise as a decorator *par excellence* in their exuberant mixture of fruit, foliage, nuts, flowers, pine cones, birds, snakes and insects. Their combination of antique garlands with the lyrical International Gothic love of nature is Ghiberti's uniquely Renaissance contribution. Ghiberti was the progenitor of a long line of lyrical artists and his poetic innovation influenced sixteenth-century sculptors such as Sansovino and Cellini.

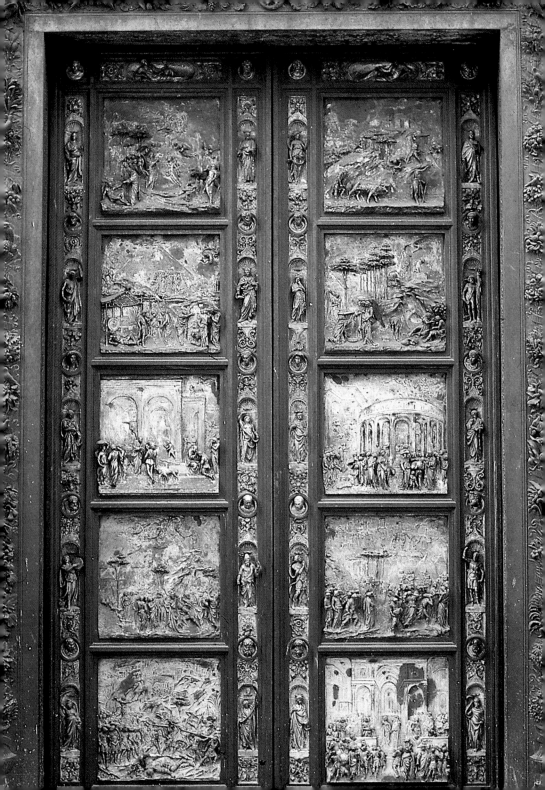

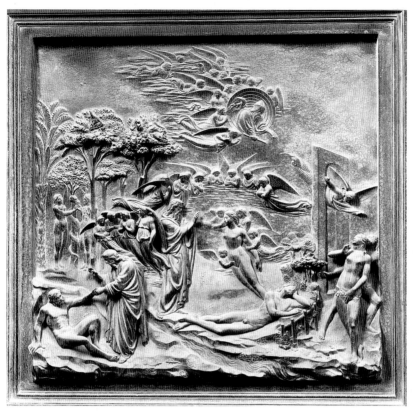

44, 45 Ghiberti, 'Doors of Paradise', 1425–52 (gilded bronze, 457 × 251 cm, 180 × 99 in without frame). Detail: 'Creation' (79.5 × 79.5 cm, 31¼ × 31¼ in)

VENICE

As the new style of the Renaissance spread to northern Italy, it blended with native traditions and tastes. Venice, surrounded by sea and lagoon, was known in local dialect as the *Stato da Mar*. It functioned as an independent city-state for a thousand years and its maritime empire stretched from Lombardy to the Aegean and on to the exotic East. In Venice (*La Serenissima*, 'the most serene') all sculptors, classed in the guild of stonemasons, were tightly controlled by the government under the Doge and other leaders. Rules prohibited foreign artists from practising without a suitable residency and payment. Later, as foreign sculptors outnumbered Venetians, protectionist laws ensured proper

Venetian representation in the guilds. There are many attribution problems in Venetian sculpture, including less documentation and the vestigial medieval practice of family workshops and communal partnerships, resulting in fewer identifiable individualistic styles. Two years after the 1401 competition, the increasing fame of the Florentine school led the Doge to look for a Florentine sculptor and architect to work on the Palazzo Ducale. This search signalled the beginning of great sculptural activity and a desire to import the Renaissance style. The Tuscan sculptors who gravitated to the north-east for work, many lured by the campaign to complete the facade of S. Marco, were not necessarily of the first rank. Rather, they were among those disappointed with their fortunes in Florence, where they competed with Donatello, Ghiberti, Nanni and Jacopo. The most significant to contribute to early fifteenth-century Venetian sculpture were Niccolò di Pietro Lamberti, with his son Piero (Pietro) di Niccolò and Nanni di Bartolo. They arrived in an artistic environment that was still strongly Gothic, where the influence of the Dalle Masegne and Nino Pisano was prevalent and where sculptors like the Master of the Mascoli Altar and Giovanni and Bartolomeo Bon (or Buon) were active.

Niccolò Lamberti played a major role in the development of fifteenth-century Venetian sculpture. After his Florence *St Mark* was poorly received, he left permanently for Venice, where he is first recorded in 1416. Together with his son Piero di Niccolò (*c.* 1393–1435), he contributed to the upper facade of S. Marco. Piero di Niccolò

46 executed the signed *Monument of Doge Tommaso Mocenigo* in SS. Giovanni e Paolo with another expatriate. He adopted the florid style of current Venetian taste as seen in the fantastic, foliated two-tiered Gothic frame (similar to contemporary painting formats) and the unusually elaborate baldachin held back by two angels to reveal the reclining effigy of the Doge. The structure is crowned by Justice, a political statement. Piero's Florentine training surfaces in several areas: the sarcophagus with shell niches containing virtues harmoniously blends Tuscan and Venetian forms.

48 The 'Judgment of Solomon', the last of the three corner reliefs on the Palazzo Ducale, faces S. Marco and surmounts the so-called Justice capital. The two earlier reliefs, probably by Venetian or Lombard sculptors, depict the Fall and Drunkenness of Noah. The 'Judgment of Solomon' has been attributed to a number of sculptors, including Piero di Niccolò and Jacopo della Quercia, although traditionally it is ascribed to the Bon studio. The strongest case has been made for Nanni di Bartolo (called Il Rosso, active 1419–51), perhaps in collaboration with Bartolomeo Bon. Cleaning has shown that the head of the true

46 Piero di Niccolò Lamberti *Monument of Doge Tommaso Mocenigo, c.* 1423 (marble). SS. Giovanni e Paolo, Venice

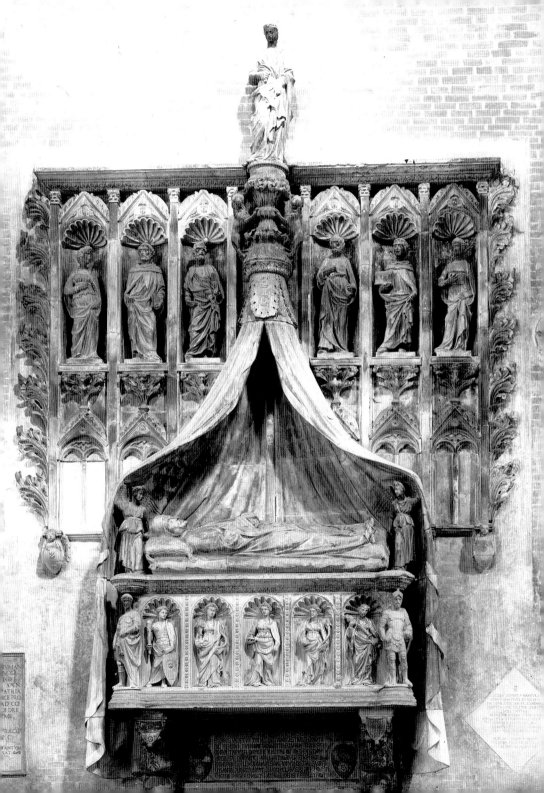

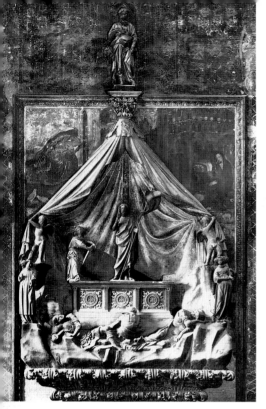

47 Nanni di Bartolo, Brenzoni monument, 1426/7–39 (marble). S. Fermo Maggiore, Verona

48 Nanni di Bartolo, 'Judgment of Solomon', 1424–38 (Istrian stone, *c*. 200 cm, 78¾ in). Palazzo Ducale, Venice

mother is carved separately and is a replacement. The high relief is carved from Istrian stone, a hard white limestone with fewer crystals than marble, favoured because of its compact durability and the relative ease with which it could be obtained from Venetian coastal cities. The subject can be interpreted as an example of divine justice, connected with the two earlier Genesis reliefs and the nearby *Porta della Carta* with its crowning figure of Justice. The 'Judgment of Solomon' follows the scheme of the Genesis reliefs but its flowing lines, psychological integration and physicality contrast with the earlier, stiffer pair. While there are echoes of antiquity – the baby held up by the executioner – the strongest influences are the works of Jacopo, Donatello, Ghiberti and Nanni di Banco.

Nanni di Bartolo had left Florence in 1424 after work on the Cathedral and Campanile. In Venice he may have been associated with

49 Giovanni and Bartolomeo Bon *Porta della Carta* 1438–42/8 (Istrian stone, marble, gilding and paint). Palazzo Ducale, Venice

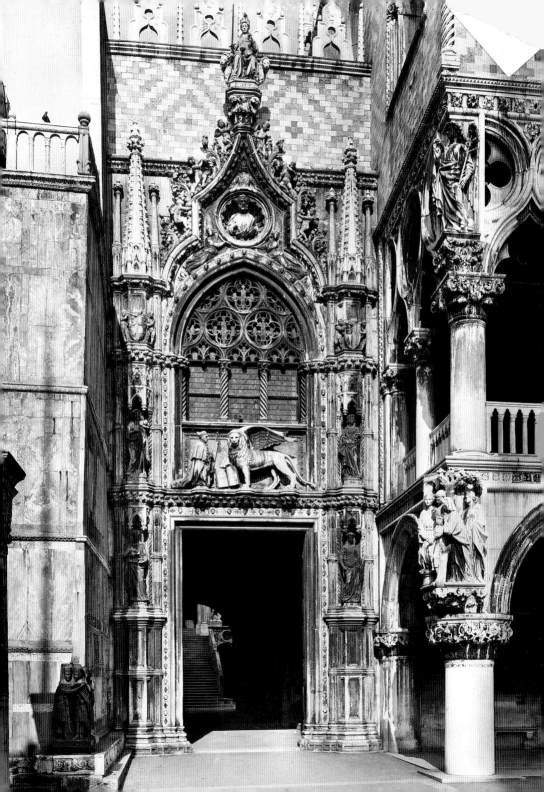

47 Lamberti and he is known to have worked at Verona on the Brenzoni monument in S. Fermo Maggiore. The monument depicts the Resurrection like a *tableau vivant* beneath a large canopy, surrounded by a fresco of the Annunciation painted by Antonio Pisanello. At the apex, on a foliated capital, stands a prophet that recalls his *Abdias* (1422) for the 'Florence Campanile. This figure, the two nude putti after Donatello and the sleeping soldiers in contorted postures are assuredly by his hand. They have a definite Florentine flavour in both style and motifs, as does the sarcophagus with its Classicizing pilasters, while the entire composition derives from the Resurrection on Ghiberti's first Baptistry doors. Nanni also tried to adapt to the Gothic idiom preferred by his patrons, to which the elegant canopy belongs.

50 The Master of the Mascoli Altar derives his name from a marble altarpiece and antependiem in the Mascoli Chapel, S. Marco, which is transitional between the styles of the Dalle Masegne and Bartolomeo Bon. The altar has also been given to Giovanni Bon, the father of Bartolomeo, to whom a small, contested oeuvre is assigned. The Gothic triptych is the stone equivalent of a form popular in painting. Although each figure stands in a Renaissance niche within the ornate frame, they appear to interact, hesitantly suggesting the unified, rectangular *sacra conversazione* altarpiece developing in Florence.

The principle native Venetian sculptors during the late fourteenth and early fifteenth centuries are Giovanni Bon (or Buon, *c.* 1355– *c.* 1443) and his son Bartolomeo (*c.* 1374 or 1405/10–1464/7?) whose activities are only vaguely known. One of the major monuments by the

49 Bon architecture/sculpture workshop is the *Porta della Carta* of the Palazzo Ducale, constructed of Istrian stone, Carrara marble and red Verona marble. The 1970s' restoration revealed that it was once extensively pigmented and gilded in harmony with the Venetian taste for rich colour and pageantry. Apart from the relief of the Madonna of Mercy for the Scuola della Misericordia, the *Porta della Carta* is the most important surviving product of the Bon studio. This theatrical entrance to the Palazzo Ducale combines a Gothicizing ceremonial entry with a triumphal arch, a florid frontispiece for both church and state and a visual transition between S. Marco and the Palazzo. Its dual function is reflected in its iconography, which fuses civic and religious elements into one statement commemorating Doge Francisco Foscari and praising the just government of Venice, divinely protected by St Mark. In the frieze above the door the Doge kneels in profile. This frieze is a nineteenth-century replacement of the original, destroyed in 1797 by Napoleon's government (the original head of the Doge, whose attribution is disputed, has been recovered and is now in the Palazzo).

50 Master of the Mascoli Altar
Madonna, Child and Saints, c. 1430
(marble, 130 cm, 51⅛ in). Mascoli
Chapel, S. Marco, Venice

At the apex, on top of the foliated capital, sits Justice (with replacement sword and scales); she was originally silhouetted against the sky, as known from Gentile Bellini's *Procession of the Relic of the True Cross* (1496). Two of the virtues in the lateral supports are by Andrea Bregno, whose arrival in Venice before 1450 marks a return of Lombard influence on sculpture.

PORTRAIT MEDALS

During this period the portrait medal came of age, manifesting many of the Renaissance's ideals and achievements, for it linked with the Roman past and ennobled individuals. Under the painter and architect Antonio Pisanello (c. 1395–1455), its virtual originator and finest practitioner, the medal combined naturalism with symbolism and proclaimed the importance of the artist (Pisanello prominently signed his medals as a painter, *OPVS PISANI PICTORIS*). The genre revived in *concetto* Roman medallions, which were commemorative. Roman coins also provided some of the visual stimuli for Pisanello and Matteo de' Pasti, among others. The medals frequently commemor-

71

51 Antonio Pisanello, medal of Cecilia Gonzaga, died 1447, obverse and reverse (bronze, 8.7 cm, 3⅜ in diameter)

ated a person or visit and were given as gifts: Pisanello's first medal, of John VII Palaeologus, Emperor of Constantinople, was commissioned when he came to Florence for the Council of Ferrara and Florence. For nearly twenty years Pisanello designed medals for the rulers of the smaller Italian courts – the Este family in Ferrara and the Gonzaga in Mantua – and also for Alfonso I at Naples. The obverse of each medal, usually bronze, had a head in profile and the reverse the emblem and/or motto of the person commemorated. Pisanello's invention added great charm to the personal devices, often based on his passion, the study of

51 animals. The reverse of *Cecilia Gonzaga* shows a rocky landscape lit by a crescent moon, in which a semi-nude figure (Innocence) sits with a male unicorn (an emblem of chastity or knowledge tameable only by a virgin). On a pedestal at the right is the artist's signature. Cecilia Gonzaga, Paolo Malatesta Gonzaga's erudite daughter who wrote in Latin and Greek, was a pupil of the noted humanist Vittorino da Feltre. She entered a convent and died young, a fact encapsulated in her melancholy device. It is believed that Ghiberti's doors, which Pisanello would have seen in Florence around 1438–9, were a seminal influence. Like Ghiberti, he integrated the International Gothic style with Renaissance humanist ideas on a sophisticated level to create refined types and a courtly aura. The Italian Renaissance medal flourished by 1450 and enjoyed a lengthy popularity.

Donatello: The Great Innovator

By 1420 Donatello's reputation as a marble sculptor was established and he had begun to work in bronze. Bronze sculpture is based on modelling, an additive rather than subtractive method like carving. If a founder casts the bronze, as is usual, only the preliminary model is the work of the sculptor. The major sources about Renaissance casting are sixteenth century – Cellini's autobiography and treatise and Vasari's *Lives* – but techniques had changed little from the Quattrocento. The basic technique of lost wax had been used since antiquity, with either direct or indirect casting. In direct casting a core is made from composite material (clay, rags, hair, sometimes urine and animal dung). The details of the sculpture are modelled in wax over the core, on which liquid clay is brushed to form the outer mould. Rods are inserted to keep the core and mould together and vents made for escaping gases. The wax is then heated to melt away, to be replaced by molten bronze. The mould and core are removed and destroyed in the process, and the piece is chiselled and polished. The drawback is that only one bronze can be cast. The later indirect method involves a fully worked clay model on which plaster is built up in sections to create a re-usable mould. The model is removed, the mould lined with wax, filled with a core, and the lost-wax technique continued. In this method, further removed from the sculptor's original model, the advantage is that multiples can be produced.

Bronze casting required much equipment, expertise and money for materials (copper, tin, lead and some zinc). It is known that Donatello used a founder in several cases and was criticized by Cellini for his imperfect castings. The *David*, for example, has a hole under the chin and a patch on the thigh. Unlike Ghiberti, Donatello did not repair flaws to make them undetectable, nor did he carefully disguise the joints of the works cast in pieces. In 1425 he entered into partnership with Michelozzo di Bartolommeo (1396–1472), a goldsmith who worked in the mint and in Ghiberti's shop. It seems that Michelozzo was responsible for the commercial side as Donatello reputedly had no nose for business or management. He was also involved in the casting of a number of works.

59

Around 1422 Donatello was engaged to execute the *Tomb of Baldassare Coscia [Cossa], Pope John XXIII* in the Florence Baptistry. Coscia, elected Pope in 1410, lost power in the Great Schism and was deposed by the Council of Constance in 1415. He died in Florence in 1419, shortly after his release from confinement. It was a great honour to be buried in the building, which contained only three small tombs. To achieve it, he left several relics to the Baptistry, including the right index finger of St John the Baptist, and permission was granted in 1421. Coscia's tomb is historically significant and may be the first Renaissance tomb in its architectural vocabulary. It was a quasi-papal tomb as well as the first sepulchral monument in Florence planned as a rational entity with proportional correspondences between its parts. A wall tomb was unusual for a city accustomed to tomb-slabs on the floor. Its constricted location between two colossal granite columns taken from a Classical building presented Donatello with a challenge, to which he rose. A stratified structure combines elements from antiquity, his fertile imagination and *trecento* Tuscan and Neapolitan tombs (Coscia was Neapolitan). Donatello was heavily assisted by Michelozzo (who cited the tomb in a 1427 *catasto* or tax return), but the bronze effigy is certainly by him.

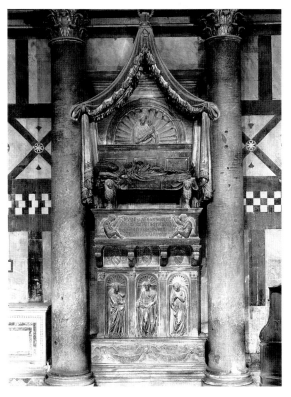

52 Donatello, Michelozzo di Bartolommeo and workshop *Tomb of Baldassare Coscia, Pope John XXIII*, *c.* 1422–7/8 (marble, bronze and gilding, 732 cm, 288 in). Baptistry, Florence

The iconography argues for the papal status of Coscia. Its base is a high sarcophagus-like plinth carved with putti heads and garlands, akin to the *Tomb of Ilaria del Carretto*, although instead of putti Donatello [37] used Christian cherub heads. Above are three shell niches, framed by four Brunelleschian pilasters, with the three theological virtues (Faith, Charity and Hope) in relief in the Neapolitan tradition. So influential was the monument that virtues became almost *de rigueur* for tombs. Between the four corbels holding up the sarcophagus there are three coats-of-arms that subtly promote Coscia as Pope. The one of the Church is in the centre, with Coscia's coat-of-arms as Pope on the dexter side (nobler in heraldry) under the effigy's head and his arms as Cardinal on the sinister side. Two putti or *spiritelli* on the face of the sarcophagus unfurl a scroll with the epitaph. It infuriated Pope Martin V, Coscia's successor, because the phrase 'formerly pope' implies that in his lifetime Coscia was Pope. Above on the bier with lion supports (allusions to the *Marzocco*) is the bronze effigy, laid out for a cardinal bishop's funeral. From the tilt of the bier it seems that Donatello wished the spectator to view the tomb from the centre of the Baptistry. While Coscia's portrait probably derives from a death mask, it is unlike the usual lifeless products of this practice for Donatello portrayed Coscia as he was in life – robust, stout, with bushy eyebrows and as if only asleep. Behind the effigy, the wall is tripartite, an approach which Alberti would recommend and would be practised in sepulchral monuments through the century. The shell lunette (symbolic of the soul's regeneration) contains a half-length Madonna and Child, ready to receive the soul of the deceased. Masking the heavy cornice and knitting the monument together is its most brilliant touch – the massive, fringed marble curtains with lavish, gilded trim. They resemble bed curtains but also connote a baldachin of state used by popes and rulers, another reference to Coscia's papacy. Earlier examples like Arnolfo's pale in comparison before Donatello's transformation of [13,14] a subsidiary motif into a dominating form. Two other tombs by Michelozzo and Donatello – those of Cardinal Brancacci in S. Angelo a Nilo, Naples, and Bartolomeo Aragazzi in Montepulciano Cathedral – explored elements of the pioneering Coscia monument, whose influence can hardly be overstated.

After a political crisis and a ban on expenditures from 1428 to 1431, construction on Florence Cathedral resumed. The authorities ordered an organ loft, called a *cantoria* or singing gallery, from a relatively [53,54] unknown sculptor, Luca della Robbia (1399/1400–82), probably because Donatello and Michelozzo were in Rome. This is the first documented work by Luca. Originally above the door to the North

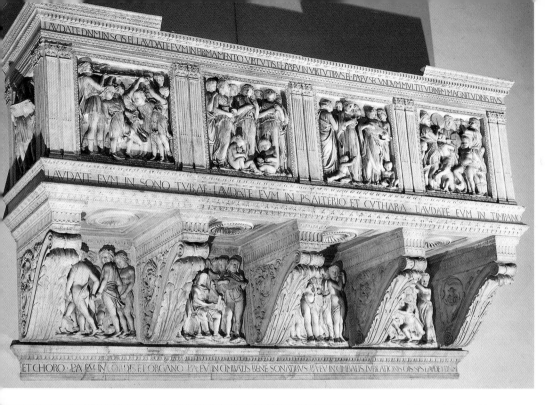

LAVDATE DNM IN SCIS ET LAVDATE EVM IN FIRMAMENTO VIRTVTIS EL PRAEV IN VIRTVTIBVS EL PRAEV SECVNDVM MVLTITVDINEM MAGNITVDINIS EIVS

LAVDATE EVM IN SONO TVBAE LAVDATE EVM IN PSALTERIO ET CYTHARA LAVDATE EVM IN TIMPANO

ET CHORO · PA EVM IN CORDIS ET ORGANO · PA EVM IN CIMBALIS BENE SONANTIBVS P EVM IN CIMBALIS IVBILATIONIS OIS SPS LAVDET DNM

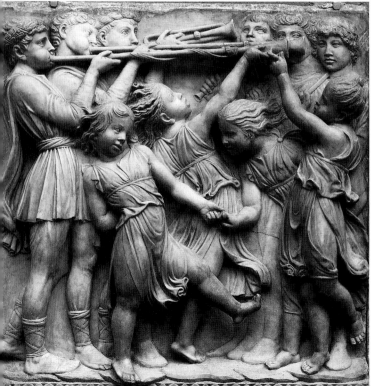

53, 54 Luca della Robbia
Cantoria 1431–8 (marble,
c. 328 × 560 cm, 129 × 220 in).
Detail

55, 56 Donatello *Cantoria*
1433–40/46 (marble,
bronze and mosaic inlay,
348 × 570 cm, 137 × 224 in).
Detail

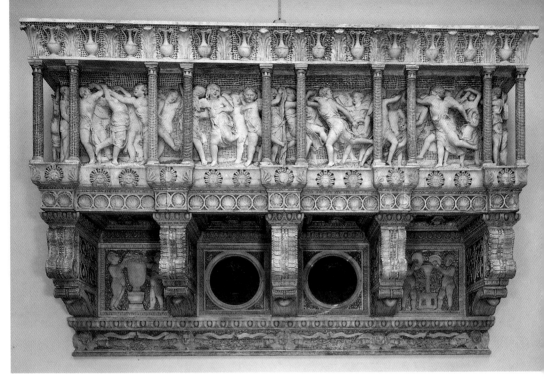

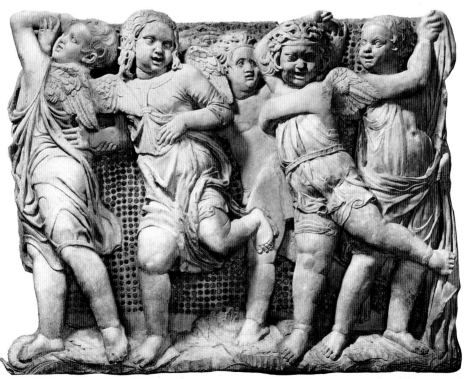

Sacristy, it was dismantled in 1688, making reconstruction a problem. The upper part, the gallery, resembles a Roman sarcophagus carried on consoles. The architectural setting, perhaps designed with Brunelleschi's advice, frames four reliefs on the front and one on each end. Four other reliefs between the five consoles are cast in shadow. Ten isocephalic reliefs with concerts of infants and adolescents playing a variety of instruments, singing and/or dancing illustrate Psalm 150, inscribed in humanist epigraphy in three bands. Vasari described two bronze angels with candle holders (perhaps those now in Paris), added after 1440. Some reliefs are more deeply carved than others and documents indicate that extra work was required to make them legible from below. The movement evident in the later reliefs shows the competition with Donatello, who had returned in 1433 and was engaged on a pendant *cantoria*.

Donatello's *Cantoria* was placed above the South Sacristy door of the Cathedral but was also dismantled in 1688. Its reconstruction after 1883 is controversial, particularly the two bronze heads in porphyry roundels, one now thought to be ancient and the other a shop imitation. Donatello carved a continuous frieze of bacchic putti on three sides of the gallery, which is indebted to his earlier frieze on the external pulpit of Prato Cathedral, executed with Michelozzo. His *Cantoria* has paired freestanding columns (accented with mosaic tesserae) behind which cavort the putti dancing in two directions simultaneously. It neither illustrates a known programme nor bears an inscription like Luca's. One theory is that both *Cantorie* depict the musician angels at the Virgin's Coronation, present in the Duomo in a stained-glass window designed by Donatello. Many antique sources have been cited for Donatello's putti, decorations and architectural details (notably the Temple of Concord for the last) but Donatello digested them so completely that they defy identification. This blending with invention is equivalent to humanist literature which emphasized the imperceptible assimilation of sources. In the raucous, drunken infants Donatello, a friend of Niccolò Niccoli, perhaps equated the dying and resurrecting god Bacchus – worshipped in dance and wine to attain mystical union with him – with Christ and the Eucharist, as would Michelangelo with his *Bacchus*. The scintillating tesserae inserted in unorthodox patterns – a foil for the undecorated figures – further enliven the *Cantoria*: in the dark church they caught the light in an otherworldly fashion, signifying heaven as in the Early Christian and Byzantine mosaics and cosmati fresh in Donatello's mind from his Roman stay.

While Luca's consummately sweet, refined figures create an ideal mood, Donatello's freely expressive putti are ribald. They are pudgy

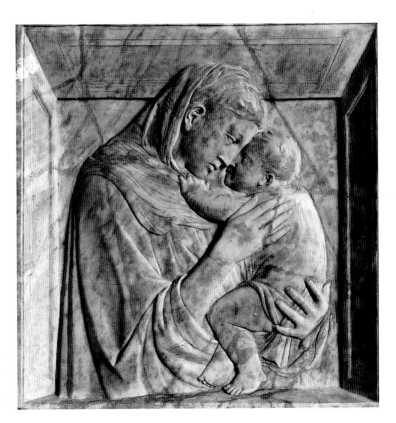

57 Donatello *Pazzi Madonna* 1420s–30s (marble, 74.5 × 69.5, 29⅜ × 27⅜ in)

unorthodox angels in diaphanous drapery, descendants from sarco-phagi, who carry wreaths of victory and eternal life. By contrast, Luca's restrained figures, in contemporary and Classicizing dress could be portraits of real children. His allusions to antiquity are covert while Donatello's are overt. Donatello's generalized scene begs to be viewed from a distance – Luca's detailed episodes at close range. In sum Luca's *Cantoria* is more accessible – because it represents an idealized, orderly, poetic vision – than Donatello's work with its provocative and unidealized pagan imps.

The half-length *Pazzi Madonna* by Donatello shows that he could 57 also express tenderness and intimacy. Its youthful style, seen in details like the baby's foreshortened foot, suggests a date in the 1420s or 1430s. The modified *rilievo schiacciato* is indebted to ancient sculpture as are its melancholy and idealized types, uncannily like Greek *stelai*. The Madonna gazes penetratingly into her son's eyes, foreseeing his death. The seemingly casual yet powerful genre scene is carved with economy – the haloes have been eliminated, an innovation not generally adopted

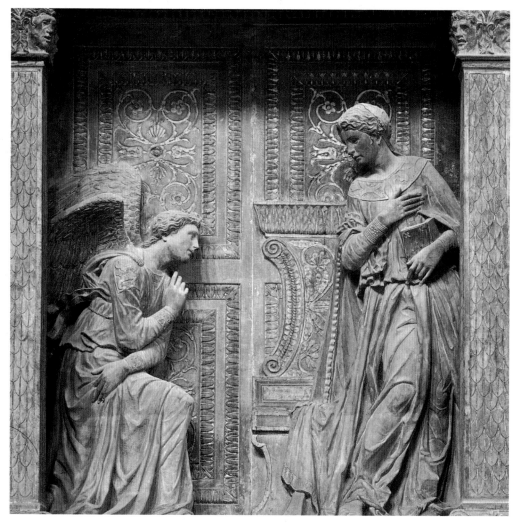

58 Donatello *Cavalcanti Annunciation* 1430s (gilded *pietra serena*, 420 cm, 165⅜ in). S. Croce, Florence

59 Donatello *David* 1430s–50s (bronze, 158.2 cm, 62¼ in)

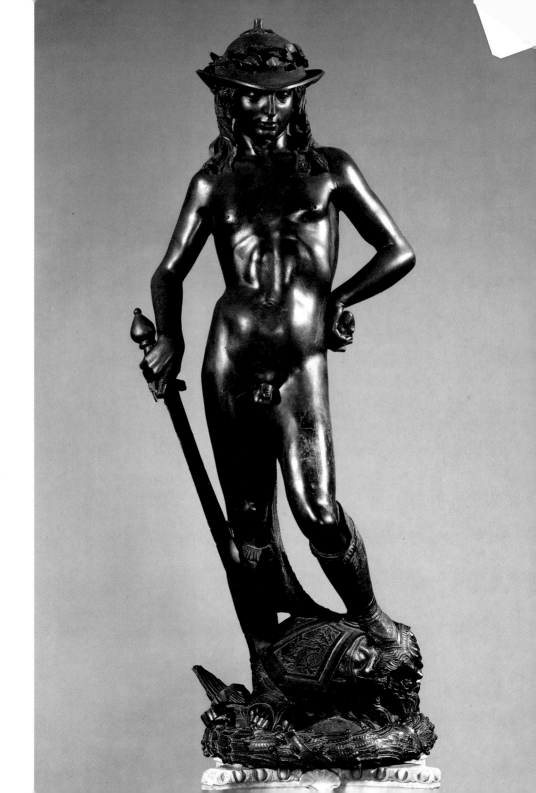

60, 61 Donatello *Amor-Atys* 1440s–50s (bronze, 104 cm, 40⅞ in)

until the next century. The relief was meant to be seen from below, once again revealing Donatello's interest in the spectator's point of view and heightening its immediacy. The *Pazzi Madonna* is one of the first works known to have been replicated in stucco and terracotta and documents suggest that Donatello was among the first Renaissance artists to rediscover large-scale terracotta (for instance, his colossal, painted terracotta *Joshua*, *c.* 1410, for a Cathedral buttress).

Donatello's illusionistic relief style and awareness of the spectator's position were not restricted to *rilievo schiacciato*. The lyrical, grandly Classical *Cavalcanti Annunciation* tabernacle dates from the 1430s and is made of the local grey sandstone, aptly known as *pietra serena*. While the aedicule shape is descended from ancient *stelai*, the ideal facial types and head-dresses originally from Greek statues and the shingled pilasters from Roman funerary urns, the Janus-like capitals are a unique invention. Janus, a Roman guardian of doorways and boundaries, looked to the past and the future; Donatello's use of the form implies that the Annunciation is the moment of the Incarnation. The life-size figures are nearly freestanding and their dramatic interaction gives them great psychological immediacy. The Virgin's *contrapposto* suggests that she would like to flee but that she is welded to her destiny. Her

58

pose is akin to both a *Venus pudica*, stressing her virginity, and a *pudicitia*, a modest clothed woman. That of the angel derives from a crouching Venus but here the reverent genuflection underlines the fact that the Incarnation has taken place. Donatello's unorthodox presentation excludes traditional elements such as the dove of the Holy Spirit and the lily. A foreshortened chair sits in front of what may be a closed double door, symbolic of Mary's virginity, gilded to block recession and set off the figures as with the *Cantoria*'s tesserae. Like those on sarcophagi, the door may also refer to death and rebirth, here that of Christ. The whole work, indeed, is suffused with funerary and triumphal allusions, suggesting it was Donatello's meditation on the meaning of life and death within the Christian doctrine of eternal life.

The bronze *David* is Donatello's most celebrated work. Undocumented, its Medici provenance suggests a later date than the traditional 1430s as the Palazzo Medici was begun in 1446 (although it could have been made for an earlier dwelling). A 1469 description of Lorenzo de' Medici and Clarice Orsini's wedding says that it was displayed in the palace courtyard – perhaps to cloak their dynastic ambitions under the ideal of republican rule. In 1495, after the Medici expulsion, it was moved with Donatello's *Judith* to the Palazzo della Signoria. Both Old Testament heroes, depicted as victors over vanquished tyrants, slew oppressors of the Hebrews and were civic symbols of Florence. It is probable that Donatello was steadily employed by the Medici and he was buried in the crypt of S. Lorenzo near Cosimo de' Medici, who

62 Donatello *Gattamelata* 1445–53 (bronze on marble base, statue 340 cm, 133⅞ in). Piazza di S. Antonio, Padua

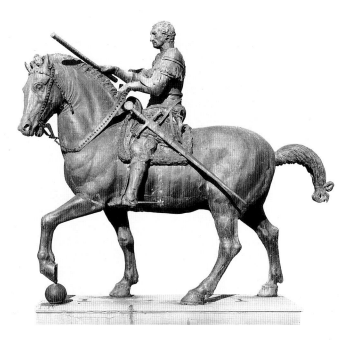

controlled the Florentine 'republic' from 1434 until his death in 1464. Certain details of the *David* could point to a commission by Cosimo. For example, the bay or laurel leaves of two victors' wreaths are associated with the name Lorenzo, grandson of Cosimo, and a traditional Medici saint, St Lawrence. (The wreath on the hat may also allude to David as musician, poet and writer of the Psalms.) Moreover, the triumphal procession of putti on Goliath's visor may derive from a Classical cameo acquired by the Medici, such gems being avidly sought throughout the period.

Despite the vogue for young heroes, Donatello's *David* is unconventional – his slightness and youth deriving from textual sources rather than visual traditions where it was customary to depict him as a king, not a shepherd. The nudity refers to Christian purity, virtue and innocence but also to the nude heroes, gods and athletes of antiquity, an appealing notion to humanists. Accentuated by the hat (used by some to identify him as Mercury), greaves and Goliath's large sword, it stresses his vulnerability and the divine nature of his victory. His lowered head, cast in shadow, was never meant to be fully seen. The highly polished bronze is sensuous, supplementing the eroticism and sinuous rhythms of his pose. Altogether, it embodies the androgynous ideal, which has made it controversial. Several scholars posit that it implies that Donatello was homosexual. It has also been sugggested that the overt sexuality relates to Neo-Platonic interpretations of Classical texts. As usual with Donatello, the many sources are thoroughly mixed. From what we know, the *David* is the first life-size nude statue in the round for a thousand years and is therefore revolutionary. It was rarely imitated even though it was on public display, a testimony to its complexity and enigmatic nature.

60,61 Another provocative work, for convenience called *Amor-Atys*, follows the antique mode; it was accepted in the seventeenth century as an ancient work even though Vasari had identified Donatello as the sculptor. The attributes contain various Classical allusions: he steps on a snake like the young Hercules; he has winged feet like Mercury and a tail like a satyr; his trousers display his genitals like the Roman Atys or peasants; and he sports wings on his back like Cupid or a Genius. His belt is decorated with opium poppy-heads and in his hair he wears a fillet with a poppy. Do these refer to sleep and death? The object he once held might have answered that but no identification has satisfactorily explained all the attributes. The most recent suggestion is that he held a garland. The figure reflects Neo-Platonism, which seemed to prefer obfuscation to clarification. It remains a puzzle that even Vasari could not solve, unlike the bronze bust in the Bargello

63 Donatello *St John the Baptist* 1438 (painted and gilded wood, 141 cm, $55\frac{1}{2}$ in). S. M. Gloriosa dei Frari, Venice

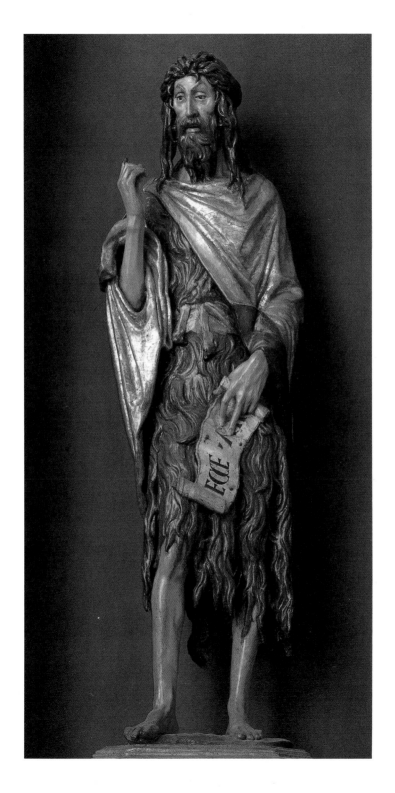

(attributed by some to Donatello) wearing a cameo with a specific Platonic image from the *Phaedrus*. The *Amor-Atys* is similar to two fountain statues given to Donatello or his school: a winged figure with a tail (New York) and a winged putto with a fish (London), whose water issued from the mouth of the fish and the putto's penis.

By 1443 Donatello had been summoned to Padua – under Venetian rule – to sculpt the equestrian monument of Gattamelata. The Paduan Erasmo da Narni, called Gattamelata ('honeyed cat'), was the mercenary commander (*condottiere*) of the Venetian army. The commission, of unknown origin, was approved by the Venetian Senate. A public revival of an imposing form of ancient sculpture, it challenged Donatello both technically and intellectually. Certainly, he knew the *Marcus Aurelius* and Roman coins with equestrians. It was also a Tuscan tradition to honour *condottiere* in illusionistically painted equestrians. Donatello's war horse, so large that part of it was cast in the ground, recalls the nearby bronze horses of S. Marco in Venice, although details of the anatomy are closer to two Hellenistic heads of horses then in the Medici collection. Perhaps the horse's tail whimsically tied up in a ribbon derives from contemporary parades. Donatello placed a canon ball under the horse's left front hoof, allowing the horse to appear to be walking (like ancient prototypes) without sacrificing stability. Gattamelata's armour is decorated with motifs from the antique – the Gorgon head (to turn his enemies into stone) on his breastplate, whose wings Donatello has enlarged to suggest a victory figure or Hypnos (sleep) the brother of Thanatos (death). A tension between the real and ideal animates the majestic work. Gattamelata carries the baton of a Roman commander, which the Venetian Senate had awarded him in 1438, yet his depiction in middle age cannot be accurate, for he died in his seventies. It is an idealized portrait of brute power (a Roman head of Julius Caesar may be a model) but Gattamelata's jowls and bushy eyebrows are individually characterized.

Standing in front of the Basilica of S. Antonio where Gattamelata is interred, the monument is a cenotaph (originally intended as a tomb within the church or cemetery). Earlier prototypes – such as Uccello's *Sir John Hawkwood* fresco (1436) in the Florence Duomo and the wooden equestrian of Paolo Savelli (1405) in S. M. Gloriosa dei Frari, Venice – were placed in churches (but the destroyed, almost contemporary monument of Niccolò d'Este by an unknown Florentine sculptor was in front of Ferrara Cathedral). The *Gattamelata* exceeds this tradition in a daring way which would have been tolerated in the humanist university city of Padua. Its podium is high, perhaps to compete with the church and piazza, and consists of five parts,

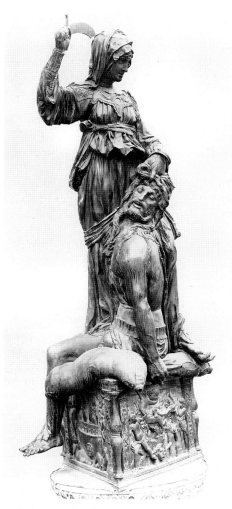

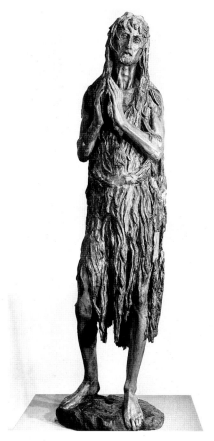

65 (*above*) Donatello *Mary Magdalen* after 1453
(painted and gilded wood, 188 cm, 74 in)

64 (*left*) Donatello *Judith and Holofernes*,
c. 1446–60 (gilded bronze, 236 cm, 92⅞ in)

including a plinth inscribed *OPVS DONATELLI. FLO.* and a tall base
containing mausoleum doors as on sarcophagi. There is no overt
Christian reference but its position tempers its blatant secularity. With
no epitaph, the *Gattamelata* becomes a universal image of power. It also
exemplifies the humanist concept of *statua*, outlined by Bruni and
Alberti, for it alludes to history and cultural ideals and at the same time
adorns and dignifies the city. The *Gattamelata* was not cast until 1447
(three years after Donatello's bronze crucifix for the authorities of S.
Antonio). In 1446, he was awarded the commission for the high altar
for the church, consisting of unusual life-size bronze statues arranged in
a *sacra conversazione*. The complex (echoed in Mantegna's *S. Zeno*

87

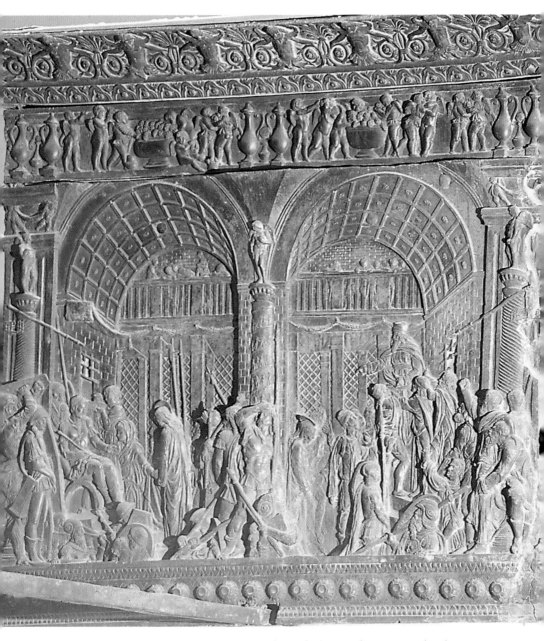

66 Donatello, 'Christ before Pilate and Caiaphas', 1460s (bronze). North pulpit, S. Lorenzo, Florence

Altarpiece) was taken down in 1579 and later reassembled; a number of reconstructions have been suggested.

His wooden *St John the Baptist* was commissioned by the Florentine 63 colony in Venice for their chapel in S. M. Gloriosa dei Frari and an inscription uncovered in cleaning dates the work to 1438. The special demands and expressive qualities of wood were exploited by Donatello in this work, as in two crucifixes attributed to him, one with a real loin-cloth and movable arms to convert it to a Man of Sorrows. (Brunelleschi also executed a wooden crucifix.) As if preaching, *St John* gesticulates and opens his mouth. His left eye too has an unusually heavy lid, a touch of individualizing naturalism. Donatello stabilized the statue not by massive drapery but by employing a stance with legs apart. Instead of hollowing the figure from the back to prevent cracking, he reduced its depth. A comparison with his bronze *St John the Baptist* for Siena Cathedral (*c.* 1457) – which is less frail and elongated – emphasizes the asceticism of the Venetian work. Unlike his Campanile prophets, based on a study of antiquity, the *St John* was a response to Italo-Byzantine models which he encountered either in Venice or Florence.

Donatello's wooden *Mary Magdalen* is an even more extreme study 65 of an ascetic saint. It can be dated to his post-Paduan period, when her cult was growing, and before 1455, the date of another *Magdalen* in Empoli which reflects this work. Her weathered features – sunken eyes, skin like leather from the desert sun and broken teeth – are almost hypnotic and her skull, visible beneath the skin, reminds us of the transitoriness of all flesh. The abraded condition of the sculpture adds to its tortured quality, which nevertheless suggests her former beauty. Her profuse hair alludes both to her previous sensuality and her humble act of washing Christ's feet. No longer a harlot, she has been purified of dross by God's fire to become a spiritual beauty joining her hands in prayer. She is like a flickering flame pointing to heaven – enlivened by the gilt highlights in her hair, discovered after the Arno flooded in 1966. The *Magdalen* is Donatello's most ecstatically religious work and influenced subsequent images of the saint produced in Tuscany.

The *Judith and Holofernes* is related to the *Magdalen* in intensity. 64 Signed on the cushion, the undocumented work is dated to the post-Paduan period (based on known purchases of bronze and style). It may have been commissioned by the Medici or ordered by the Sienese and later modified for the Medici. After their expulsion, it was displayed in 1495 with the *David* at the Palazzo della Signoria to demonstrate the 59 Republic's triumph. Judging from the waterspouts at the four corners of the bronze cushion, it was intended for a fountain, although during restoration no trace of any ducts was found. The figures' intertwined

victor-over-vanquished pose propels the viewer around in a manner not seen since antiquity (an effect exaggerated by the *figura serpentinata* of the next century). Judith's generalized face was meant to be viewed from below and in shadow like the *Zuccone*. The beautiful widow – from a Jewish city besieged by the Assyrians, under Holofernes – plotted to kill Holofernes, who lusted after her. Following a banquet, she beheaded the inebriated commander and returned to her people with his head as a trophy. She is a symbol of humility overcoming pride and other vices (Holofernes' medal shows the rear quarters of a horse or centaur, emblem of bestiality, from a cameo in the Medici collection), and a beacon of Florentine patriotism. The theme of wine and debauchery is echoed in the three orgiastic reliefs freely modelled on the pedestal and in Holofernes' ecstatically open mouth. Donatello depicted the climax of the narrative: with grim resolve, Judith has raised her scimitar for the blow of decapitation, while Holofernes' neck is partly severed and blood courses through his distended veins. Straddling his shoulder, she stands with one foot on his wrist (his pulse) and the other between his legs, near his genitals. Technical innovations enhance the work: Donatello used real cloth in casting (whose warp and weft can be observed in the head-dress) and Holofernes' legs may have been cast from nature. The chiselling and reworking add intensity and the gilding of the weapon, uncovered in restoration, highlights the divine sponsorship of the deed.

During his last years, the octogenarian sculptor worked on a series of bronze reliefs of the Passion of Christ for S. Lorenzo, Florence, which were assembled in the sixteenth century into two pulpits. It has been suggested that they were intended for three related projects – a pulpit, an altar and the tomb of Cosimo de' Medici – explaining differences in their measurements. Donatello may have modelled the scenes in wax and been assisted by Bellano, Bertoldo and others in the casting. The reliefs stretch the technical limits of what could be achieved in bronze, as demonstrated in the Resurrection with its freestanding architectural elements. His representation of 'Christ before Pilate' is separated from the adjacent scene by a historiated column like those of Trajan and Marcus Aurelius. A two-headed servant, a Janus figure, offers a bowl to Pilate to wash the guilt from his hands. With this acute psychological device, Donatello visualized the inner conflict of Pilate: to yield either to his wife's pleas for clemency or his own desire for expediency. (The source may have been a Romanesque representation of January as a two-faced man holding a vessel for feasting.)

Only Donatello's major commissions have been considered here. There are also problematic and lost works, including the *Dovizia*,

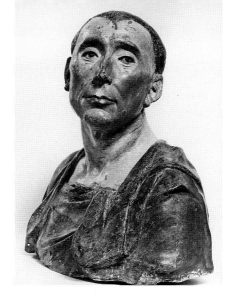

67 Donatello (?) *Niccolò da Uzzano*(?)
1430s? (painted terracotta, 46 cm,
18 in)

perhaps Donatello's first statue *all'antica*, erected on an ancient column
in the old market in Florence (1421–31). A portrayal of communal
wealth, she represented a rationalization of wealth and charity. Carved
of porous stone, the work disintegrated. Donatello has also been
considered the originator of the portrait bust. The earliest dated bust is
by Mino da Fiesole in 1453, although by then it was a popular form.
The terracotta of (?) Niccolò da Uzzano (who died in 1433) – identified 67
by its resemblance to images of the wealthy banker and humanist – has
been attributed to and taken away from Donatello on the same
grounds: its uncompromising realism. The toga leaves no doubt that
the sitter is represented in an antique mode. In 1984 restoration revealed
that it had been mounted incorrectly, altering the sitter's expression,
which now exudes sagacious strength and nobility. Traces of joints
prove that it was a life- or death-mask (probably from shrinkage it is
just under life-size), the technique described as early as the fourteenth
century by Cennino Cennini. After the dirty layers of repainting were
removed a subtler, modulated surface remains. Even during his life
Donatello was famous and was one of seven artists included in the
Genoese humanist Bartolomeo Fazio's book *De viris illustribus* (*On
Famous Men*, *c.* 1456). Collectively, his highly individualized works
show that he was a chameleon, changing with the commission, to
achieve a variety and freedom matched by few other artists. He
profoundly re-interpreted many subjects through his understanding of
human behaviour and culture and also extended the technical
possibilities of various media. Thus his work embodied the artistic and
intellectual freedom of the Renaissance he helped to fashion.

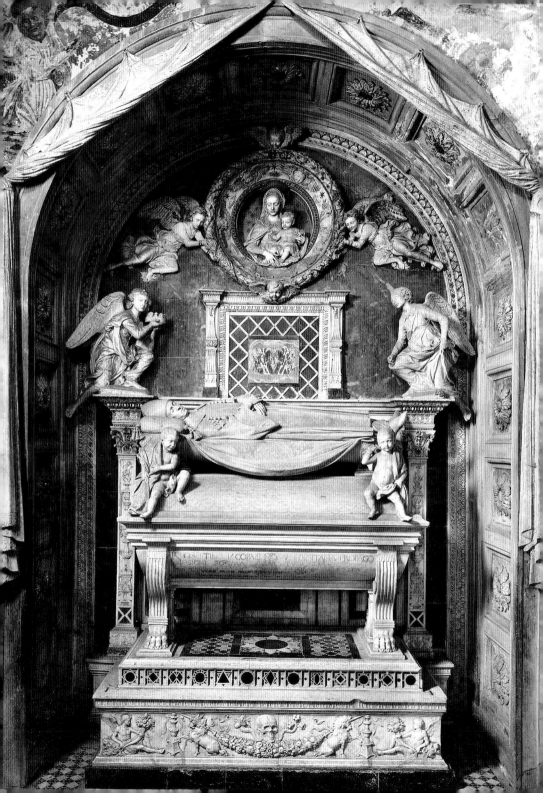

Sculpture in Mid-Fifteenth Century Florence

Florentine sculpture during the middle decades became ever more diverse and secularized, fed by a relaxation of sumptuary laws, a prosperous economy, political stability, the advance of humanism and a general feeling of well-being encouraged by Florence's transformation from a provincial backwater into a European power. Private versus corporate patronage grew and extended to a lavish scale, emphasizing personal tastes and iconographies. Individuals who enriched the city were motivated not only by self-aggrandizement but also by a feeling that they owed a moral debt to the community. The Medici subtly but increasingly manipulated the oligarchical government; when Cosimo de' Medici died in 1464, his son Piero the Gouty took over the reins of state smoothly. Piero controlled this 'disguised aristocracy' until his death in 1469, when power passed to his son Lorenzo the Magnificent (died 1492). Except for a few challenges (notably the Pazzi conspiracy in 1478), the Medici remained in power until 1494. Piero's opulent tastes are a barometer of attitudes at mid-century, his patronage encouraging a decorative orientation that harmonized with artists' new interests.

The spread of humanism continued, with Marsilio Ficino's translations of Plato for Cosimo de' Medici and Alberti's treatises (based on ancient models) on the three arts of painting, sculpture and architecture. A humanist as well as a practising sculptor, painter and architect, Alberti composed his treatise *De Statua*, known in ten later manuscript copies, after *On Painting* (1435). Although neither as comprehensive nor as multifaceted as the painting treatise, it was the first theoretical work on the subject since antiquity, marking a watershed for Renaissance sculpture. The goal of the sculptor in *De Statua* is to reproduce Nature, working from the most beautiful examples culled from tangible reality, not from the imposition of philosophical or religious principles on objects, as in medieval times. By this method, Alberti postulated the Renaissance theory of the equilibrium between the individual and the ideal. *De Statua* consists of a short theoretical introduction, followed by minute measurements of the human body, stressing the figure in the round and Alberti's anthropocentrism, an

68 Antonio Rossellino *Tomb of the Cardinal of Portugal* 1461–6 (gilded marble, 400 cm, 157½ in). S. Miniato al Monte, Florence

intellectual trend which culminated in Giovanni Pico della Mirandola's *Oratio de dignitate hominis* (*Oration on the Dignity of Man*, 1486). Alberti's emphasis on the harmony of the parts with the whole derives from ancient practices via Vitruvius, recalling the canon of Polyclitus. Since the treatise was not published until 1568 in Italian (the original Latin text was only published in 1877), its contemporary influence was limited. His methods of measurement have been criticized as too complicated for practical use but Dürer was employing them in the next century. However, Alberti's ideas probably reflect some practices of sculptors, and a correspondence between his measurements and certain Donatello works has been noticed.

When Donatello departed for Padua in 1443, his gap was quickly filled by a group of lyrical sculptors with roots in the more graceful forms of Ghiberti. They forged a language more palatable to the public and embroidered variations on three established themes. The first, the Madonna and Child, was disseminated in public buildings and houses. The second, the tomb, was keyed to the Florentine family system – the desire to perpetuate the name of the family and to venerate members and ancestors – and to the growing cult of the individual. This thirst for commemoration was fed by new knowledge of ancient funerary rites and monuments, which embodied the idea of immortality via such memorials, the motive that led Vespasiano da Bisticci to write his *Uomini Illustrati* (*Famous Men*), a Renaissance Plutarch's *Lives*. The third theme was the portrait bust. The dramatic rise of portraiture in mid-century is usually regarded as part of Renaissance individualism but it was also related to the cult of the family. Even when self-glorification (on the ancient model) was the goal, its justification almost always included a dynastic dimension.

Alberti, in the preface to his treatise on painting, credits Luca della Robbia – and the more established Brunelleschi, Masaccio, Ghiberti and Donatello – with creating the Renaissance style. Little is known about Luca's education, although he was probably trained in Ghiberti's shop. On the basis of style, it is believed that he mastered marble carving under Nanni, completing his *Assumption*. Manetti, in his book on the illustrious men of Florence, characterized Luca as a moral individual and intellectual sculptor. Innately classical, he was reputedly a friend of Niccolò Niccoli. Without doubt, Luca's charming sculptures, which anticipate the *grazia* of Raphael, appealed to a wider audience than the arcane works of Donatello. They are understandable, although their casualness belies an underlying rigorous study.

Luca della Robbia's most important innovation lay in technique, for it was he who 'invented' enamelled or glazed terracotta sculpture,

according to Manetti and Vasari. Before 1441 he had practised mainly in marble and his first datable use of glazed terracotta (1441–3) was the *Tabernacle for the Sacrament* for S. Egidio in the hospital of S. M. Nuova (now at S. Maria, Peretola), although earlier experiments from the 1430s exist. In 1442 he was commissioned to execute a Resurrection for the lunette over the door of the North Sacristy of the Cathedral (beneath his *Cantoria*) and a pendant Ascension over the door to the South Sacristy. Thereafter, he worked almost exclusively in that medium, except for such works as his bronze doors of the Old Sacristy of S. Lorenzo. Perhaps the techique was inspired by the blue background of Nanni's *Assumption* and the inlaid glass of Orcagna's Or San Michele relief, the Campanile and the Loggia dei Lanzi. The stunning effect of his blue and white glazes, coupled with their durability (unlike painted terracotta or stucco) and low cost, were responsible for their popularity. The technique was a brilliant adaptation to monumental sculpture of ceramicists' enamel glazes (either lead or tin coloured by various metal oxides). Luca converted the process to achieve lustrous surfaces and tonalities different from those of majolica. Although he developed a broad palette, as in the tabernacle, he often restricted his range to sky blue and milky white. For nearly seventy-five years the formula remained the secret of the Della Robbia shop, including his nephew Andrea and his grand-nephew Giovanni, although others in Tuscany and beyond made similar products. It was Vasari who began the mistaken notion that it was used primarily as a cheap substitute for more costly materials (this was true, however, with later mass-produced works from moulds).

In 1448 Luca sculpted the first freestanding figures in the medium – two white acolyte angels with wooden wings for the Cathedral. He collaborated with Brunelleschi, contributing roundels to the Pazzi Chapel from 1442 to 1461. After Brunelleschi's death (1446), Luca explored his decorative talents in the Cardinal of Portugal chapel ceiling in S. Miniato al Monte. For Piero de' Medici, he decorated not only part of the Chapel of the Crucifixion in S. Miniato but also his luxurious private study in the Palazzo Medici, whose only remaining elements are the beautifully glazed white, blue and gold tondi of the Labours of the Months based on Columella's *De re rustica* (from a manuscript discovered by the Classicist and humanist Poggio Braccio-lini). He also designed numerous heraldic reliefs for the guilds and families.

In the fifteenth century, to feed growing demands for didactic, domestic instruction, an unusually large number of devotional images of the Virgin and Child were produced in Florence, where few

22

prosperous homes were without several. Luca created many of these in two basic forms: unique works and those for replication (mass-produced by the shop). The autograph devotional reliefs are among his best-conceived works, never simpering or saccharine, but serene, simple and down-to-earth (emphasized by a frequent absence of haloes). In these images – such as the *Madonna of the Apple* for the Medici – Luca's thick blue glaze, symbolic of heaven, is resonant. Here the refined application of the glazes and the colouration of the blue-grey eyes with violet pupils and the turquoise base add subtle nuances. The playful Child holds an apple, denoting Adam's fall which he, the second Adam, will redeem, while the Virgin meditates on her Child's destiny.

After 1460, Luca's nephew Andrea, with whom he occasionally collaborated and to whom he bequeathed his technique, began to expand the medium. Luca in turn may also have been stimulated by him. An unusual bust of a woman in a tondo, a symbol of eternity, dates from this later period. Although there are no documents for the work, originally attributed to Andrea, it is now given to Luca on the basis of its sensitive modelling. The figure is like contemporary female portraits painted in profile and sculpted in the round. She is dressed in the latest fashion, with a high, shaved, aristocratic forehead and wispy hair cascading from a bejewelled head-dress. The nature of the work is still debated: is it a portrait or a representation of the ideal feminine beauty of the age? The tentativeness and vivacity of youth, the specificity of features, the subtle eyes and turn of the head to the side are so well captured that it must have been modelled from life. By depicting the fragility of youth and beauty as bittersweet, the work parallels Neo-Platonist writings. Exceptionally for a sculptor of the time, Luca remained in Florence, although other relatives exported the Della Robbia style while continuing to work in Florence. Andrea and his relations experimented with terracotta altarpieces, establishing a relationship with those of contemporary painters. These pieces – mass-produced from moulds – together with devotional images, ensured the prosperity of the Della Robbia shop into the next century.

Meanwhile, a new generation of marble sculptors, all of whom worked in a lyrical mode, flourished. Three who dominated marble sculpture in Florence until 1470 were born in Settignano, a hill town outside Florence famous for its quarries and stonecutters. Bernardo Rossellino (1409–64) introduced his younger brother Antonio and a friend, Desiderio, to Florence. Bernardo Rossellino was also the architect for some significant commissions, such as Alberti's Palazzo Rucellai and projects in Rome and Pienza. His most important

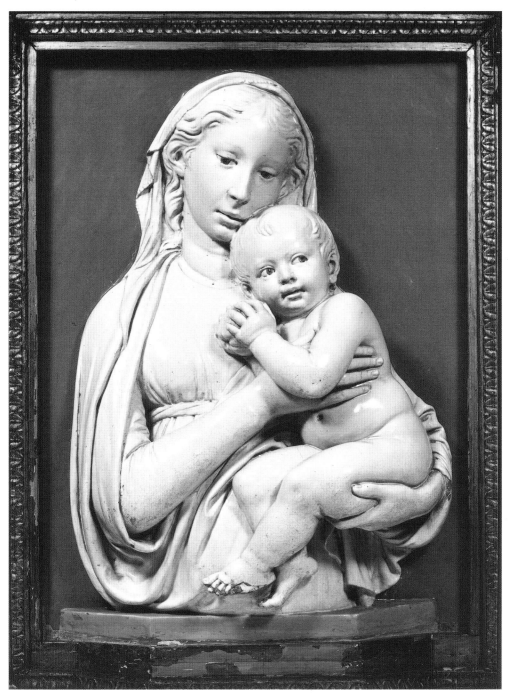

69 Luca della Robbia *Madonna of the Apple* 1460 (glazed terracotta, 70 × 52 cm, 27½ × 20½ in)

sculptural commission was the *Tomb of Leonardo Bruni* in S. Croce. The humanist Chancellor of Florence, who died in 1444, had requested a simple tomb slab. Although the monument is undocumented, Da Bisticci's description of Bruni's funeral, held 'according to the custom of the ancients', clarifies much of its iconography. The effigy of this quintessential Renaissance man lies in state as in his funeral. He holds his *Historiae Florentini populi* (*History of the Florentine People*) – the first major work of Renaissance historical writing to emphasize Classicism – and wears a laurel crown. The tablet on the sarcophagus contains Bruni's Latin epitaph, composed by his successor, in which it is said that the Muses mourn his death. While certain components derive from

Donatello's Coscia tomb and Michelozzo's dispersed Aragazzi tomb in Montepulciano, Rossellino's detached intellectual rigour is foreign to both. Its harmonious integration of figures in an architectural frame established it as the model for sepulchral monuments for the remainder of the century. The dominance of the architecture and its style have

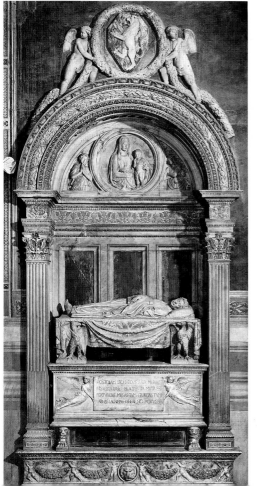

70 Bernardo Rossellino *Tomb of Leonardo Bruni* 1444–6/7 (marble, c. 610 cm, 240 in). S. Croce, Florence

71 Desiderio da Settignano *Tomb of Carlo Marsuppini*, c. 1453–64 (marble, c. 613 cm, 241⅜ in). S. Croce, Florence

suggested that Alberti was responsible for it. The tomb's format recalls the triumphal arch, a fitting motif for a Christian humanist. However, its message is the triumph not so much of salvation as of the individual and his everlasting fame. This is stressed by the crowning element, Bruni's coat-of-arms, which recalls the *Marzocco*, stamping the monument with a loftier republicanism. Only the red marble behind the bier and pigment on the escutcheon point to the once copious polychromy and gilding.

The tomb rests on a platform surmounted by a sarcophagus-like plinth with putti carrying swags and with a lion's head (the *Marzocco*) alluding to Bruni's service to the city and his work *Laudatio Florentinae urbis (In Praise of the City of Florence)*. Directly above, the rectangular sarcophagus rests on lion heads and feet; two victories hold the epitaph. On the next level, eagles (carriers of souls) support the bier on which Bruni's effigy is tilted up, more successfully than in the Coscia tomb. The noble head of Bruni, based on a death mask, is propped up

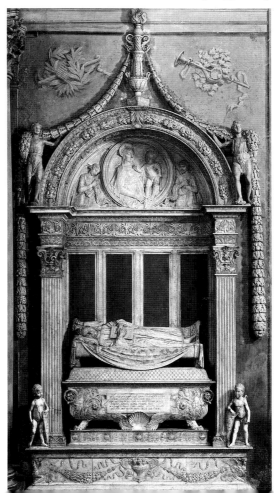

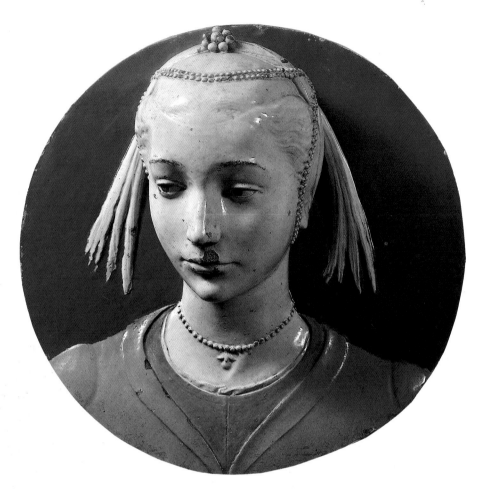

72 Luca della Robbia *Tondo Portrait of a Lady* 1465 (glazed terracotta, 54 cm, 21¼ in diameter)

naturalistically by his hat. Tripartite panels of red marble behind the bier emphasize the effigy and provide a geometric stability, while the tomb is unified by composite pilasters, reminiscent of Masaccio's *Trinity*. Above is a medallion with a half-length Madonna and Child, whose blessing signals that Bruni has achieved salvation. It is the only overt Christian motif, suggesting that he earned immortality for his civic and scholarly accomplishments rather than for his Christian virtues. It could thus be designated the first humanist tomb.

There is no more accurate way to gauge the change of taste in mid-century than by comparing the Bruni tomb with that of Carlo

73 Andrea della Robbia *Madonna of the Stonemasons* 1475–80 (glazed terracotta, 134 × 96 cm, 53⅛ × 37¾ in)

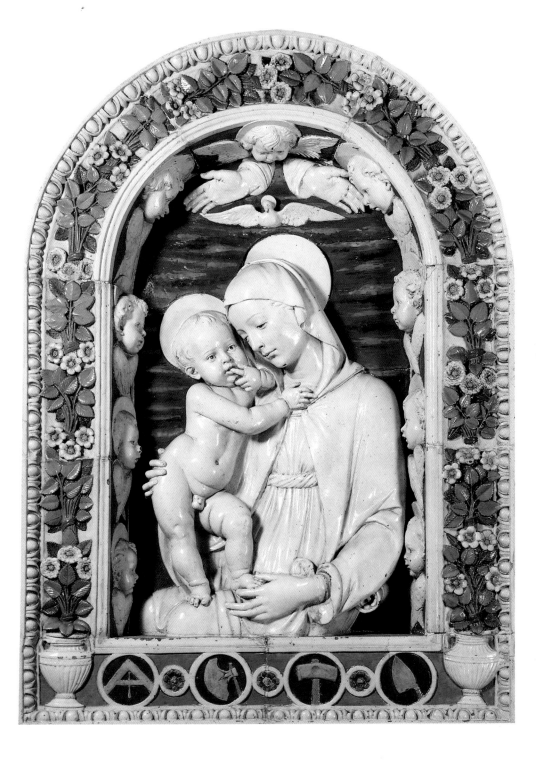

71 Marsuppini (died 1453), Bruni's successor as Chancellor. The *Tomb of Marsuppini* was installed opposite as if in competition with Bruni's monument. It was designed by Desiderio da Settignano (*c.* 1453–64), who had probably assisted Rossellino on the Bruni monument. Here, emphasis has been placed on profuse ornament and figures as opposed to architecture. Every element is more copious in the later work, including the longer, more laudatory epitaph. Like the Bruni tomb, it is set on a base surmounted by a plinth, in this case with swags and a creative pastiche of antique elements: fluttering banderoles, sphinxes and so on. Three-dimensional putti support escutcheons at the ends of the plinth. Instead of a rectangular sarcophagus there is a curvilinear bathtub variety, whose flamboyant foliage was praised by Vasari. The Marsuppini tomb also reflects the obsequies which celebrated the deceased in the manner of the ancients, while the figure holds a book, symbolic of the humanist's dedication to letters. Desiderio has tilted the bier at an even more extreme angle, a comment on the earlier tomb. The marble slabs behind the bier have increased to four, softening the perfect triadic character of the austere Bruni tomb. On the same level as the Madonna and Child, two adolescent figures hold elongated garlands that cascade down the frame to add to the overall curvilinear, decorative focus, the antithesis of the rectilinear Bruni tomb. A vertical sepulchral lamp, culminating in an eternal flame, crowns the whole. Although some of the outward humanist trappings of Bruni's are repeated, the effect is very different. Grandeur and monumentality are sacrificed for richness and elegance. Desiderio's technique defies the marble and resembles wax, glowing like illuminated alabaster. The third contemporary tomb planned for S. Croce, that of Poggio Bracciolini (died 1459), was never carried out due to lack of funds.

68 Trained by Bernardo, Antonio Rossellino (1427–79) contributed to the *quattrocento* tomb with his *Tomb of the Cardinal of Portugal* in S. Miniato al Monte. It is his first recorded commission and is part of the jewel-like mortuary chapel of Jaime of Portugal (a prince of the royal house), who died in Florence aged twenty-five in 1459. The three-walled chapel is a rare example of the harmonious effect which could be achieved when all three arts were brought together in a completed collaborative effort. Manetti designed it and other aspects were undertaken by the Rossellino family, Piero and Antonio Pollaiuolo, Alesso Baldovinetti and Luca della Robbia. Antonio Rosellino was responsible for the tomb and the throne opposite. Like Desiderio, he was a subtle and virtuoso marble sculptor. Beautifully carved and once richly gilded, the tomb's melancholy images capture the character of the deceased. Since it was conceived as an integral part of the chapel, it is

unlike the Bruni and Marsuppini monuments. However, many components derive from the two earlier tombs, such as the decorated base (with Mithraic elements, unicorns symbolic of the Cardinal's chastity and a skull from which grow the palm of victory and the lily of innocence); the cardinal's effigy (the face and hands taken from posthumous moulds); and the roundel with a Madonna and Child supported by angels. All, however, are differently expressed. The tomb also departs from its predecessors in two significant ways: its stress on spirituality, befitting an ecclesiastic, and its basically illusionistic character, which in many ways anticipates Bernini and the Baroque. The deep niche is framed by curtains, pulled back as though revealing a *tableau vivant*. Above the effigy a small slab of stone (identified as petrified wood) appears affixed to an illusionistic, inlaid lattice-work grating. This ingenious image, never satisfactorily explained, suggests a glimpse into another world and refers to earlier Roman tombs, viewed through a grill. The idea is supported by the heavenly vision of the Virgin and Child in a 'tondo' that breaks into the grill's frame.

Portraits, like tombs, were intended to preserve the *virtù* of famous men and the virtue of young women, prized symbols of individuality in humanist culture. The portrait bust, better than any other work of art, enshrines this nobility. Busts became fashionable at mid-century in Florence, far more than elsewhere in Italy, yet there is no contemporary theoretical discussion about them. Medals, relief portraits and busts all resulted from three factors: the pursuit of naturalism and an interest in the individual and in antique *exempla*. While medals and relief portraits, like painted portraits before about 1470, were rendered in profile, the sculpted bust was carved in the round, in marble, in polychromed wood, wax and terracotta (glazed, painted and unpainted) and only later in costly bronze. Like tombs, busts enhanced the prestige of families and recorded individuals' appearances in a conscious straining for immortality. Male busts were frequently inscribed to ensure that the sitters would be remembered, unlike many anonymous Roman busts. The inscriptions are usually on the bottom or back, intended more for documentation than display. The Roman custom of making wax masks (*imagines*) and later marble busts, as part of their ancestor cult, lay behind the Renaissance adoption of the form. These portraits, particularly of the Republic, like their *quattrocento* successors, were rooted in realism, recording the facial topography with often penetrating psychology. The Renaissance bust, usually life-size or nearly life-size, blends the Roman with the reliquary bust to produce a novel version cut off at the sternum without a base and with the head turned slightly aside. Sometimes death-masks were used, perhaps

PATRI PATRVO QVE

introduced from the passage in the Elder Pliny's description of the technique. Renaissance busts usually represented the living and, as in Roman times, women and children were also portrayed. In contrast with men depicted either in vigorous middle or sagacious old age, when their power and wealth were at their height, women were shown in the flower of their youth, advertising their marriageable charms and child-bearing potential. Men tended to be depicted psychologically, whereas women were described physically, with less insight into their personalities – differences that reveal much about the values of the society. After 1500, portrait sculpture waned in popularity against the painted portrait, although around 1550 the bust re-appeared as a vital but different form in Florence, Venice and other Italian cities.

It is impossible to pinpoint when the first autonomous bust was sculpted, although the portrait of Niccolò da Uzzano may be early. 67 Some relief portraits, which preceded independent busts, were in bronze. Moreover, wax effigies and death-masks were common and were placed in churches as *ex votos* or used in the preparation of sepulchral effigies. The first surviving dated bust (1453), a portrait of 75 Piero de' Medici, is by Mino da Fiesole (1429–84). He also created busts of Piero's brother Giovanni, dressed in pseudo-Roman armour, and his wife, Lucrezia Tornabuoni. All three, carved in the round, were set in niches over doors in the Palazzo Medici. (There is evidence that portrait busts could be displayed either in profile or frontally.) Piero's bust is more idealized than many others. It is also stiff, perhaps indicating the sitter's reserve or Mino's hesitation in sculpting the Medici heir apparent. There is a schematic evenness, most obvious in the doublet's pleats whose richness is characteristic of Piero's taste. Sitters were sometimes clothed *all'antica* and Mino also carved a profile portrait in relief of the Emperor Aurelius. Such idealized portraits of Roman rulers were popular and in 1455 Desiderio was commissioned to make a series of reliefs depicting Suetonius's twelve Caesars (no original survives).

The preparation of death-masks was related to the portrait bust, as noted, and was modified by mid-century to include the life-mask, expressly tailored to the preparation of busts. When Donatello's physician Giovanni Chellini died in 1465, his tomb (designed by B. Rossellino) contained an effigy based on a death-mask, with sunken eyes and pendulous folds of skin. Chellini is the only *quattrocento* subject whose features are also recorded in a portrait bust made from a life- 76 mask. Indeed, this portrait by A. Rossellino, who produced some of the most individualistic and sensitively carved busts, is one of the finest examples of the age. It is certainly from a life-mask not only because the features are rendered in fine detail, down to the veins under the

74 Verrocchio *Tomb of Piero and Giovanni de' Medici* 1469–72 (marble, porphyry, serpentine, bronze and *pietra serena*, 540 cm, 212½ in). S. Lorenzo, Florence

75 Mino da Fiesole *Piero de' Medici* 1453 (marble, 50 cm, 20 in)

76 A. Rossellino *Giovanni Chellini* 1456 (marble, 51 cm, 20⅛ in)

parchment-like skin, but also because the ears are pressed back against the head. Rossellino captured the sagacity of this renowned man of healing – his humorous eyes and cynical smile suggest his knowledge that death lurks close beneath the skin – a thoughtful character study surpassing most Roman busts. The other authenticated bust by
77 Rossellino is of the historian Matteo Palmieri. Until the nineteenth century, it was displayed over the exterior portal of his house (unusual in Florence) so that it is damaged and most detail effaced. The drill holes for the leonine hair are more prominent and resemble those from late antiquity. The features were once less coarse than now but the vigorous conception of the humanist – who wrote about free will and was accused of heresy – is preserved. Palmieri's own comments on aging hint at the purpose of these busts: 'No longer able to exercise his body, exert his mind, his deeds and sayings are recorded for posterity. To his children, he leaves the glory of his virtue, from which through many generations his seed becomes honoured.' His plebian features imply an open character, echoed in the asymmetrical folds of his doublet and mouth. Realism is maintained, even to the broken nose, yet Rossellino left no doubt about the inherent nobility of the individual.

The Florentine sculptor Benedetto da Maiano (1442–97), who developed into an effective portraitist in the Rossellino shop, carved his
78 portrait of Pietro Mellini in 1474. The dated bust preserves the wizened

106

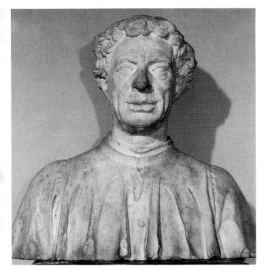 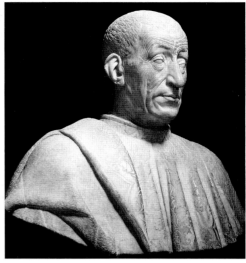

77 A. Rossellino *Matteo Palmieri* 1468 (marble, 53.3 cm, 21 in)

78 Benedetto da Maiano *Pietro Mellini* 1474 (marble, 53 cm, 20⅞ in)

features of Mellini, a wealthy merchant, who also commissioned a pulpit with scenes of St Francis for S. Croce. Benedetto created a prose-like approach to the minutiae of appearance, paralleled in paint by Ghirlandaio. Here Benedetto displays an unsparing verism, portraying every wrinkle in the roadmap of Mellini's face. The slightly pursed, sceptical lips betray the bemusement of a basically genial but careful man. These qualities were praised in merchants, who were what made Florence a great commercial centre and the florin the standard coinage for all Europe. Mellini's bust is unlike the others in its rounded base, allying it to ancient types and declaring it to be an autonomous work of art. The inventory of Benedetto's studio at his death indicates that he made extensive use of terracotta models, although his bust of Filippo Strozzi (Paris) is the only one for which the model still exists. It shows an older, less idealized man than the final marble, which was clearly manipulated to produce a more official image.

Of the busts of children, some seem to be portraits but others definitely represent the young Christ and St John, the latter identifiable by his animal skin. The religious busts served as *exempla* for young children of wealthy households (as recommended by Cardinal Dominici in his treatise on the family) and are evidence that religious ideas were being expressed more accessibly. There are at least three

107

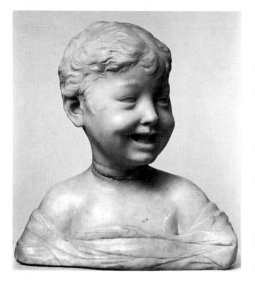
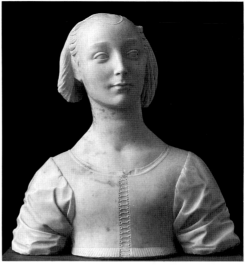

79 Desiderio da Settignano *Laughing Boy*, *c.* 1453–63 (marble, 33 cm, 13 in)

80 A. Rossellino *Portrait Bust of a Lady*, *c.* 1460–70 (marble, 53 cm, 20⅞ in)

marble busts of children by Desiderio. One, the famous so-called
79 *Laughing Boy*, has a casual quality, with a modulation of light and
movement. The sculptor has intensely studied a fleeting expression and
mood, interests that were explored in the seventeenth century.
Desiderio's portrayal of the boy, his tongue up against the roof of his
mouth in spontaneous laughter, captures the essence of childhood. In
spite of the Classicizing drapery, the sculpture cannot represent the
Christ. Two more pensive busts (Washington, D.C.) – with the same
drapery worn by the Christ Child in a marble tondo in Paris – were also
probably intended as portraits.

Female portraits celebrate different qualities from those of men and
children but usually follow the same format. They are rarely signed,
dated or named, indicating that there was not the same urge to
commemorate women for posterity. On the other hand, their presence
undeniably added to the family's prestige. While they represented a
return to Classical practice, little is Classical about them. The sitters are
generally idealized and youthful (before character moulds their faces),
dressed in the height of fashion. Their shaved foreheads, plucked
eyebrows and elaborately arranged and jewelled coiffures lend them an
aristocratic mien and greater uniformity than their male counterparts.
There is only one female portrait that can be securely attributed to
Desiderio (Bargello). Like many of his marbles, one soft surface seems

81 Andrea del Verrocchio *Portrait of a Woman* (Ginevra dei Benci?), 1475–80 (marble,
61 cm, 24 in)

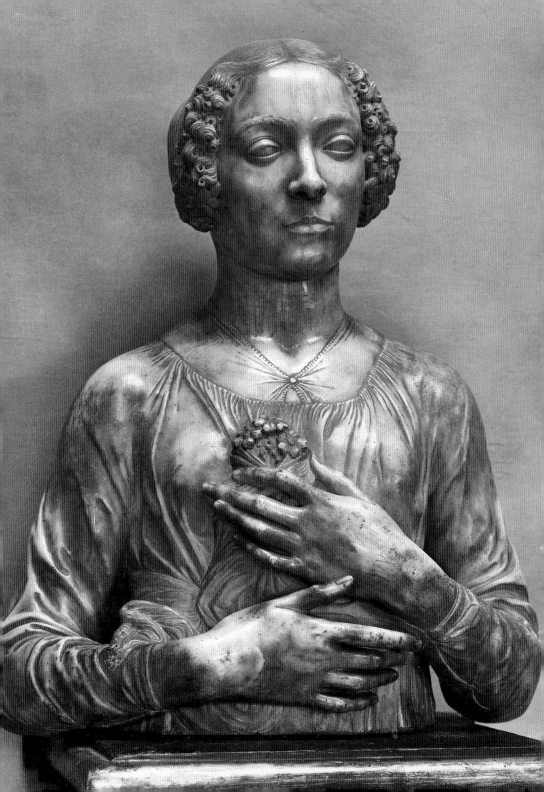

to melt into another. A female bust, sometimes given to Desiderio, can be attributed to A. Rossellino on stylistic grounds: it is much more three-dimensional and clearly defined (for example, the lacings of her bodice) and more of her torso is shown than in standard types. Her hair is deeply undercut and vivaciously hangs away from the head. The sitter's personality is also more assertive than usual. Her animation results partly from her pose: she seems to react to an unseen person, her head held back. Like several others, it reminds one of the Latin epigram composed by Alessandro Bracci, a member of Ficino's Platonic Academy, eulogizing Albiera degli Albizzi, who died at the age of fifteen in 1472. 'To the Marble Bust', the earliest published poem on the subject, reads:

> Albiera, whose noble form is to be admired, asks, o passerby,
> > That you stop a little and consider
> Whether Polyclitus' or Praxiteles' deft hand
> > Ever made such visages from Parian marble.
> But lest there be on earth any lovelier goddesses,
> > Death, at the command of the deities, carried one off.

Just as the painted profile portrait developed into a three-quarter view around 1470, Andrea del Verrocchio (1435–88) continued to transform the sculpted bust. His sitter holds a nosegay of flowers to her bosom in a very romantic pose; she is shown to below the waist, including her two hands, implying interaction with the viewer. This radical innovation was clearly not lost on Verrocchio's pupil, Leonardo, who would exploit its potential as well as its luminosity in his painted portraits. Indeed, the sitter has sometimes been identified as Ginevra dei Benci, the subject of a Leonardo portrait now in Washington, D.C. There is a pronounced resemblance between the two sitters – their wide-set, melancholy eyes and strong-willed expressions. Ginevra, an unhappily married woman with these character traits, wrote sad poetry and travelled in the Neo-Platonic circles of Lorenzo de' Medici. Her diaphanous drapery is a technical tour-de-force that owes something to the study of Classical wet drapery and parallels the dresses of Botticelli's Three Graces in his *Primavera* of almost the same date (one Grace also sports a nearly identical hairstyle). In short, the bust portrays the ideal Florentine beauty of the late 70s. Of all the female portrait busts, this one approaches most closely the gravity of Roman portraits, and the drill work in its curls is also allied to ancient techniques. The sculpture can be easily appreciated from many angles, and the hands endow it with a three-dimensionality that the High Renaissance developed.

Embellishment: Late Quattrocento Florence

As the Quattrocento matured, the guiding humanist chancellors and other rulers of the city were increasingly constrained by a system of favours controlled by the Medici. Consequently, the outlines of political and cultural life became blurred and more complicated. The courtyard of the Palazzo Medici, built by Michelozzo for Cosimo, was a perfect square and grand in scale, in contrast with earlier utilitarian and irregular courtyards which provided hygienic light and air. On the model of an ancient atrium, the Medici Palace *cortile* became an outdoor living-room, decorated with a frieze of marble medallions connected by incised garlands. These reliefs, formerly attributed to Donatello and Michelozzo, were adapted from ancient gems and a sarcophagus in the Medici collection. They underline the Medici's pretensions as collectors, aggrandizing them to all who entered. The lantern-jawed man who ruled Florence from 1469 to 1492, Lorenzo de' Medici, was raised in this palace. As a popular scholar-prince, he embodied an equilibrium between the active and contemplative life so prized by Neo-Platonists, yet Savonarola, the fiery Dominican preacher, criticized him and predicted that a cataclysm followed by a Christian renewal would befall worldly Florence. When Lorenzo died in 1492, celestial apparitions were interpreted as ominous portents. His outward successes – surviving the Pazzi conspiracy, bringing off diplomatic ventures, attaining a cardinalship for his son Giovanni and reducing the tensions of his time by supreme juggling – were marred by the reverses of the Medici bank (perhaps because he left control to others). Himself a poet, he appreciated artists and was an arbiter of taste on public artistic commissions in the city. In contrast to the more public art of his grandfather, he preferred costly items such as antique gems and small objects that he could contemplate in private. Under his influence, an interest arose in otherworldly beauty and higher truths, encouraged by the Neo-Platonic poets and philosophers of his circle. This diverted attention from the economic and political situation. It is easy to see why the secularity of this culture and its Classical underpinnings provoked charges of worldliness. But the Neo-Platonic focus on a higher reality harmonized with Christianity and paved the way for the religious

fanaticism of Savonarola, which followed the invasion of Florence by Charles VIII of France in 1494, the expulsion of the Medici and the restoration of republican government.

The aura of the time is best evoked in lines from Lorenzo's most famous sonnet:

> How beautiful is youth,
> But in a moment it's gone!
> Who ever wants to be happy, let him be so;
> There is nothing certain in tomorrow.

The Neo-Platonists were not dilettantes and their quest for permanence behind the flux of appearance was motivated by deep convictions. To simplify, they viewed the universe as structured in a series of hierarchies. At the top, the realm of Ideas (Goodness, Truth and Beauty) was equivalent to the Christian God and existence was a shadow of this more perfect realm which could only be understood through contemplation. There is no textual correspondence between Neo-Platonic writings and works of art, although a similar emphasis on beauty, intellectual syncretism, abstraction and a dreamy mood also appear in Florentine art from 1470 to 1495 (such as Botticelli's). The focus on beauty led not only to superficial elegance but also to a stress on theoretical perfection. Ultimately, Neo-Platonism, which addressed neither practical issues nor institutions, contributed to the unrest at the end of the century. Although it sought to reconcile Christian faith and pagan learning in a renewal, this renewal took a reactionary form.

Very few pieces of public sculpture were commissioned during Lorenzo's rule; among them was Benedetto da Maiano's *St John the Baptist* (c. 1476–81). It belonged to an elaborate doorway that he and his brother Giuliano executed for the Sala dei Gigli in the Palazzo Vecchio. Benedetto was trained in the Rossellino shop after working in the family business of inlaying furniture, which contributed to his decorative style. Along with Mino, he was one of the most important sculptors working in the final decades of the century. One of his late masterpieces, the *Altarpiece of the Annunciation* for the Mastrogiudici Chapel in S. Anna dei Lombardi, Naples, is in effect a painted altarpiece turned to stone, replete with a predella and three-dimensional saints in niches. It depends heavily on the nearby *Nativity Altarpiece* by A. Rossellino for the Piccolomini Chapel (1470–75) and, for its perspective, on sacramental tabernacles. Benedetto's terracotta model for the Virgin still exists. Exquisitely decorated, it lacks the psychological interaction in Donatello's depiction of the scene. The relief links the great flowering of marble sculpture at mid-century and Michelangelo,

82

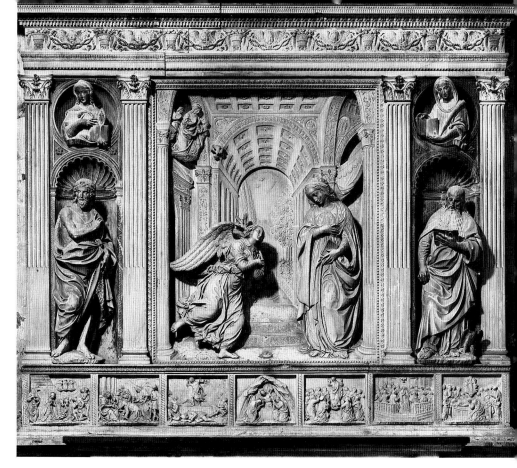

82 Benedetto da Maiano *Altarpiece of the Annunciation* before 1489 (marble). Mastrogiudici Chapel, S. Anna dei Lombardi, Naples

for its modelling and massive forms support the suggestion that Michelangelo worked in Benedetto's shop.

During the late decades of the century Andrea della Robbia (1434–1525) continued his uncle's business in glazed terracotta sculpture. He shared the same furnace and account book up to Luca's death in 1482 but was working autonomously by 1455 and had developed his own traits. The influence of painting can be seen in his characteristically puffy clouds, raised in relief (the sky is a flat azure in Luca's work). Andrea's sky appears in his first dated work, the *Madonna of the Stonemasons*, commissioned by the Arte dei Maestri di Pietra e Legname to replace an earlier work (Andrea served more than thirty times on the

73

council of this guild). The relief was executed in three pieces and the frame in nine. Whereas Luca's Madonnas usually occupy deep space, Andrea's figures hug the surface. Moreover, Andrea's scenes are less abstract and Classical. The recessed border of seraph heads situates the figures in heaven, while the white roses of the floreated frame symbolize the Madonna's purity and contribute to the work's decorative nature. The four medallions inscribe emblems of the guild, elaborating on Luca's earlier coat-of-arms for Or San Michele. Andrea's art fell victim in the 1480s to the demand for replicas. He accelerated production, sometimes at the expense of quality, and was responsible for only the major figures in some pieces (a *modus operandi* also followed by painters). In the 1490s he decorated the Loggia di S. Paolo, attached to the Franciscan hospital of the same name, with roundels of saints and two bust portraits of its director, an unusual commemoration on a public building. The roundels had a propagandistic function, like the babes wrapped in swaddling clothes with outstretched arms on the Ospedale degli Innocenti (*c.* 1487), which were appeals for support in the wake of a scandal about babies' neglect and high mortality rate.

Andrea's son Giovanni was neither as accomplished nor as distinctive an artist as his father. It is therefore not always easy to distinguish his works from those of his atelier, about which virtually nothing is known. His *Lamentation* altarpiece (Bargello, 1514–15), with its blending of traditions from painting and sculpture, creates an overworked and garish effect to modern eyes. It captures the period's mood between the fall of the Medici in 1494 and their re-instatement in 1537. While Giovanni's style was more colourful than Andrea's and the quality of his works uneven, the popularity of his reliefs – produced in collaboration with his two brothers and four sons – continued throughout Tuscany because they were relatively inexpensive and combined the advantages of sculpture and painting. Benedetto Buglioni and his ward, pupil and successor, Santi Buglioni, also manufactured a similar class of ware into the middle of the Cinquecento.

The two major sculptors of the late Quattrocento before Michelangelo were Andrea del Verrocchio and Antonio del Pollaiuolo, both of whom contributed scenes to the prestigious Silver Altar for the Baptistry. Their careers had other parallels, not least a goldsmith background and patronage by the Medici. These two men offered new sculptural energies, although both left Florence in the 1480s, Verrocchio dying in Venice and Pollaiuolo in Rome. Verrocchio abandoned his goldsmithing for lack of work but applied its elegance and principles of design to sculpture. As a painter, he was eclipsed by his pupil,

Leonardo, but he was a gifted sculptor. His marble work grew out of the style of A. Rossellino and Desiderio and his first attributable piece in that medium is a lavabo with Medici emblems for S. Lorenzo, probably ordered by Piero de' Medici around 1465–6. Before 1467, Verrocchio received the commission for Cosimo de' Medici's tomb in the crypt of S. Lorenzo, marked by subtle inlay in the pavement before the main altar (in green serpentine, white marble, red porphyry, the three Medici colours based on those of the theological virtues, and bronze). He quickly became the Medici's favourite sculptor after Donatello. (A useful list of works he executed for them was drawn up in 1496 by his brother.)

Verrocchio's first major sculpture was the tomb of Piero and 74 Giovanni de' Medici, the sons of Cosimo, ordered by Lorenzo and Giuliano. Although related to earlier Florentine sepulchral monuments, it departs from the figured tombs in white marble which had been popular during mid-century. It was made of the same materials as the pavement above Cosimo's tomb to stress the dynasty. Appropriately, it is double-sided – in an arch between the Old Sacristy and the former Chapel of the Sacrament – and thus a signficant step towards a freestanding tomb. A bronze rope grill defines the aperture between the two spaces, an adaptation of the inlaid lattice-work in Rossellino's Cardinal of Portugal tomb and a three-dimensional version of the one 68 painted in P. Pollaiuolo's altarpiece for the same chapel. This motif probably derived from the feature on early Christian Roman tombs and catacombs known as the *fenestella confessionis*. Verrocchio's use suggests a transition between the spaces or from this world to the next. The impressive structure is framed by an elaborate floral border sprouting from *all'antica* funerary vases. At the apex of the arch, a bronze diamond (for the strength, durability and immortality of the Medici) is embedded in a flower. The border contains other emblems such as diamond rings woven throughout the garlands. The porphyry bathtub sarcophagus is encased in spiky but luxuriant bronze acanthus vegetation – resembling goldsmith work – which connotes life and renewal. The lions' feet of the sarcophagus, indebted to the Marsuppini tomb, rest on a marble plinth supported by four tortoises, symbolic of longevity and earthly elements (also part of Cosimo's personal *impresa*). Ostensibly devoid of Christian imagery and lacking much funeral symbolism, the tomb has other dynastic allusions in inscriptions and in four cornucopia of abundance, lush plants and a rosette with a diamond surmounting the sarcophagus. Its understated imagery and elegant decoration are representative of late fifteenth-century art.

Concurrently, Verrocchio was working on his Florentine master-

piece *Christ and Doubting Thomas* for the most important niche of Or San Michele owned by the Mercanzia (merchant's court). He tailored his composition to a niche originally designed by Donatello for a single figure (his *St Louis*). There was no precedent for the subject in the three-dimensional tradition, yet Verrocchio solved the problems magnificently, abandoning symmetry by placing St Thomas on the extreme left, projecting out of the niche. Thus the viewer enters the composition via the diagonal of St Thomas's foot overlapping the ledge. The gestures of the figures inextricably bind them together. Christ's upraised hand is traditional in this scene but Verrocchio has modified it to resemble both a blessing and a baptism. Even the drapery evokes the two personalities: the majestic folds of Christ's garment contrast with the more agitated cloth of the saint who doubted Christ's resurrection. This interest in physiognomy and expressive drapery was passed on to Leonardo. Indeed, there is a striking resemblance between Verrocchio's Christ and Leonardo's in *The Last Supper* (*c*. 1494). It has been suggested that Leonardo worked on Christ's head for the sculpture, although it is

83 Verrocchio *Christ and Doubting Thomas* 1467–83 (bronze, 230 cm, 90½ in). Or San Michele, Florence

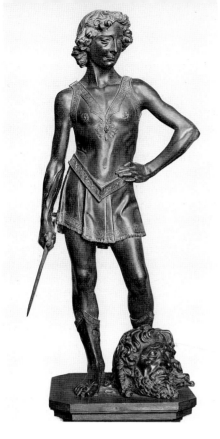

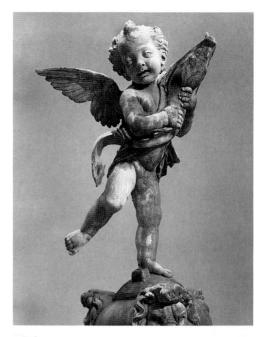

84 (*left*) Verrocchio *David* before 1476
(bronze, 125 cm, 49¼ in)

85 (*above*) Verrocchio *Putto and Dolphin*,
c. 1470 (bronze, 69 cm, 27⅛ in)

more likely that he adapted Verrocchio's type for the painting. Certainly, the Or San Michele group is on the brink of the High Renaissance.

Two undated bronzes for the Medici by Verrocchio are among the most famous works of the late Quattrocento. The *David*, stylistically 84 earlier, was sold by them in 1476 to the Signoria, the ruling body of Florence, and placed in the Palazzo Vecchio, thus gaining a republican meaning similar to Donatello's *David*. There the similarity ends. There 59 is no doubt that Verrocchio's proud hero was capable of slaying the giant. The explicitness and angularity contrast with the ambiguity and sensuousness of Donatello's – nude and vulnerable while Verrocchio's is elegantly clothed. He carries a small sword in one hand and, with his other confidently poised on his hip, looks triumphantly out at the viewer. The figure, to be viewed in the round, lacks the anatomical exaggerations and the psychological implications or complexity of Donatello's. It is, rather, perfectly chased and was meant to be appreciated for its exquisite patina. Verrocchio also designed a

117

85 sculpture with multiple points of view in his *Putto and Dolphin* for a fountain at the Medici villa at Careggi. It is an early example of the resuscitation of the ancient fountain, with water issuing from a spout in the dolphin's mouth. The putto poses in a precarious but graceful arabesque on top of a partial sphere, his body turned in gentle *contrapposto*.

Before he left Florence for Venice, Verrocchio was occupied with the monument to Cardinal Forteguerra in Pistoia Cathedral, the most dramatic sculptural tableau of the century. During this time he continued to explore the lyrical tradition in other projects. By 1486 he

86 had departed permanently to cast his *Colleoni* monument. In 1479 the Venetian authorities had decided to erect a monument to the mercenary Bartolommeo Colleoni of Bergamo who had died in 1475, leaving funds for an equestrian in his honour. He naively stipulated that it be sited in Piazza S. Marco, too prominent a place for this potentially dangerous symbol of power. Instead, the authorities decided cleverly to put it before the remote Scuola di S. Marco. A competition was held and Verrocchio sent a life-size wax model of the horse in 1483. It was unfinished at his death in 1488, although he had completed the figure and horse in clay. In his will, he enjoined his pupil Lorenzo di Credi to finish it, but this responsibility was transferred in 1490 to the Venetian bronze caster Alessandro Leopardi (who designed the base and signed on the horse's girth). Certainly the *Colleoni* invites comparison with its

62 predecessor, Donatello's *Gattamelata* in nearby Padua. The most obvious difference between these images of brute power resides in the torsion of Verrocchio's, Donatello's being confined to a plane. Colleoni stands erect in his stirrups to regard his enemy in violent *contrapposto*, while his horse turns and raises one hoof without support (Verrocchio's is technically more advanced). His war machine, embodying belligerent force, is dressed in contemporary armour, whereas Gattamelata wears pseudo-antique armour. Donatello's image is calm, abstract, dignified and universal; Verrocchio's is specific, vigorous and dynamically active. The grimly determined visage with its furrowed brow, staring eyes and intense expression may have influenced the *terribilità* of Michelangelo's *David*.

Verrocchio's rival in sculpture, Antonio del Pollaiuolo (1431/2–98) – son of a chicken merchant, as his name attests – was trained as a goldsmith, perhaps by Vittorio Ghiberti on the 'Door of Paradise'. Pollaiuolo received a series of commissions in precious metals: the silver crucifix and his relief for the Silver Altar for the Baptistry, a lost tabernacle for the arm of S. Pancrazio. His reputation arose from his ability as a general designer; among his commissions were liturgical

118

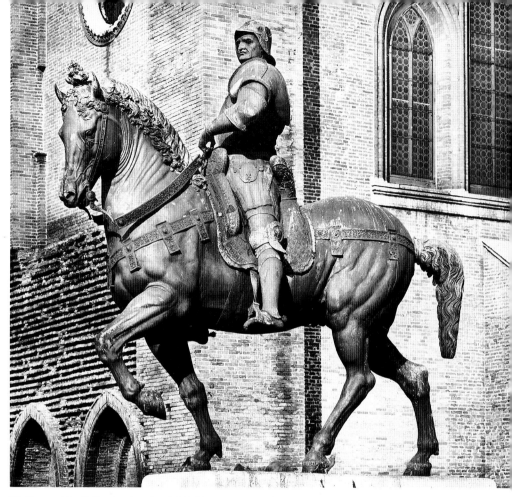

86 Verrocchio *Colleoni* 1481–8/96 (gilded bronze, statue 395 cm, $155\frac{1}{2}$ in). Campo SS. Giovanni e Paolo, Venice

garments and paintings. He seems to have specialized in works featuring wiry, nude figures: his *Battle of the Nudes*, the first signed engraving by an important Italian artist, is a tour-de-force of male anatomy. His first visit to Rome in 1469 and the experience of Classical sculpture were critical to his development. Only two dated, monumental bronze sculptures by him are known, both of which are Roman papal tombs. The first, the *Tomb of Pope Sixtus IV* (1484–93), was awarded to him by Giuliano della Rovere (the Pope's nephew and the future Pope Julius II). It is freestanding, probably influenced by royal tombs the Pope may have seen in France, and has two parts: the

recumbent effigy, whose face is rendered from a death mask, and the base with chamfered sides. The latter has representations of the seven virtues and the liberal arts, the most unusual element of the tomb, although they had appeared earlier on the tomb of Robert of Anjou in Naples. The iconography suggests that the virtues and the liberal arts were bereft at the Pontiff's death, designating Sixtus not only a pope and Franciscan theologian but also a patron of the arts – he commissioned the Sistine Chapel and opened the Vatican Library – who initiated a new golden age. It influenced later tombs, particularly Michelangelo's for Julius II.

88 Virtue figures (possibly executed by Piero, his younger brother) were repeated in Pollaiuolo's second Roman tomb in St Peter's for Pope Innocent VIII (Lorenzo Cibo). In its present form it consists of two parts with the deceased represented twice, alive and dead. The lower section contains the sarcophagus with recumbent effigy, above which is the three-dimensional Pope *in cathedra* bestowing the apostolic blessing, surrounded by reliefs of the four cardinal virtues. On top, a heavy cornice is surmounted by a lunette with the three theological virtues in relief (Charity in a mandorla usurps the traditional place of the Madonna and Child). The tomb seems unresolved, a conclusion supported by two drawings – one from the early sixteenth century by Martin van Heemskerck and an anonymous seventeenth-century sheet – which reveal that the sections of the tomb were originally reversed. Thus the seated figure was on the spectator's level and the effigy and sarcophagus were skied above the heavy cornice, which is now meaningless. The most innovative section is clearly the seated naturalistic Pontiff. First moved in 1507, later dismantled and reconstructed in 1621, the tomb was initially placed near the Ciborium of the Holy Lance and was framed by a unifying triumphal arch with pilasters whose bases were decorated with the Cibo arms. The Pope once held in his left hand the relic of the Holy Lance of Longinus that pierced Christ's side, a personal gift to him. Just as that may commemorate the event of the relic's presentation, so the tomb seems to depend on the temporary monuments constructed in memory of papal visits, which show the Pontiff alive and *in cathedra*.

 Pollaiuolo's background as a goldsmith equipped him to respond to the taste for small bronzes in the last third of the century. The statuettes, frequently patinated to resemble antique bronzes, were meant for the

87 delectation of connoisseurs. Pollaiuolo's bronze *Hercules and Antaeus* demonstrates his knowledge of anatomy (from dissecting corpses) and his ability to represent physical and emotional violence. This, with the bold and free modelling, saves the work from preciosity. The subject

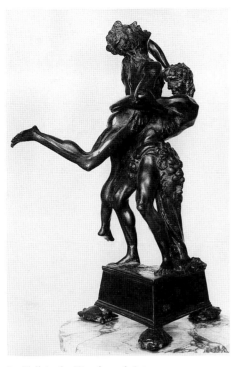

87 Pollaiuolo *Hercules and Antaeus* 1470s (bronze, 45 cm, 17¾ in with base)

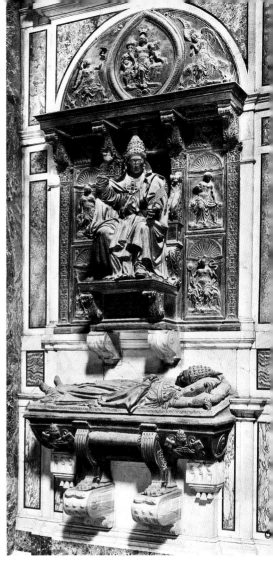

88 Antonio del Pollaiuolo *Tomb of Pope Innocent VIII* 1492–8 (gilded bronze, c. 549 cm, 216 in). St Peter's, Rome

was mentioned by Alberti in *De Statua*, specifically in regard to facial expression, and in *On Painting*. The group was famous in the artist's own lifetime: Leonardo studied it and Michelangelo included a sketch of it on a sheet illustrating bronze casting. It is one of the earliest appearances of a mythological subject in the round. The unusual poses of the protagonists correspond to those painted by Pollaiuolo on a panel in the Uffizi, which is related to a larger lost painting for the Medici Palace. He placed them face to face in mortal combat, not as in ancient

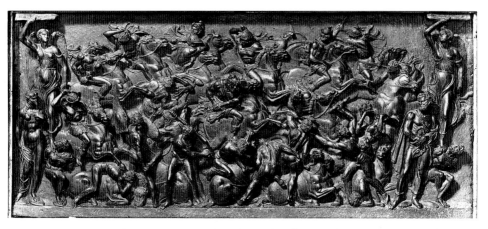

89 Bertoldo di Giovanni *Battle (with Hercules)* after 1478 (bronze, 45 × 99 cm, $17\frac{1}{4}$ × 39 in)

art but as they are described in Lucan's *Pharsalia* and as represented on the Porta della Mandorla. Since Hercules had to lift his foe off the ground to conquer him, Pollaiuolo used Hercules's lion skin, the trophy of an earlier labour, as a prop. Hercules's role as a protector of Florence was confirmed officially as early as 1281, when he appeared on the city's seal. He was significant for the Medici, especially Lorenzo, as he was the protector of the golden apples of the Garden of the Hesperides, associated with the Medici emblem, the *palle* (balls). The statuette was mentioned in the Medici inventory of 1495 and its three tortoise supports, like those of Verrocchio's double tomb, also argue for a Medici commission.

In the late Quattrocento most small bronzes were directly cast and each object was unique. Bertoldo di Giovanni (*c.* 1420–91) – disciple of Donatello and the Medici court artist of the late century (referred to as 'our Bertoldo') – greatly contributed to the vogue for them. He specialized in small bronze sculptures, medals, plaques and reliefs. He also served as 'curator' of the Medici collection of antiquities in their palace and gardens near S. Marco. Bertoldo's role as the reputed teacher of the precocious Michelangelo has tended to eclipse awareness of his art. His bronze *Battle (with Hercules)* relief was recorded in 1492 in Lorenzo's suite in the Medici Palace. Although based partly on a damaged sarcophagus of the second century AD in the Pisan Campo-santo, the piece is no mere copy. It tested his imaginative and technical skills because he had to re-create the missing figures and translate the forms into bronze. In the process, he compressed it and heightened the relief so much that the figures appear almost freestanding, saving it from being an academic exercise. However, the relief intentionally

122

90 Bertoldo di Giovanni, medal of the Pazzi conspiracy, reverse with Giuliano and obverse with Lorenzo, 1478 (bronze, 6.4 cm, 2½ in diameter)

91 (*below*) Bertoldo di Giovanni *Bellerophon and Pegasus* before 1486 (bronze, 32.5 cm, 12⅞ in)

clings to certain conventions of the sarcophagus style, which would have afforded its patron antiquarian pleasure. It has been suggested that Hercules (in the centre, on horse-back with the lion skin and club) was included as a civic protector or as a specific reference to Ercole (Hercules) d'Este of Ferrara, whom Lorenzo made General of the League of States against Naples and Rome in 1478. Bertoldo also executed the famous medal commemorating Giuliano and Lorenzo after the Pazzi conspiracy earlier that year. The obverse depicts Lorenzo, who escaped, and the reverse in a mirror image portrays Giuliano, who was killed in the Duomo during mass on 26 April. Both sides feature eccentrically floating, bust-length portraits (associated with portraits by Botticelli); each is framed by Brunelleschi's temporary wooden choir enclosing the high altar (within which priests celebrated mass, unaware of the intrigue). Its narrative content is

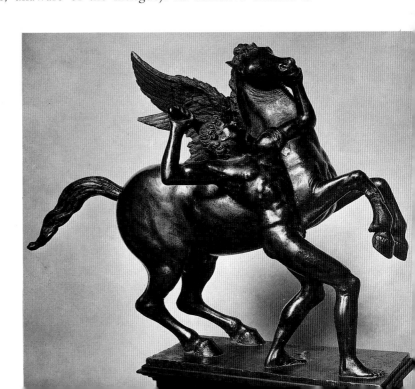

unprecedented in a medal. The vignette below Giuliano depicts his assassination with journalistic exactitude, while the scene under Lorenzo portrays him warding off his attackers and fleeing. These images, commissioned by Lorenzo and widely circulated, fed both Lorenzo's wish to be regarded as saviour of the Republic and the Medici legend in general. Perhaps the flat modelling of the forms was intended by Bertoldo to simulate rubbed ancient coins. The medal was Renaissance political propaganda in the antique mode: the inscription on the obverse expresses gratitude for Lorenzo's survival, that on the reverse connotes mourning.

91 Early in the sixteenth century the Venetian diarist Marcantonio Michiel described Bertoldo's most famous statuette, the *Bellerophon and Pegasus*, in a private house in Padua. Thus it has traditionally been dated to Bertoldo's Paduan period, *c.* 1483–6, although an earlier date has also been proposed. The Greek hero Bellerophon attempting to tame Pegasus before slaying the Chimera (from Pindar's thirteenth *Olympian Ode*) had not been represented since antiquity and is typical of the Renaissance. Bellerophon symbolized courage and Pegasus immortality, although the myth included a warning about excessive pride. The bronze cast in one piece is signed by Bertoldo and inscribed as cast by his disciple Adriano Fiorentino. Its heaviness suggests that holding bronzes was not yet part of Renaissance connoisseurship. The pose is unusual for the myth, coming from a common ancient type, the horse-tamer, whose most imposing representation was in Rome on the Quirinal Hill (Monte Cavallo). Bertoldo probably adapted the motif from a coin or the S. Lorenzo pulpits, on which Vasari relates he assisted Donatello.

From the 1480s Bertoldo seems to have worked on several projects simultaneously, among them the twelve stucco reliefs *all'antica* executed after 1479 for the Palazzo Scala-Gherardesca, Florence. They were derived from the humanist Bartolomeo Scala's own writings and partly based on antiquities in the Medici collection. Bertoldo probably also designed the glazed terracotta frieze for the portico at Poggio a Caiano (Lorenzo's favourite villa, where the sculptor died in 1491), although in translating the artist's wax model into terracotta the Della Robbia shop somewhat obscured the original hand. Installed by 1495, it is the sole architectural sculpture known to have been commissioned directly by Lorenzo. The frieze has much in common with other sculpture from the eleventh hour of the century: small-scale figures, exaggerated postures and ancient motifs. Giuliano da Sangallo, the villa's architect, played a role in its conception and its programme was set by a humanist in Lorenzo's circle, probably the poet Poliziano. Its literary sources include Claudian, Ovid and Hesiod and, like Signorel-

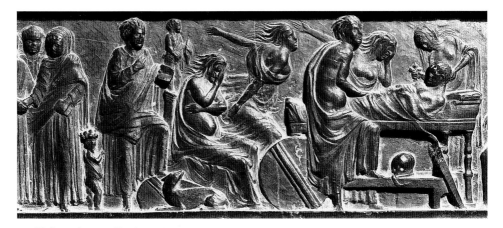

92 Giuliano da Sangallo, frieze detail from the *Tomb of Francesco Sassetti* 1485–90 (*pietra serena*, traces of gilding). S. Trinità, Florence

li's *Pan* (*c.* 1490) and Botticelli's *Primavera* (*c.* 1478), it celebrates country life and pastoral poetry. The theme, with an astrological twist, is the return in spring of the golden age to Florence under Medici rule, a bucolic subject appropriate for the villa where Lorenzo hoped to resuscitate ancient culture.

Giuliano da Sangallo (*c.* 1443–1516), influential in Medici artistic matters (his father was a court musician), is known primarily as an architect; those sculptural programmes associated with him are usually allied with architecture and his sculptural activities remain obscure. One more securely attributed work is the *Tomb of Francesco Sassetti*, a learned manager of the Medici bank, which with its pendant for his wife Nera Corsi Sassetti is in the family chapel in S. Trinità. Both are based on the *arcosolium* type, reflecting Giuliano's experiences in Rome, where he voraciously studied the antique, attempting to penetrate its occult secrets. The simple tombs consist of niches containing elegant black sarcophagi with bucrania. Decorative reliefs in sombre *pietra serena* with touches of gilding frame the niches, among them roundels with a double portrait of the deceased and his wife, Sassetti emblems *all'antica* and narrative friezes including a scene of mourning. Full of pathos, this scene was adapted from a Roman sarcophagus type representing the death of Meleager, an example of which was in Florence. The rough but lively execution and rhetorical gestures echo prototypes in late antiquity and the last works of Donatello and Botticelli.

92

125

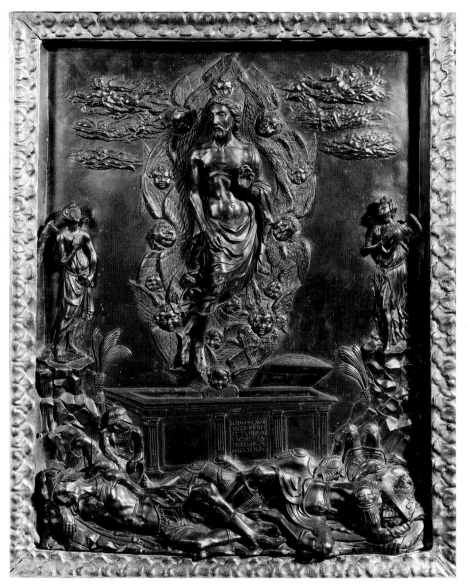

93 Il Vecchietta *Resurrection* 1472 (bronze, 54.3 × 41.2 cm, $21\frac{3}{8} × 16\frac{1}{4}$ in)

Renaissance Fever outside Florence, 1450–1500

A sudden increase in sculptural commissions throughout Italy after 1465 put Florentine sculptors in great demand. They spread the revolutionary Florentine style, which blended with regional styles and ideas, sparking a creative eclecticism.

ROME

The efflorescence of sculptural activity was pronounced in Rome, where the papal court commissioned many works. The architect, theoretician and sculptor Antonio Averlino, called Filarete, who worked on the bronze doors of St Peter's (1445), planted the seeds of the Renaissance Roman school. After him two sculptors rose to prominence: Isaia da Pisa, who worked in Naples on the Castelnuovo *Triumphal Arch of Alfonso I*, and Paolo Taccone (active 1445/51–70), 96 called Paolo Romano, an indigenous sculptor who also worked on the Castelnuovo arch. As with most sculpture of the school, Romano's work reveals the influence of ancient art and, as a result, contains a certain sobriety. During the pontificate of Sixtus IV (1471–84), who brought his antiquities to the Vatican, artists were seduced even more by ancient marbles. Mino da Fiesole resided in Rome at this time, as did Andrea Bregno, the most prolific sculptor there, who designed many tombs and worked on the Piccolomini Altar in Siena Cathedral (*c.* 1481–5). As discussed, the Pollaiuolo brothers also executed papal tombs in Rome.

SIENA

When Donatello departed from Siena, he left one pupil of the first rank, Lorenzo di Pietro, called Il Vecchietta (1410–80), who began and continued as a painter. The colouristic, emotional penchants of Siena can be seen in his polychrome wooden images. True to his pictorial inclinations, Vecchietta gravitated towards bronze. From 1467 to 1472 he worked on the bronze ciborium for the high altar of S. M. della Scala (on the high altar of the Cathedral). Vecchietta's last years were occupied with a memorial chapel for his own interment in the same church, a sign of the high status of artists. The chapel's iconography

concerns the Holy Sacrament and contained an expressionistic freestanding bronze *Risen Christ* on the altar – the first such example as an altarpiece, influential on Michelangelo's work in S. M. Sopra Minerva, Rome – and a painting of the Madonna and Child on the back of the altar. These works demonstrated his prowess in both media (he signed the painting as a sculptor, the sculpture as a painter).

93 A related work, the signed and dated bronze relief *Resurrection*, has a more idealized Christ (rising from a sarcophagus embellished with Classical pilasters within a mandorla of seraphim). Christ is blessing and probably once held the banner of the Resurrection. The sleeping soldiers below lie in contorted postures, ignorant of the miraculous event. The intended position of the relief has not yet been established, although two holes in its surface suggest that it was attached to another object. (Vecchietta had earlier rendered the same scene on a reliquary chest.) The two angels recall Donatello, while the beautiful surface, the misunderstood perspective of the sarcophagus lid and the figures' discrepant scales are International Gothic features also found in Sienese painting. With the subtle rhythm of Christ's steps and the refined burnishing, the relief exemplifies Vecchietta's mastery of delicate grace in the Sienese pictorial mode.

Donatello's presence in Siena from 1457 to 1461 also stimulated two young artists who were trained as painters and sculptors by Vecchietta: Francesco di Giorgio Martini (1439–1501/2) and Neroccio di Landi, who became partners in 1468/9. Francesco – a sculptor, painter and architect – is primarily known for his architectural practice and theory, recorded in a treatise based on Vitruvius. His early wooden sculpture was influenced not only by Vecchietta but also Donatello. He was evidently in great demand, for he entered the service of the Dukes of Urbino and of Alfonso, Duke of Calabria. Francesco was concerned with engineering and other practical problems: after preparing a model for the cupola of Milan Cathedral (1490), where he probably met Leonardo, he submitted a design for the facade of Florence Cathedral (a contest judged by Lorenzo de' Medici). His mature sculpture was in bronze – notably the influential relief of the *Flagellation of Christ*, boldly modelled and typically Sienese in emotion. Two bronze angels holding cornucopia candelabra were commissioned from him for the high altar of Siena Cathedral in 1495; the left angel, superior in conception, is
94 uniquely depicted as though just alighting, its wings in the process of folding. Its feet do not touch the ground but are supported by a small pedestal under the arch of one foot. The luminosity of its face, the flickering reflection of light on its windswept drapery and the tangibility of its wings may show Leonardo's influence.

One of the most bizarre examples of personal aggrandizement, the Tempio Malatestiano in Rimini, was embellished inside by Agostino di 95 Duccio (1418–81). No one knows who trained this distinctive Florentine marble carver, who fled to Venice in 1446 after having been accused of stealing silver from SS. Annunziata. In Rimini, where he remained until 1457, he worked with the medallist Matteo de' Pasti. Back in Florence he received the commission for a 'giant' in marble for the Duomo to rival Donatello's terracotta colossus. In August 1464 he was given the marble but by December had abandoned the project for unknown reasons. His Riminese patron – Sigismondo Malatesta, successful mercenary and tyrannical lord of Rimini – transformed a Gothic Franciscan church into a secular 'temple' (Alberti's word for church) where he and his mistress – the witty and beautiful Isotta degli Atti – were buried in courtly fashion. With the Tempio Malatestiano, its facade modelled on the Roman Arch of Augustus at Rimini, the

94 (*below*) Francesco di Giorgio Martini, angel for the High Altar, 1495–7 (bronze, 124 cm, 48⅞ in). Cathedral, Siena

95 (*right*) Agostino di Duccio, 'Saturn', *c.* 1456 (marble). Tempio Malatestiano, Rimini

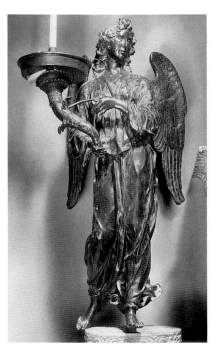

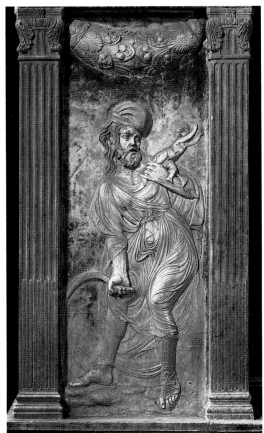

funerary monument or mausoleum became so grand that it engulfed the entire edifice. Malatesta, the only living person publically consigned to Hell by the Pope (one of his wives was smothered or poisoned), has largely been remembered for his alleged depravities. His humanist aspirations seemingly knew no bounds: he removed the remains of the Neo-Platonist Gemistus Pletho from Greece to be buried within the lateral arches and used marble stripped from S. Apollinare in Classe at Ravenna. He hired the most distinguished architect, Alberti, and De' Pasti, who preserved the unfinished project in a medal of 1450, has been credited with supervising the interior of this transvestite building. It is impossible to discuss fully the esoteric interior, one of the most richly sculpted in all Italy. The eight chapels glorify and immortalize Sigismondo, his ancestors and the 'divine' Isotta, whom he eventually married. The idiosyncratic ideas amalgamate Neo-Platonic with Christian and pagan elements. Agostino's style can be connected to the Rossellino brothers and Desiderio, although it is more obsessively linear: the wiry lines form whiplash curves which became pronounced after the sculptor left Florence. For example, in a relief of the Roman god Saturn, who holds the scythe with which he castrated his father and is about to eat his children, the drapery creates an exquisite pattern without a physical rationale. This

95

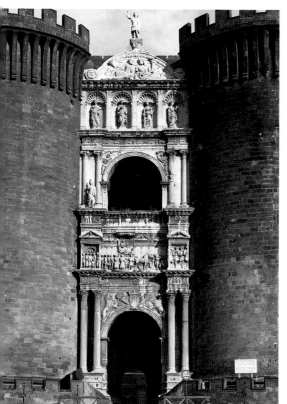

96 Francesco Laurana *Triumphal Arch of Alfonso I* 1453–68 (marble). Castelnuovo, Naples

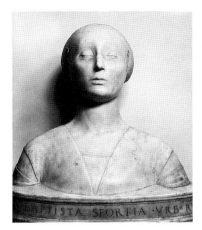
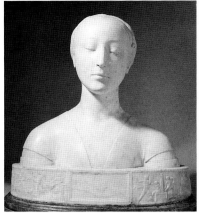

97 Laurana *Battista Sforza*, *c.* 1474 (marble, 50.8 cm, 20 in)

98 Laurana *Portrait of a Woman*, *c.* 1472–4 (marble, traces of pigment, 46.6 cm, 18⅜ in)

99 Laurana *Death-mask of a Woman* (Battista Sforza?) 1472? (terracotta, traces of paint, 34.5 cm, 13½ in)

surface quality bestows an otherworldly, timeless effect on the flat reliefs that harmonizes with the interior's Neo-Platonic content.

NAPLES

During the 1450s Naples, ruled by the Aragonese dynasty, was a great centre for sculpture. Francesco Laurana (*c.* 1430–1502?) was born at Vrana in Dalmatia and may have worked on the Tempio Malatestiano; his name first appears in 1453 in connection with the *Triumphal Arch of Alfonso I*, the gateway to the Castelnuovo. Two superimposed arches in six registers, between two towers of the castle, combined Roman triumphal and funerary imagery with Christian elements and historical and heraldic devices of Alfonso I (Alfonso V of Spain who moved his court to Naples) and his illegitimate son and successor Ferrante I. Its complexity is explained by its tripartite function – a triumphal monument, a castle gate and a cenotaph. No one artist was responsible for all of it: documents record Laurana working with Pietro da Milano, Paolo Romano and at least thirty-three assistants. The figures increase in size as they ascend and there were later accretions. The arch lacks its crowning saints and equestrian, although the upper part includes the tomb of Parthenope, the first queen of Naples, and a container with Alfonso's heart. Its propagandistic message proclaims Alfonso's policy of clemency towards his polyglot empire and the legitimization of Ferrante is backed up by Hadrianic quotations. The most prominent section is the relief depicting Alfonso's triumphal entry into Naples in 1443.

96

131

Laurana was an international sculptor. From 1461 until 1466 he worked in France; in 1467 he travelled to Sicily, where he worked on the Mastrantonio Chapel in S. Francesco, Palermo, and before his death in France he was employed in Marseilles and Avignon. His stylized and hypnotically ethereal portraits of women are related to earlier Florentine busts but are even more idealized. All share certain physical characteristics – frontality, rounded faces with high cheek-bones and eyes with heavy lids – which reflect an unrelenting abstraction based on geometric forms that keep individual traits to a minimum. This approach can partly be explained by a generalizing trend in Dalmatian sculpture. Laurana's haunting portraits embody the aristocratic feminine ideal. Of the nine surviving busts by him, only two are inscribed with the sitters' names (Beatrice of Aragon and Battista Sforza) and only two more can be identified with any certainty. Thus dating is

97 problematic and pivots on changes in costume. The portrait of Battista Sforza, the wife of Federigo da Montefeltro, is identified by an inscription on the base; her features are recorded in the profile painting by Piero della Francesca in the Uffizi, which contains a similar geometry. Laurana's bust may have been posthumous (she died in 1472 in childbirth) and modelled on a death-mask. A cast from an original

99 mould of a death-mask is believed to show the Duchess's face in *rigor mortis*; this galvanizing mask reveals the extent of Laurana's idealism. The metamorphosis from the mask to the purity and perfection of the highly polished marble does not obscure her strong character. Less

98 securely identified is the bust with a French provenance; it is carved in one piece and has a deep hollow, projecting base with a tablet for an inscription (Frick, New York). Like others by Laurana, it may have been polychromed because the lips have traces of pink pigment. The nose is restored and the eyelids chipped. The sitter has most often been identified as Ippolita Maria Sforza, who married Alfonso, Duke of Calabria in 1465. It is not known whether two nearly identical busts with mythological reliefs commemorate the same woman or were generic portraits representing idealized beauty (indicated by their uninscribed tablets) or belonged to the same context. The relief subjects on the Frick bust are probably allegories of chastity and feminine virtue, perhaps from Classical literary and visual sources. They are comparable to the triumph of chastity on the back of Piero della Francesca's portrait of Battista Sforza.

CENTRAL ITALY

The sculptural vocabulary of the late Quattrocento outside Florence
100 was often an innovative mixture, as in the *Monument of Maria Pereira*

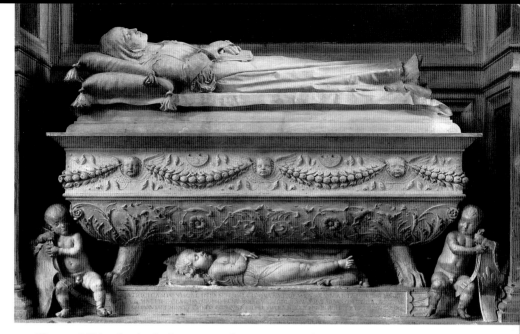

100 Silvestro dell'Aquila, detail of *Monument of Maria Pereira and Beatrice Camponeschi*, c. 1490–1500 (marble). S. Bernardino, Aquila

and Beatrice Camponeschi by the Abruzzese sculptor Silvestro di Giacomo da Sulmona, called Silvestro dell'Aquila (active 1471–1504), with its Tuscan and Roman elements. The carving style and certain details are indebted to Desiderio's Marsuppini monument but the artistic origins of Silvestro, the most significant sculptor of Aquila at the time, are obscure. The double effigy with the poignant representation of the child placed like an after-thought beneath her mother's bathtub sarcophagus, as though in a truckle bed, is unique. According to the inscription, the tomb was commissioned by Maria (of the Aragonese royal family) for her daughter who died aged fifteen months. Its beautiful carving and lyrical forms render the transitoriness of life even sadder. Beatrice Camponeschi's death came at a time when infant mortality was higher than survival. Since the concept of childhood had not yet emerged, it is not strange that Beatrice's effigy mirrors her mother's posture. Although it is usually claimed that dead children were first represented (with their parents) in the sixteenth century, this tomb provides an earlier example. Silvestro's effigy of Beatrice suggests that children's deaths were no longer considered inevitable and that their lives and immortal souls were important.

Around 1463 the itinerant sculptor Nicola d'Apulia, later known as Niccolò dell'Arca (c. 1435–94), arrived in Bologna. He was probably a

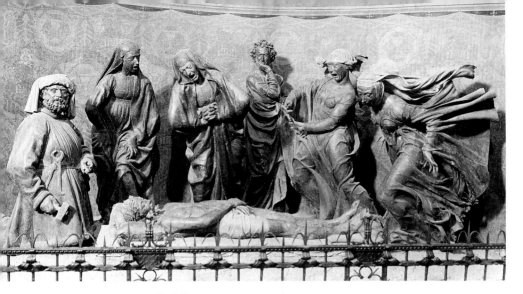

101 Niccolò dell'Arca *Lamentation of the Dead Christ* 1463–85? (painted terracotta). S. M. della Vita, Bologna

native of Bari, his nickname deriving from his work on the shrine (*arca*) of St Dominic, begun by N. Pisano. His small-scale marble sculptures for the shrine have a quirky presence and reveal a Burgundian influence, perhaps via ivories. Some of their characteristics hint at the expressive side of this reputedly temperamental sculptor. His best-known work is a large terracotta ensemble lamenting the dead Christ in Bologna. In function it paralleled Franciscan meditations in which the worshipper merged personal sorrow with the collective Christian body, becoming a participant in Christ's death. Niccolò's authorship is attested by an inscription but the date is debated. If the earlier date of 1463 is correct, it would predate the popularity of the scene in painting as well as terracotta (especially one by Mazzoni of 1478). Originally, the group may have been more compressed, according to computer analysis of the postures, and perhaps once there was also a Joseph of Arimathea figure. Appropriate for its site – a hospital church witnessing suffering and death – the ensemble was the focus of meditation and prayers, which may partly explain its extraordinary power. The extreme pathos of the mourners, except for the impassive Nicodemus (perhaps the donor), is unprecedented in large-scale Italian art. The two Maries rush in to view the body, their intense grief physically expressed, their drapery frozen in space and time. This *tour-de-force* treatment of drapery would be impossible without terracotta, which Niccolò explored to the full. The work, resembling a *tableau vivant*,

101

134

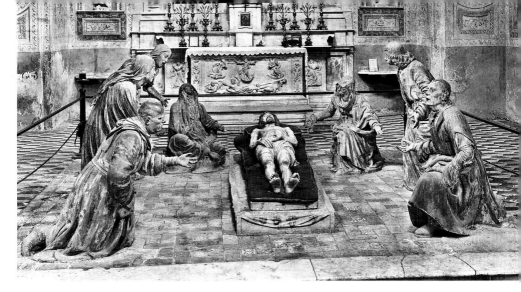

102 Guido Mazzoni *Lamentation of the Dead Christ* 1490–92 (painted terracotta). S. Anna dei Lombardi, Naples

may have been influenced by contemporary religious dramas and is one of many northern Italian Renaissance Lamentation groups.

Guido Mazzoni (active 1473–1518), born in Emilia-Romagna, produced a number of terracotta groups following his first known *Lamentation* of 1478. At Naples in 1492 he modelled one (now restored) which includes a portrait of its patron Alfonso II – bald with bushy eyebrows – among the mourners. His presence transforms the group into an *ex voto*. Mazzoni has replaced the expressionistic movement of Dell'Arca with unrelenting realism, an extreme of the *quattrocento* desire to equal nature. His hyper-realism is due in part to his training as a mask-maker; it is known that Mazzoni expanded the technique to include casting body parts. However, exposure to Florentine artists like Verrocchio *en route* to Naples tempered his realism. In 1495 Mazzoni was one of the first Italians to be lured to France under Charles VIII. The French were soon enamoured of the Italian Renaissance and began importing artists on a regular basis.

102

LOMBARDY

In Lombardy, the most culturally active part of northern Italy at this period, a different taste had developed due partly to the region's proximity to transalpine countries. French and German artists, who had worked on the Milan Duomo (begun in 1387), mixed with local workers to forge a style characterized by dense, overall surface

ornamentation and polychromy. They were not so much concerned with the beauty of proportion as with total decorative enrichment incorporating a Classical vocabulary. In the city of Pavia near Milan in 1396 Gian Galeazzo Visconti had founded the Certosa, a Carthusian complex, which became the site of intense sculptural activity after 1460. (Duke Francesco Sforza enticed the architect/sculptor/goldsmith Filarete to Pavia between 1451 and 1465, a significant influence on Lombard sculpture.) Many sculptors embellished the courtly monastery with terracotta and marble, including Antonio Rizzo, Cristoforo and Antonio Mantegazza and Giovanni Antonio Amadeo (1447–1522). Amadeo, born in Pavia, was given joint responsibility with the Mantegazza brothers for the decoration of the wedding-cake facade in 1474. A more measured Lombard facade by Amadeo and his shop can be found on the Colleoni Chapel in Bergamo, a burial chapel attached to S. M. Maggiore for the *condottiere* of Verrocchio's equestrian. Having carved the tomb for Colleoni's daughter Medea, Amadeo began work on the chapel as sculptor and architect in 1472, finishing the facade in 1476 and the interior later. The completely decorated surface functions as an ornamental screen and typifies the Lombard aesthetic with its inlaid polychromy of red, black and white marble punctuated by rich carving.

Cristoforo Solari (active 1489–1520), called Il Gobbo ('the hunchback'), was descended from generations of Pavian sculptor/architects and succeeded Amadeo as architect of Milan Cathedral. Solari's name first appears in Venice around 1489 but soon after he returned to Lombardy to become Ducal Sculptor. In 1497, after the death of Beatrice d'Este in childbirth, her husband Lodovico Sforza commissioned Solari to carve her tomb for S. M. delle Grazie. There must have been a pendant for Lodovico, although no evidence exists for it. Today, two effigies remain, largely completed before the flight of the nefarious Lodovico in 1499. Beatrice's tomb, dismantled in 1564, once reputedly also contained a representation of the Pietà. In 1891 the two effigies were installed in the Certosa, where they are seen from above. They belong to an international type for royal tombs and their weightiness and verism approach the High Renaissance. Their naturalistic detail – the fussiness of the drapery and rippling palls – is intensified by a highly polished surface. Solari's forte is evident in the two faces, which parallel the portraits painted by Boltraffio and Leonardo.

A very different portrait of Beatrice d'Este was sculpted by Gian Cristoforo Romano (before 1470–1512). Romano, a pupil of Bregno in Rome, was first employed in Ferrara and travelled to Pavia to work

103

104

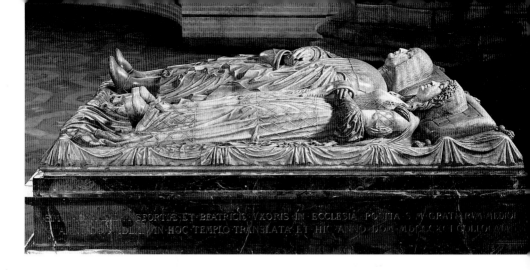

on the Certosa. He precipitated a change in Lombard sculpture, influenced by his own courtly style indebted to Roman imperial art. In contrast to Solari's massiveness, Romano's bust is delicate and quattrocentesque in its pristine idealism. It depicts the Renaissance princess from Ferrara, who was betrothed at five and married at fifteen, as still a child. Presumably she is portrayed during her betrothal, because the inscription terms her the daughter of Ercole d'Este. She tried to compensate for an unsatisfactory marriage by transforming Milan into a cultural centre of great distinction but her influence, like her life, was transitory. Romano acknowledges but restrains the fussy Lombard taste in the decorative detail of the costume and head-dress. The D'Este *impresa* on her bodice is complemented by the knot patterns resembling cryptic designs by Leonardo. Her intricate coiffure terminates in a long braid, neatly bound with ribbons, which falls down

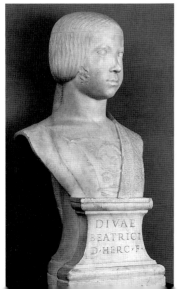

103 (*above*) Cristoforo Solari *Effigies of Lodo-vico Sforza and Beatrice d'Este*, *c.* 1497 (marble, 185 cm, 72$\frac{7}{8}$ in length). Certosa, Pavia

104 Gian Cristoforo Romano *Beatrice d'Este*, *c.* 1490 (marble, 59 cm, 23$\frac{1}{4}$ in)

137

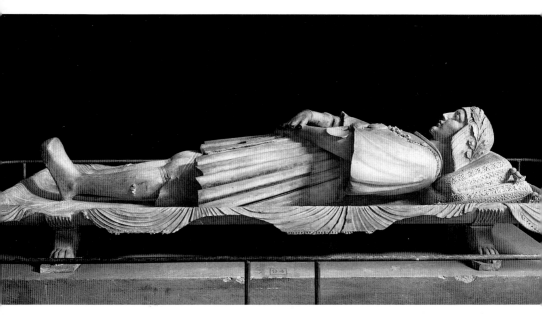

105 Agostino Busti, Il Bambaia *Effigy of Gaston de Foix*, *c.* 1515–22 (marble, 216 × 84 cm,
85 × 33⅛ in)

105 her back like a plumb line. Romano's influence can be seen on the
sculptor Agostino Busti (1483–1548), called Bambaia, in the *Effigy of
Gaston de Foix* (died 1512 in the Battle of Ravenna) from an unfinished
tomb. Gaston, the French hero and nephew of Louis XII, controlled
Milan briefly with Gian Giacomo Trivulzio in 1511.

PADUA

During the last third of the century various sculptors of small bronzes
who had been influenced by Donatello worked in Padua and Venice,
including Bartolomeo Bellano, a contributor to the S. Lorenzo pulpits.
He was engaged on projects in Padua such as the reliefs for the choir
screen of S. Antonio and a David statuette (Philadelphia). In 1504
Pomponius Gauricus in *De Sculptura* chastized him as a 'clumsy
craftsman', perhaps because his bronzes were by that time technically
outmoded. Bellano's pupil Andrea Briosco (*c.* 1460/70–1532), some-
times termed Crispus or Riccio ('curly-haired'), was one of the greatest
bronzists of the early sixteenth century, although his types and
techniques are largely late fifteenth. Gauricus relates that he was trained
as a goldsmith and sculptor in terracotta. He was able to master detail

138

while endowing statuettes with monumentality and considerable charm. They amalgamate Florentine and Paduan traits, which may be partly explained by a Florentine visit in 1480. Riccio's oeuvre is smaller than previously believed and many problems of attribution remain. His superb bronzes with subtly worked surfaces are unique, and were directly cast using a modelled core, a technical innovation. There are also versions of his originals cast with pre-formed cores. His statuettes were imitated in copies and pastiches.

Riccio's success was due not only to technical mastery but also to his eloquent integration of humanist ideals. He was able to evoke poetically the world of pagan mythology (but his sources need to be explored further). The bronzes parallel concepts found in contemporary literature such as the *Hypnerotomachia Polifili* (*The Dream of Polyphilus*), a popular, illustrated philosophical romance by Francesco Colonna, published in Venice in 1499. In 1506 a paschal candelabrum, perhaps Riccio's masterpiece, was ordered for S. Antonio, probably at the instigation of the philosopher Giovanni Battista Leone. Its tall format has been allied to the illustration of an obelisk in the *Hypnerotomachia* and its exquisitely chased wild mixture of Christian and pagan motifs expresses the Classicizing ethos. In fact, Riccio bestowed on the satyr a popularity it never enjoyed in antiquity. Perhaps it was Neo-Platonism that encouraged interest in this primitive being, considered to be at the mercy of his untamed appetites, as in *Satyr with an Amphora and Shell*, used as a candle-holder. Riccio's bronzes 106 frequently include comic or playful elements, as well as an elegaic, arcadian mood appropriate to his pastoral figures. He celebrated the exploits of heroes – *Warrior on Horseback* (London) – and produced decorative plaquettes, all enlivened by a masterful approach to texture and rich patination. It is no wonder that Riccio's pieces spawned a whole school of bronzists including Severo Calzetta da Ravenna and Agostino Zoppo. His epitaph fittingly concludes that his 'works came closest to the glory of the ancients'.

It is Pier Jacopo Alari Bonacolsi (*c.* 1460?–1528), aptly called Antico, who created the most technically advanced bronzes of the period. Probably born in Mantua, Antico was a court artist who spent his life working for the Gonzaga family as a goldsmith and sculptor of elegant bronze reductions of large-scale ancient marbles. He was among the strictest of the Classicizing artists of the late Quattrocento, continuing the tradition of Mantegna that catered to Mantuan humanism and restoring antiquities, such as the Dioscuri of the Quirinale. It is not known where he trained but by the 1480s he had already made a Classicizing vessel as well as statuettes of Meleager, Hercules and Marcus

106 Andrea Briosco, Il Riccio *Satyr with an Amphora and Shell* (bronze, 20 cm, 7⅞ in)

107 Pier Jacopo Alari Bonacolsi, Antico *Hercules and the Lernaean Hydra* 1490s (parcel-gilt bronze, 32.7 cm, 12⅞ in diameter)

Aurelius. Around 1500 he worked for Isabella d'Este and became her artistic adviser and friend after Mantegna's death in 1506. Antico's statuettes are both more monumental and archaeologically oriented than Riccio's and are sumptuously finished and frequently gilded. He was the first sculptor to realize the advantages of casting replicas of his bronzes and thus marks a turning-point in Western sculpture. He invented or mastered indirect casting to preserve his original models of wax on wire armatures. This process consisted of piece-moulding the models, from which hollow wax casts were produced. They were filled with a plaster core and an exterior mould of plaster and sand was made. The lost-wax process with molten metal followed, after which the piece was chased and finished. The models and piece-moulds could be re-used repeatedly. It is believed that Antico developed the method while working with precious metals in order to conserve material. With this innovation he established the supremacy of the north in casting: a comparable technique was not used in central Italy until the end of the Cinquecento by Giambologna and Antonio Susini. Antico also produced other bronze objects, including a series of roundels depicting the exploits of Hercules. Two parcel-gilt examples from the

107 D'Este collection survive, one of *Hercules and the Lernaean Hydra*, the other with the Nemean Lion. Since Hercules was a popular d'Este name, and since they seem to date stylistically from the late fifteenth century, the roundels have been linked with Ercole I, who died in 1505.

VENICE

The Renaissance arrived late in the Venetian Lagoon, where artists still operated in medieval workshops and were influenced by Gothic forms and Lombard sculptors through the middle of the Quattrocento. This trend continued with the work of the Bon family and their associate Antonio Bregno (active 1425–after 1457), who came from near Como perhaps in the 1420s to work on the Ca' d'Oro. The once painted and gilded monument to Doge Francesco Foscari (died 1457) in S. M. *108* Gloriosa dei Frari is a transitional work and was later altered. Antonio's brother Paolo, an architect, probably collaborated on the project, which has also been attributed to Niccolò di Giovanni Fiorentino. With its carved canopy it depends on both Lamberti's tomb of Foscari's predecessor, Doge Mocenigo, and Nanni di Bartolo's Brenzoni *46,47* monument. The Classicizing vocabulary has warriors *all'antica* bearing Foscari arms standing on top of Corinthian columns and introduces in Venice the Florentine idea that a tomb should be a self-contained architectural unit. Venetian wall tombs were subsequently built on a scale unmatched in Italy and are thus frequently regarded as architecture. Permission for interment in a Venetian church was difficult to obtain so the deceased was often not buried on the site. Consequently the Venetians stressed perpetuation of fame rather than salvation in their memorials. Bregno was also responsible for the Foscari Arch (1423–85), a crucible of Venetian architecture and

108 Antonio Bregno *Monument of Francesco Foscari* after 1466 (limestone). S. M. Gloriosa dei Frari, Venice

sculpture in the Palazzo Ducale courtyard. He worked on the structure with Antonio Rizzo (active 1465–99/1500), also from the Bon workshop.

A native of Verona, Rizzo was first noted working at the Certosa of Pavia in 1465 and soon afterwards in Venice. After his patron Doge Barbarigo was disgraced in 1495, he too fell on bad times: caught embezzling from palace funds in 1498 and forced to flee the city, his name was suppressed and his works confused with those of Bregno. From the 1460s Venetians began to glorify the Doge as the embodiment of the state, as shown by Rizzo's *Monument of Niccolò Tron* in S. M. Gloriosa dei Frari, commissioned by Tron's son. This eclectic but novel memorial, arranged in five registers, reveals not only Rizzo's taste for elaborate design but also his training as a sculptor and lack of familiarity with architectural principles. It incorporated the Venetian taste for tripartite horizontal organization and was built opposite the Foscari monument, which it dwarfed. In the years separating the two, Gothic features have been more or less purged from the Tron 'tomb'

110

(he is buried under the floor) which, at first glance, seems to contain a Renaissance repertory of motifs. However, a Lombard exuberance, uncurbed by central Italian standards, is reminiscent of Gothic taste. The vast assemblage of 26 figures on 4 different scales is by various hands. Some 20 in the upper zone make it appear top-heavy and the 7 virtues on the fourth level in white Carrara marble, against the frame's duller Istrian stone, seem to dominate. Except for the curving entablature, all the elements are small, giving a busy, composite effect. The entire memorial is surrounded by a red frescoed curtain, which harmonized with the once heavily painted and gilded sculptures. It seems to have borrowed its format from elaborate painted polyptychs like those by the Venetian Bellini and Vivarini families. The portly Doge with rather coarse features appears twice, in a recumbent and a standing effigy, flanked by Charity and Prudence (the only figures

110 (*right*) A. Rizzo *Monument of Niccolò Tron* begun 1476 (marble). S. M. Gloriosa dei Frari, Venice

109 (*below*) Antonio Rizzo *Eve*, from the Foscari Arch, *c.* 1485 (marble, 204 cm, 80$\frac{3}{8}$ in). Palazzo Ducale, Venice

universally attributed to Rizzo). The latter, animated effigy influenced later Venetian memorials. Despite its anti-architectonic qualities – no logical support and a feeling of agglomeration – the whole achieves a monumentality knit together by the repeated arch.

Rizzo was the architect and sculptor in charge of the second phase of the Foscari Arch (1478–85). (He became Protomagister of the Palazzo Ducale in 1483, refurbishing it after a devastating fire.) While supervising the arch, he contributed only two sculptures – the *Adam* and *Eve*, which originally stood in lower niches of the main facade. Traces of priming suggest that the figures were painted to imitate bronze. They attempt to conceal their nudity with leaves and Eve with a *Venus pudica* pose. Both hold the forbidden fruit, indicating that the Fall has occurred and they have become aware of their human condition. The *Adam* is related to works by A. Rossellino and Mantegna, while the *Eve* reflects northern somatic types rather than the more idealized forms of antiquity and central Italy and is almost identical to a nude in a painting by Giovanni Bellini (Accademia, Venice). Rizzo, indeed, worked from the drawings of Giovanni's brother Gentile.

Pietro Lombardo (*c.* 1435–1515) came from Lombardy (as his name implies) and was a sculptor/architect. He is mentioned in Bologna and Padua and is thought to have been in Florence during the 1460s because a strong Florentine influence persisted in his work. With his sons and his workshop, Pietro was responsible for many tombs during the last quarter of the century. All are based on the triumphal arch more emphatically articulated than in Rizzo's Tron monument. After Rizzo's flight in 1498, Pietro became Protomagister of the Palazzo Ducale, a post he retained until his death. His *Monument of Pietro Mocenigo* in SS. Giovanni e Paolo (restored in 1984) bears some relationship to Rizzo's Tron monument but has more thoroughly digested ancient sources and treats secular subjects with greater ease. Its lower reliefs, two Labours of Hercules and military trophies, and the sarcophagus reliefs of Venetian victories *all'antica* praise Mocenigo as a Roman hero, astutely declaring on the sarcophagus in Latin, 'from the booty of the enemy', to show that state funds were not used. Such thematic treatments, previously ignored in Venetian sculpture, were established by Pietro. The effigy of the deceased Doge, in full armour beneath his state cloak, originally held a banner in triumph, like a resurrected Christ, a theme echoed at the top by the Risen Christ figure. The number three is a leitmotif, harmonizing and unifying the monument, which has balanced architecture and sculpture.

The Venetian funerary triumphal arch format reached maturity with

111 Pietro Lombardo *Monument of Pietro Mocenigo* 1476–81 (Istrian stone and marble). SS. Giovanni e Paolo, Venice

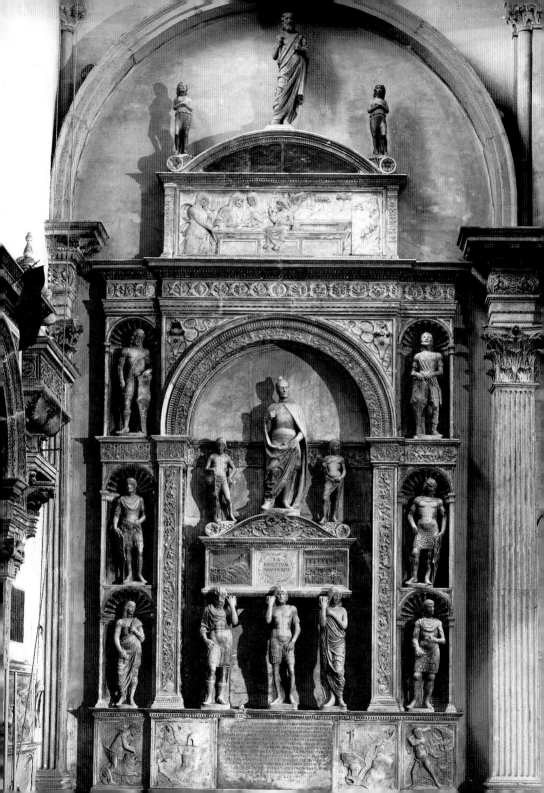

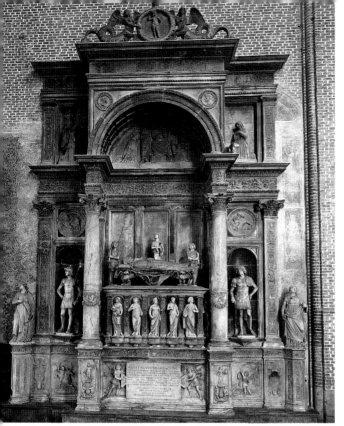

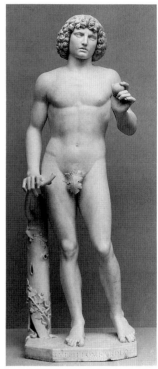

112, 113 Tullio Lombardo *Monument of Andrea Vendramin, c.* 1480–95 (marble). SS. Giovanni e Paolo, Venice. Detail: *Adam* (193 cm, 76 in)

112 the *Monument of Andrea Vendramin*, erected in S. M. dei Servi by Pietro Lombardo and his son Tullio (*c.* 1455–1532) but dismantled by Napoleon in 1810 and re-erected in 1816 in SS. Giovanni e Paolo. In 1819 the nude figures of *Adam* and *Eve* (known only in a copy), originally in the lower niches, were transferred to the Palazzo Vendramin. Antique principles were now purged of Lombard fussiness, and its Classicism was planned rather than improvised as in the Tron monument. Since it is the first time that Tullio is separately identified, it is tempting to attribute this clarity to him. The Classicism, however, does not fully explain the medallions, quoted from the Arch of Constantine, which were probably added at Vendramin's request, for he had been ambassador to Rome under Paul II. Their subjects – Nessus and Dejaniera and Perseus and Medusa – are blatantly mythological and moralizing. The extent of Tullio's Classicism can be

seen best in his *Adam*. The first Venetian artist to absorb himself in *113*
Classical style and imagery, he is known to have restored antiquities and
Michiel implies that he collected them. The black marble of *Adam*'s
original niche would have accentuated the nude's stark whiteness,
shocking in the context of Venetian tradition. The statue reveals a basic
unfamiliarity with the human body and its proportions but still
manages to seem convincing. It is an early Venetian example of the
sensuous nude, which appears in early *cinquecento* Venetian painting
with Giorgione and Titian. The tomb is crowned by a tondo with a
Christ Child supported by mermaids with front legs and wings, a
Venetian whimsicality. The monument was admired by Gauricus, who
considered Tullio the finest marble sculptor in Venice.

Tullio is also credited with two bust-length reliefs of male and female
figures inspired by sculpted Roman and painted Northern and Italian
double portraits (such as works by Lotto and Jacopo Bellini). They are
depicted semi-nude *all'antica*, which removes them to an idealized,
mythological realm. It has been suggested that the more three-
dimensional relief, signed *TVLLIVS LOMBARDVS F.*, influenced a *114*
woodcut illustration of a funeral memorial to two lovers, Sertullius and
Rancilia, in Colonna's *Hypnerotomachia*. The name of the man – 'Ser
Tullius' – was a play on Tullio, who was probably a friend of the
author. The relief's format – busts on a plinth inscribed like a Roman
funeral marker – resembles several paintings attributed to Giorgione
and Titian. Stylistically and typologically, the man is close to one of the
flanking warriors of the Vendramin monument, which has been *112*

114 T. Lombardo *Self-portrait (?)*
with his Wife in Ancient Guise 1490–1510
(marble, 47 × 50 cm, 18½ × 19⅝ in)

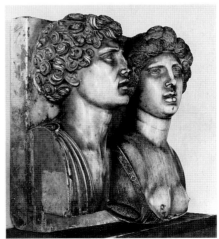

proposed as a self-portrait. Like freestanding portrait busts, the relief was probably commemorative, perhaps with a matrimonial twist. On the basis of the vine wreath worn by the man in the other relief (Vienna), it has been identified as Bacchus and Ariadne, or a couple in the guise of the two mythological lovers. Both reliefs have the enigmatic quality found in Giorgione's roughly contemporary paintings.

After 1485 Tullio also worked on the monument to Doge Giovanni Mocenigo (son of Pietro) in SS. Giovanni e Paolo and on a series of marble reliefs for the Chapel of St Anthony in Padua, with other sculptors. He executed the expressive scenes of the Miracle of the Miser's Heart and the Miracle of the Repentant Youth, filled with emotion and smoothly animated movement. His younger brother Antonio (c. 1458–c. 1516) participated in the same series, contributing the Miracle of the New-Born Child, which by comparison seems staid, more rigidly Classical and less deeply carved. Like his brother, Antonio was intensely involved with the antique, as shown by his adaptation of an ancient statue for a figure on the Vendramin monument. Antonio's works are not as well documented as those of his father and brother but it is known that he also contributed to the Zen Chapel in S. Marco. After 1506 he worked in Ferrara, executing exquisite carvings for the so-called Camerino d'Alabastro, Studio di Marmo and other rooms in the palace complex of Alfonso I d'Este. Two mythological reliefs reveal his type of Classicism in style and content: one represents the contest
115 between Minerva and Neptune for Attica and the other Vulcan's Forge, with a quotation of the *Laocoön*.

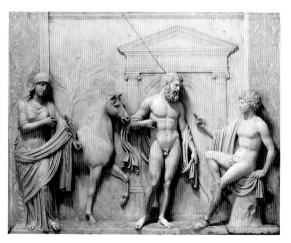

115 Antonio Lombardo *Contest between Minerva and Neptune*, c. 1508 (marble, 83 × 107 cm, $32\frac{5}{8} \times 42\frac{1}{8}$ in)

The High Renaissance

Did the High Renaissance ever exist? The term is artifical, a qualitative judgment of 'High' signifying the best. Such terms are inventions of historians, tools to help them grapple with chaotic data. Vasari divided the Renaissance into three stages, the last of which he thought the finest. He viewed the 'universal man' Leonardo as its initiator and Michelangelo, who surpassed the ancients, as its apogee. 'High Renaissance' has been synonymous with the early sixteenth century, ending in 1520 with Raphael's death or the Sack of Rome in 1527, but no cut-off point exists. It is also difficult to find a starting point for the hypothetical period and the term cannot account for artists like Michelangelo. Patronage was integral to the style, which surfaced first in Florence and quickly flourished in papal Rome and the secure Venetian Lagoon. By the end of the Quattrocento Italian artists had achieved mastery in rendering the natural world. In the High Renaissance, themes which had been explored for centuries – the portrait, the Adoration of the Magi, the Madonna and Child – were treated with technical assurance, sophistication, breadth, monumentality and artful simplicity. The artist, now linked to the liberal arts, was compared to God and God to an artist, so that Vasari could call Michelangelo *Il Divino*. Beautiful form conveyed the sanctity or divinity of a figure, rather than haloes. The geometrical principles of the circle and stable triangle, which had always been important, were used more extensively. Narrative became more unified and figures were represented with great psychological understanding. The result was a majestically serene but exciting art that emphasized style. The High Renaissance was like a gasp, hardly perceptible and short-lived, flowering despite political machinations in the twilight years before the Reformation changed Catholic Europe. Only in Venice did the style continue through the century. Elsewhere, it gave way to Mannerism, which expressed the turmoil of the time and later the ascendant power of the aristocracy with its court art.

Leonardo da Vinci (1452–1519) was not known as a sculptor, yet he trained in Verrocchio's shop where he would have participated in sculptural commissions. In 1482 Leonardo, accused of sodomy, wrote his famous letter to Lodovico Sforza, Duke of Milan, asking for

employment. In listing his mostly engineering skills, he mentioned a knowledge of bronze casting and offered to undertake an equestrian monument (he was in Verrocchio's shop during the creation of the *Colleoni* horse's model) to Francesco, the Duke's father. The offer was accepted but the project did not start until 1489. An equestrian of Francesco was first ordered (but not finished) from the Mantegazza brothers and then Pollaiuolo, who designed one with a rearing horse. Leonardo was engaged on a terracotta model of 'the Horse' for four years. His ambitious drawings first envisioned the horse rearing over a prostrate foe, as in Pollaiuolo's drawings. The three times life-size model produced numerous casting difficulties, which perhaps caused Leonardo in later drawings to adopt a strutting horse, like the ancient *Marcus Aurelius* or *Regisole* in Pavia (which he saw in 1490). In his Madrid Codices, the only fifteenth-century detailed account of casting, Leonardo discussed a modified lost-wax technique but recognized that problems remained. The horse was still not cast by 1493, when its metal was used for canons to repel the French. In 1499 the model was used for target practice by the conquering French, after which it fell into ruin. Rearing horses continued to fascinate Leonardo and formed the centre of his destroyed *Battle of Anghiari* fresco (begun 1503) in the Palazzo Vecchio, Florence. His notes record that he made wax *bozzetti* to 'visualize' the horses' rhythms, a practice that increased in the sixteenth century. After returning to Milan in 1506, he re-used his earlier ideas on an equestrian memorial to the *condottiere* Trivulzio. The drawings include a more integrated relationship between the life-size horse and rider, shown on a pedestal with bound figures influenced by Michelangelo's tomb of Pope Julius II. Once again, this genius's design came to naught and a rearing equestrian was not executed until the seventeenth century.

The *paragone*, the comparison of painting with other arts, was debated by Leonardo in order to raise painting to the level of a liberal art. He further argued for the superiority of painting over sculpture, thus angering Michelangelo, who defended sculpture. Leonardo's argument rested on the traditional idea of the supremacy of sight (revealing his interest in optics), sculpture being dismissed because the sculptor does not reproduce light mimetically:

> The painter has ten considerations with which he is concerned in finishing his works, namely light, shade, colour, body, shape, position, distance, manners, motion and art; the sculptor has only to consider body, shape, motion and art. With light and shade he does not concern himself, because nature produces them for his sculpture. Of colour there is none. With distance and closeness he only concerns

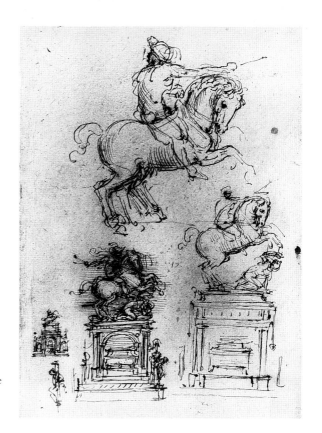

116 Leonardo da Vinci, study for the
Trivulzio equestrian monument,
c. 1508–11 (pen and ink on paper,
28 × 19.8 cm, 11 × 7⅞ in)

himself in part, in that he only uses perspective but not the perspective
of colour which varies in hue. . . . Therefore, sculpture has fewer
considerations and consequently is less demanding of talent.

He added that sculpture was dirty and physically exhausting, not the
pursuit of an intellectual, whereas painters could create intellectually
wearing silks or satins.

Pomponius Gauricus, the author of *De Sculptura* (published in
Florence in 1504), was neither a practising artist like the *trecento* Cennini
(*Libro dell' Arte*) nor a humanist artist like Alberti but a Neapolitan man
of letters. His treatise, clothed as a Ciceronian dialogue informed by
Vitruvius and Pliny, indicates the ascendancy of sculpture and the arts.
It plays down the public sculpture of the fifteenth century in favour of
small-scale, well wrought objects to be savoured in private. One
contribution of this rather pretentious work is the theory of the
'pregnant moment' – an instant when the past is synthesized and the
future suggested, as attained in painting by Leonardo.

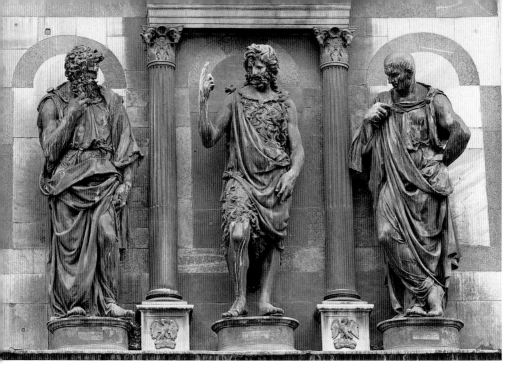

117 Giovanni Francesco Rustici *Preaching of St John the Baptist* 1506–11 (bronze, 265 cm, 104⅜ in with base). North door, Baptistry, Florence

Some of Leonardo's experiments with the terracotta horse and his models for the *Battle of Anghiari* are reflected in the terracotta groups of fighting horsemen attributed to Giovanni Francesco Rustici (1474–1554). Of noble birth, he too trained in Verrocchio's workshop and was listed by Gauricus as one of the major sculptors of Tuscany. According to Vasari, he also worked in enamelled terracotta. Rustici was employed by the Medici and after their expulsion in 1527 he left Florence for France, where he was engaged on an equestrian for Francis I until the monarch's death in 1547, when he returned to Florence. Rustici's finest sculpture, the memorable *Preaching of St John the Baptist*, is over the north entrance of the Baptistry. It was commissioned in 1506 to replace a *trecento* sculpture of the subject by Tino da Camaino and followed the group by Sansovino on the east door. During this period Rustici and Leonardo shared a house so it is natural that the older man's influence should be felt, although his exact role in the work is unknown. While the commanding Leonardesque forms are not illusionistically sculpted as a coherent group – each statue has its own pedestal and is separated by the columns – St John, patron saint of the

117

118

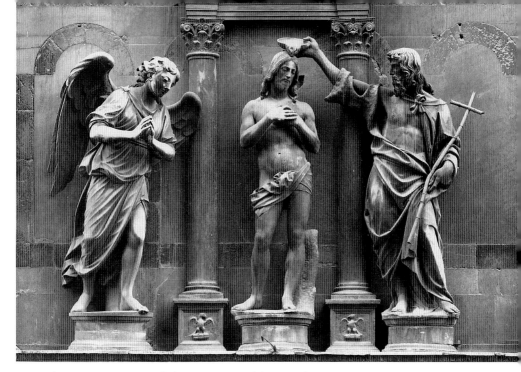

118 Andrea Sansovino *Baptism of Christ* 1502–05 (marble, 282 and 260 cm, 111 and 102$\frac{7}{8}$ in with bases). East door, Baptistry, Florence

city and building, is emphasized by his central placement and the poses and gazes of the flanking figures, rather like a triptych in the round. Rustici has them looking down to engage with the viewers below. In the Pharisee, whose huge hand clutches his beard, Rustici's surface treatment is decorative, almost an enlargement of Ghiberti's. It is really the bald Levite that departs from the slighter, idealized figures of the Quattrocento. His powerful arms resemble those of Michelangelo's figures on the Sistine ceiling and the bulges and rolls on his forehead extend Verrocchio's expressive anatomy and reflect Leonardo's studies of the grotesque. These traits may signify the Levite's insensitivity towards St John, while his *contrapposto* parallels his indecision over John's proclamation of the messiah. The group's intensity recalls Donatello and the Levite's drapery is indebted to 'Lo Zuccone'. *42*

Simone Bianco, who was born in Tuscany, worked in Venice and signed in Greek to indicate his orientation. He repaired antique busts (as did T. and A. Lombardo) and was most celebrated during his lifetime for busts of men in the antique mode. Simone was a pictorial sculptor with links to Titian and his circle.

Andrea Sansovino (*c.* 1467–1529), born Andrea Contucci in the Tuscan town of Monte San Savino, was primarily a marble sculptor. According to Vasari, he was trained by Pollaiuolo but some scholars see him trained by a marble specialist. Like Leonardo, he straddled two centuries and his art belongs to the High Renaissance. In 1491, aged only twenty-four, he was sent to Portugal as an artistic emissary by Lorenzo de' Medici. Vasari claims that he stayed for nine years, yet not one work from the period remains. His first major sculpture is the

118 *Baptism of Christ* on the Baptistry's east portal, ordered in 1502 to
117 replace a *trecento* group by Tino da Camaino, like Rustici's ensemble. Sansovino's two figures were conceived with separate plinths in a tripartite architectural setting that implies a third, probably an angel (the present figure dates from 1791). The style, a more monumental form of Ghiberti's, is refined and decorative, although one can see Sansovino's study of the antique in the Christ's body, pose and supporting strut. The commission was interrupted in 1505, when he was summoned to Rome by Julius II to work on two tombs, whose figures have a High Renaissance simplicity and gravity, with decorative detail reminiscent of the Quattrocento. While in Rome Sansovino also produced the pedimental group for the facade of S. M. dell' Anima and in 1512 began his *Virgin, Child and St Anne* for S. Agostino. The group reflects Leonardo's lost cartoon of the theme,

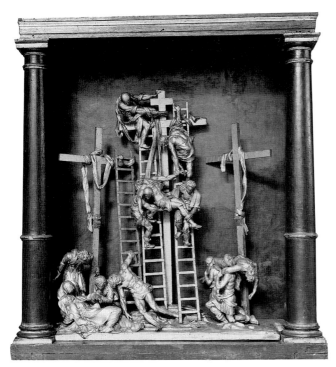

119 Jacopo Sansovino *Deposition, c.* 1510 (wax, cloth and wood with gilding, 76.2 × 72.4 cm, 30 × 28½ in)

120 J. Sansovino *Bacchus* 1511–18 (marble, 146 cm, 57⅛ in)

121 J. Sansovino *Madonna del Parto* 1518 (marble, over life-size). S. Agostino, Rome

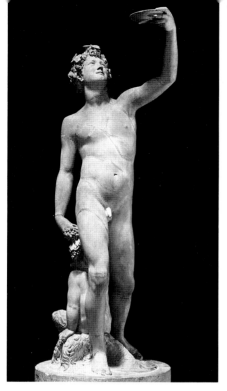
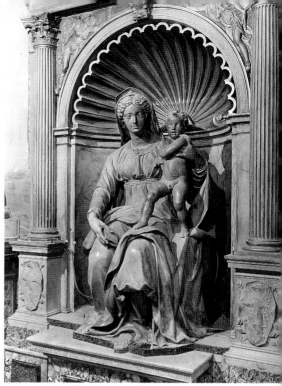

exhibited in Florence in 1501; both express a popular concern of the time to prove Mary's exalted lineage and purity. The sculpture was placed against a pier with Raphael's fresco of Isaiah, the prophet of the Virgin Birth. The realism of the wizened face of St Anne is astounding and contrasts with the Classicizing head and coiffure of the Virgin. In 1513 Pope Leo X appointed him Capomaestro of Loreto Cathedral, notably of its 'Holy House', designed by Bramante, which occupied him for the rest of his career. Weighed down by administration and supervising the project, he himself executed only two narrative reliefs. Having intermittently revisited his birthplace, he remained there from 1527, when funds from Rome were cut off after its sack by northern troops at the climax of the struggle between Pope Clement VII and Charles V.

In 1502 Jacopo Sansovino (1486–1570), born Jacopo Tatti, entered the workshop of Andrea Sansovino, whose surname he assumed. He accompanied his master to Rome in 1505, where he was also engaged in the restoration of antiquities in the Vatican. He probably witnessed the *Laocoön*'s excavation in 1506 with Michelangelo and Giuliano da Sangallo and later copied it. At Bramante's invitation, he lodged in the

Della Rovere palace where he befriended the painter Perugino, for whom he made a model of a *Deposition* to use in a now-lost painting. His earliest surviving work, it testifies to his pictorial inclinations and demonstrates the importance of wax for studies, since wax continues to be malleable, unlike clay. Jacopo's model is a milestone in the history of sculpture, preserving a practice of many sculptors which replaced drawing. As artists' status grew, so their models and drawings were kept as evidence of their imaginative process (if wax models began to deteriorate, they were sometimes cast). Sansovino returned to Florence in 1511, where he entered a partnership with his lifelong friend, Andrea del Sarto, who depicted him as one of the bystanders in a fresco in SS. Annunziata. Sansovino in turn provided him with models (such as the St John in the painter's *Madonna of the Harpies*). At this time, Sansovino received the important commission from the Cathedral for a figure of St James, one of twelve apostles ordered in 1506 from Michelangelo.

Between 1511 and 1518, when he returned to Rome, Sansovino worked on his *Bacchus* for Giovanni Bartolini, departing from Michelangelo's *Bacchus*, which he had no doubt seen. Sansovino's lithe god of wine and his joyful celebration contrast with Michelangelo's bloated, inebriated yet mysterious god. Vasari admired Sansovino's for its virtuoso carving, especially the extended arm, a technical feat which no ancient sculptor had accomplished in marble without a strut. The *Bacchus* was indebted to an ancient statue (Torlonia, Rome), although Vasari relates that Sansovino modelled it from life, after an assistant who posed naked on a winter's day and then went mad, posing nude all over Florence. This anecdote is early evidence of the confusion between art and life. Sansovino designed temporary decorations for the triumphal entry of Pope Leo X into Florence in 1515, his first foray into architecture (it is as an architect that he is best known). An unusual relief for the structure in clay and linen on board survives (London). Back in Rome he sculpted the marble *Madonna del Parto* for its niche designed by him in S. Agostino, a Florentine commission. The figure of the Virgin was based on a Classical prototype, *Apollo playing a Citharode*, and although her head was certainly influenced by Andrea's work in the same church, she is more alert, more Classicizing and High Renaissance, particularly in a refinement akin to Raphael's response to Michelangelo's expressive forms. After this, his interests turned increasingly towards architecture. It is a barometer of Jacopo's abilities that his design for the Florentine church of S. Giovanni, Rome, won the competition over those submitted by Raphael and others. In 1527, with the Sack, he fled to Venice – his achievements there will be discussed in Chapter 10.

Michelangelo

Michelangelo Buonarotti (1475–1564) was the first artist recognized as a genius in his own lifetime; practising sculpture, painting and architecture, he considered himself a sculptor foremost. Usually described in superlatives, his sculpture is better known than any other Renaissance sculptor's yet remains enigmatic, due to the complexity of the age and the intricacy of his mind. The Neo-Platonic approach to myth, adopted by Michelangelo, endowed secular art with subtlety and the emotion previously reserved for religious works. His art, sometimes termed High Renaissance, explored a small number of themes but continued to evolve, pushed to extremes later called Mannerist, although it defies both categorizations. Only a few contemporaries, such as Titian, could comprehend it; lesser talents could merely emulate his motifs and ideas.

A born sculptor, or so he and his biographers claim, Michelangelo was placed with a wet-nurse (as was customary with middle-class infants) whose husband and father were stonecarvers in Settignano. Thus he said he drank in the chisel and hammer with his 'mother's' milk. His father, a minor noble, wanted him to study for a profession so Michelangelo was educated more than most artists. A short apprenticeship with Ghirlandaio, begun in 1488, freed him to develop a singular style and technique, having learnt the rudiments of painting and design. There is some truth to the claim, however, that Michelangelo was autodidactic: in his youth he drew from Giotto's Peruzzi Chapel and Masaccio's Brancacci Chapel frescoes. These drawings after painters with sculptural forms consist of cross-hatching in pen and ink, like his carving in marble with claw chisels. Ascanio Condivi, Michelangelo's biographer (1553), records that his copy of an antique faun's head (now lost) prompted Lorenzo de' Medici to invite him to stay in his palace, where he remained until Lorenzo's death in 1492. There he encountered Bertoldo and had access to the collections and the stimulus of such thinkers as Poliziano, Ficino and Pico della Mirandola. From this sprang his interest in Neo-Platonism and poetry (he wrote sonnets) and his conviction that art was an intellectual activity. Two obsessions developed in this setting against which he

measured his own achievement: the sculpture of Donatello and of the ancients. It was during this time that his nose was broken, a disfigurement which contributed to his noted shyness and misanthropy. Pietro Soderini, leader of the later Florentine republican government, remarked: 'he requires to be drawn out by kindness and encouragement: but if love is shown him and he is well treated, he will accomplish things that will make the whole world marvel.'

122 The earliest extant work by him is the *Madonna of the Stairs* relief, whose implicit monumentality belies its small size. The waxy, translucent slab, like alabaster, is reminiscent of Desiderio. Carved in *rilievo schiacciato*, it represents Michelangelo's exploration of *quattrocento* techniques. In both form and content – the Madonna's pose and the premonition of death – we see the influence of Greek *stelai*. The Madonna's face is in Classical profile and she sits on a square block – a studio prop for models – Michelangelo's hallmark. He chose not to show the Child's face but placed him in an odd position, either nursing or sleeping (foreshadowing his death) and encased in drapery, suggesting protection, a shroud or a womb. In the background, four youths handle a long cloth, identified as either the one used to lower

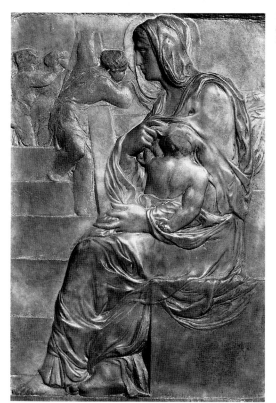

122 Michelangelo *Madonna of the Stairs*, c. 1490–2 (marble, 55.5 × 40 cm, 21¾ × 15¾ in)

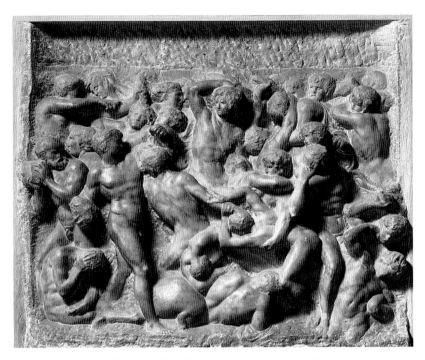

123　Michelangelo *Battle*, *c.* 1492 (marble, 84.5 × 90.5 cm, 33¼ × 35⅝ in)

Christ from the cross or a shroud. The novel stairs are possibly related to
Girolamo Benivieni's *Scala della vita spirituale sopra il nome di Maria*, in
which the name of Mary (Maria) with its five letters is associated with
five steps, as here. Altogether, the relief is much closer to Donatello's
Pazzi Madonna than the intervening lyrical madonnas by Rossellino 57
and Desiderio.

　The *Battle* relief, his second piece – carved in white Carrara marble, 123
probably for Lorenzo de' Medici and left unfinished at his death –
renewed the concept, found in Pliny's writings, that an unfinished
work was preferable because it showed the artist's method and thought
process. Indeed, after 1500 Michelangelo found it difficult to complete
his projects, for several reasons: his patrons' mercurial wishes, his own
high standards and his belief that the idea was paramount. The whole
relief is conceived in terms of the body as an expressive vehicle. As such,
it embodied Protagoras's dictum that man is the measure of all things,
which was echoed by Alberti and others and became a Renaissance
characteristic. It also depicts Michelangelo's idea that figures are

159

124 Michelangelo
Crucifix, c. 1492
(painted wood,
135 × 135 cm, 53⅛ × 53⅛ in)

imprisoned in stone, waiting to be liberated. Variously identified as the
Battle of the Centaurs and the Rape of Dejaniera or Battle of Hercules
and the Centaurs (a republican theme), it reflects Michelangelo's study
89 of late Roman sarcophagi, Bertoldo, the Pisani and Pollaiuolo.

After Lorenzo died, Michelangelo returned to his father's house and
began to study anatomy. The prior of S. Spirito furnished him with
corpses to dissect and, according to Condivi, he carved a wooden
124 *Crucifix* for the high altar of the church in return. Following
Brunelleschi and Donatello's crucifixes, the thin Christ inspires pity,
but the modelling of the sensuous torso is very close to that of his other
nudes. Around 1493, he carved a lost, eight-foot marble Hercules,
purchased by the Strozzi family. During the troubled 1490s, the era of
Savonarola's fiery sermons about the scourge of God who would visit
worldly Florence, Michelangelo's ties to Lorenzo's cousins – Giovanni

and Lorenzo di Pierfrancesco, who adopted the name Popolano and the republican cause – were strengthened and his own republican ideals confirmed. With the impending march on Florence of Charles VIII of France, he fled in 1494 because of his ties to the Medici, first to Venice then to Bologna. There he stayed with Gianfrancesco Aldrovandi, who had lived in Florence and loved to hear him read Dante, Petrarch and Boccaccio in a Tuscan accent. He found Michelangelo work on the shrine of St Dominic, for which he carved an angel holding a large candelabrum which mixes *quattrocento* naturalistic wings and incipient High Renaissance idealization and polish. A statue of St Petronius testifies to his study of Donatello and Jacopo della Quercia, while his *St 125 Proculus* echoes Masaccio and Donatello. Already, the later *David*'s

125 Michelangelo *St Proculus*, shrine of St Dominic, 1494 (marble, 58.5 cm, 28 in with base). S. Domenico, Bologna

126 Michelangelo *Bacchus*, *c.* 1496–8 (marble, 203 cm, 80 in with base)

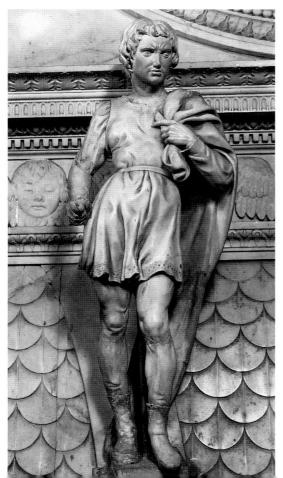

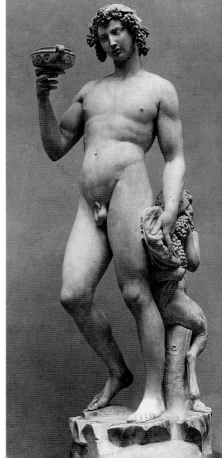

terribilità can be discerned in his furrowed brow. These works are also indebted to the Pisano workshop, seen in the use of the drill. Michelangelo continued with the drill for a time but increasingly used claw chisels. In Bologna he also studied the Genesis reliefs of Jacopo, with their singular dependancy on the heroic human figure.

After republican rule resumed in Florence in 1495/6, Michelangelo returned and carved a St John the Baptist for Lorenzo di Pierfrancesco and a sleeping Cupid for himself (both now lost). According to Condivi, Lorenzo suggested: 'If you can manage to make it look as if it had been buried under the earth I will forward it to Rome, and it will be taken for an antique, and you will sell it much better.' It was duly sold as an antique by an unscrupulous dealer to Cardinal Raffaello Riario. Once he discovered it was not antique, he demanded repayment, justifying Lorenzo's remarks. Even so, Michelangelo gained his patronage, arriving in Rome on 25 June 1496, where he stayed until 1501, finally able to immerse himself in ancient sculpture. The *Bacchus*, his first life-size figure in emulation of antiquity, was carved for Riario but passed to the collection of the banker and humanist Jacopo Galli, a friend of Riario. It was drawn by Van Heemskerck in Galli's garden together with ancient fragments, with its right hand and cup broken off, making it appear even more antique. The unnecessary tree-trunk support (the satyr could have sufficed) underlines Michelangelo's intention of echoing Roman copies of Greek bronze originals. While he studied assiduously, he did not copy any known work (the satyr echoes depictions of an older Bacchus, as on the Pisan Camposanto vase used by N. Pisano). Michelangelo's epicene adolescent god is clearly inebriated, more so than in any ancient sculpture (perhaps influenced by literary descriptions); his tipsy stance and his flaccid muscles reveal the consequences. So accomplished was the execution of the flesh that even after outdoor exposure these can still be appreciated. The group forms a spiral, a nascent *figura serpentinata*, with the coy satyr nibbling at the grapes adding to the torsion. Its precious grace is also a trait of incipient Mannerism. Condivi, who wrote during the Counter-Reformation, interpreted the subject of the dying and resurrecting god as a condemnation of the senses but Michelangelo at this period viewed the human body as a symbol of the divine. The work's meaning is also bound up with Neo-Platonism and its mystical orientation. The purpose of Bacchic (Dionysiac) cults was to attain mystical union with the god through inebriation and eating raw flesh and blood (alluded to here by the animal skin). In the Catholic doctrine of Transubstantiation the Communion bread and wine are transformed into the body and blood of Christ. These references would not have escaped the erudite

127 Michelangelo *Pietà*, *c.* 1498–1500 (marble, 174 × 195 cm, 68½ × 76¾ in). St Peter's, Rome

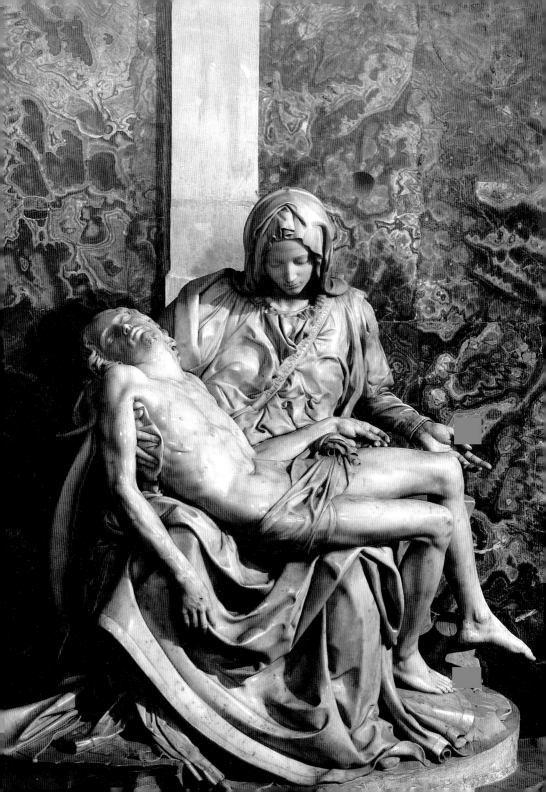

Riario and his circle. After thus surpassing the antique in form and content Michelangelo used antiquity more selectively.

Through Galli, the French ambassador, Cardinal Jean de Bilhères, commissioned the *Pietà* in 1497 – a French and German subject still uncommon in central Italy. The Madonna's expression, the head of Christ falling back limply as in sleep, his relaxed not rigid limbs and his veins engorged with blood all suggest the mystery of life and death and thus the Resurrection and Eucharist. Mary's surprising youth, Michelangelo said, denoted her chastity (according to Condivi) and may be explained in a phrase from Dante's *Paradiso*, known by him: 'Virgin Mother, daughter of thy son'. Mary and the rock on which she sits have been interpreted by some as Mary *super petram* (on the rock of the Church) for the group was placed on the altar of S. Petronilla, an early church incorporated into Old St Peter's, emphasizing its Eucharistic significance. The Virgin's left hand also invites meditation on Christ's death. Her lap is enlarged by voluminous drapery to solve the problem inherent in the theme: a seated woman supporting a full-grown man. The High Renaissance beauty of the figures is related to the Neo-Platonic idea that earthly beauty reflects the divine. It is a very physical work but at the same time transcendent in its Classical restraint and the purity of its marble (fine Carrara, unlike the *Bacchus's* flawed Roman marble) and its triangular form. The exquisite virtuosity of the carving – the thin ripples of the neckline of the Virgin's garment defy the medium – Michelangelo never repeated. In his later reworkings of the theme no such lyricism reappears. The *Pietà* – his only signed work (on the banderole, across the Virgin's chest) – established him as the premier sculptor of Italy.

Michelangelo returned in 1501 to a changed Florence: Savonarola had been burned at the stake and a stable republican government was in power. Vasari says that he was lured by the project for a large prophet, a revival of the old plan to adorn the Duomo buttresses, begun in 1410 with Donatello's terracotta *Joshua*. Whatever the means, he was commissioned for the *David* and given the block which had been acquired in 1464 for Agostino di Duccio, who Vasari and Condivi say had damaged the marble. The work was dropped after Donatello's death (1466) and A. Rossellino was given the block in 1474 but died soon after. Around 1502 a bronze *David* was ordered from Michelangelo whose ideas for this lost work are preserved in a drawing with a verse: 'David with his sling and I with my bow – Michelangelo' – the bow was part of the stonecutting drill. It seems that Michelangelo thought of himself doing battle with the damaged block, identifying with the civic hero.

The first colossal statue of a male nude since antiquity, the *David* unites ancient and Florentine celebrations of man, as in Pico's *Oratio de dignitate hominis*, both in form and meaning. The supra-human figure is no longer the Biblical shepherd boy of the early Renaissance but a powerful young man. No doubt its form was partly determined by the block's shallowness and the false starts of others but the exaggerated coiffure (perhaps symbolizing the Lion of Judah), facial expression, pronounced musculature and large hands are explained by its destination high on a buttress. Not coyly dressed like Donatello's figure, he is concomitantly defenceless and more physical: heroic, virtuous and confident. Moreover, Michelangelo depicted him at a different moment from either Verrocchio or Donatello: not after his victory but before, when he has just spotted his foe and is preparing his sling and stone. The *David* is less academically antique than the *Bacchus*, although there is a similar support and a clear debt to the Polyclitian stance. The torso is unabashedly antique and, when seen from the front, strongly resembles N. Pisano's 'Fortitude'. But the frontal view was not the main one intended: it was to be seen from the direction in which he is looking. The *terribilità* (roughly, 'awesomeness') of his visage is intensified by shadow from the thick hair over the deeply drilled eyes and face of the 'giant', as it was called. It was originally embellished with gilding and a victor's wreath. Michelangelo's wax model, recorded by Vasari, no longer exists and a stucco *bozzetto* claimed as his is generally believed to be a later emulation. As the *David* was being completed, an *ad hoc* committee, including Piero di Cosimo, Leonardo, Botticelli and Giuliano da Sangallo, met to decide its position. The Cathedral's buttress was no longer favoured; clearly, the sculpture's civic significance had eclipsed its ecclesiastical meaning. They decided that it should take the place of Donatello's *Judith* in front of the Palazzo Vecchio, where it would function as a guardian, near the *Marzocco* of Donatello, against enemies of the Republic (the degree of this symbolism is disputed). After it was unveiled, it changed the course of Western European sculpture. (In 1873, to prevent further damage, it was moved to the Accademia where it unnaturally dominates the exhibition hall.)

After eighteen years in Milan Leonardo had returned to Florence as an acclaimed genius in 1500. In drawings and three tondi of the Madonna and Child Michelangelo grappled with Leonardo's highly unified designs. The *Doni Tondo*, the only easel painting assuredly by him, was begun *c*. 1503/4 for Agnolo Doni and Maddalena Strozzi, probably on the occasion of their marriage. It is the first High Renaissance tondo, a form popular since the 1450s. The male nudes in

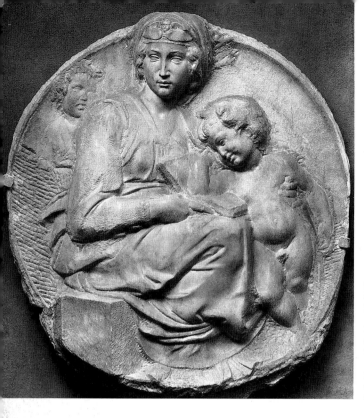

128 Michelangelo *Pitti Tondo*,
c. 1504–05 (marble, c. 85 cm,
33½ in diameter)

129 Michelangelo *St Matthew*,
c. 1504–08 (marble, 271 cm,
106¾ in)

130 Michelangelo *Atlas Slave*,
c. 1520–34 (marble, 277 cm,
109 in)

the background, symbolic of baptism, recall his *Crucifix*, *Bacchus* and
David. The *Taddei Tondo* (named after its owner, Taddeo Taddei, one
of Raphael's Florentine patrons), like the *Pitti Tondo*, was left
incomplete at Michelangelo's departure for Rome in 1505 but its
acceptance by Taddei reflects not only his desire to own a work by him
but also the new aesthetic that the *concetto* was the most important
factor. The smaller *Pitti Tondo*, which Vasari relates was for Bartolom-
meo Pitti, is close to the *Bruges Madonna* with her Child. More deeply
carved than the *Taddei Tondo*, the *Pitti*'s figures imply a convex shape,
echoing the mirrors used by some painters of tondi to embody the idea
of the Madonna as a mirror without blemish. The sibylline Madonna is
accentuated by her head projecting above the tondo. She seems
conscious of her son's tragic destiny, such foresight and humility
indicated by the seraph on her headband. She holds a book, symbolic of
wisdom, on which the Child (modelled from the Phaedra sarcophagus
in Pisa that influenced N. Pisano) casually leans. At her left, the Baptist,
carved in *rilievo schiacciato*, serves as a reminder of the Child's mission.

128

During these years Michelangelo worked on the vast *Battle of Cascina* fresco for the Sala del Cinquecento in the Palazzo Vecchio, destroyed in Vasari's campaign. Painted in competition with Leonardo's *Battle of Anghiari*, it depicted a Florentine victory and was conceived in terms of the nude male body (Leonardo's focused on frenzied men and horses in combat). This epic confrontation of protean geniuses pitted Leonardo the naturalist against Michelangelo the philosopher. A copy of the central section of Michelangelo's and his drawings – with their exaggerated poses, grace and beauty – reveal that he was approaching Mannerism. Leonardo saw an inherent danger: 'O anatomical painter, beware, lest in the attempt to make your nudes display all their emotions by a too strong indication of bones, sinews and muscles, you become a wooden painter.' At the same time Michelangelo was working on *St Matthew*, one of the series of twelve apostles for the 129 Duomo. The marble arrived not long before he left for Rome in 1505 so little was accomplished until after his return in 1506. One pivotal experience of his second Roman stay was the excavation of the *Laocoön*, known through the writings of Pliny. It was reputedly carved from one

piece of marble – a technical feat that became a goal of sixteenth-century sculptors – but Michelangelo discovered that it was not. One can see its influence in the writhing torsion of *St Matthew* – one foot on a sculptor's block and his left hand holding his gospel. The *Laocoön* represented the physical punishment of the Trojan priest and his sons by the gods; in contrast, Matthew's struggle is internal, expressed in physical form. Divine inspiration courses through his body like electricity but he is imprisoned in the block (like the soul in the body), one of Michelangelo's most eloquent expressions of this pessimistic concept. Since he was in Rome again from 1508 to 1512, the Duomo authorities decided that he would not honour the contract and commissioned J. Sansovino to carve the next apostle.

The interruption on the *St Matthew* in 1505 was due to the summons from Pope Julius II to execute his tomb (originally for the Lady Chapel of Old St Peter's). The monument was Michelangelo's nemesis: he worked on it over four decades (1505–45), through six projects, the last five negotiated with the Pontiff's heirs. The first, whose reconstruction is hotly debated, was probably presented as a wooden model. Vasari and Condivi are sources for it, together with the artist's drawings and the Sistine ceiling, which Julius commissioned from him in 1508 and which incorporates many of his ideas for the tomb. Envisioned as a freestanding *molus* in imitation of ancient mausolea (but also somewhat resembling contemporary catafalques and triumphal cars), it consisted of three storeys, more than forty over-life-size figures and bronze reliefs, all in praise of the Pope. In 1506, his protests about lack of funds being futile (they were diverted to war and Bramante's new St Peter's, intended as the mausoleum of Julius and the first pope, St Peter), Michelangelo left for Florence to carve the *St Matthew*, which reflects his agitated state. It is this personal expression that resonates so profoundly in his works. After Julius died in 1513, the second project, controlled by his heirs, became a more traditional wall tomb. Three of its most finished figures survive, only one being installed on the final tomb: the pyramidal *Moses* intended for the second level. Today it is ensconced on the monument's lower level in S. Pietro in Vincoli, thereby vastly reducing its effect. The muscular figure grows out of Michelangelo's seated prophets and sibyls on the Sistine ceiling and may be his idealized impression of Julius, the great warrior Pope, who had been determined to restore the glory of the papacy and its territory after Pope Alexander VI Borgia. Throughout their relationship, Michelangelo clashed with this powerful personality, constantly complaining about the requirements Julius placed on him. The pose was influenced by Donatello's *St John the Evangelist*. His *contrapposto*, as

131 Michelangelo *Moses*, c. 1513–16 (marble, 235 cm, 92½ in). S. Pietro in Vincoli, Rome

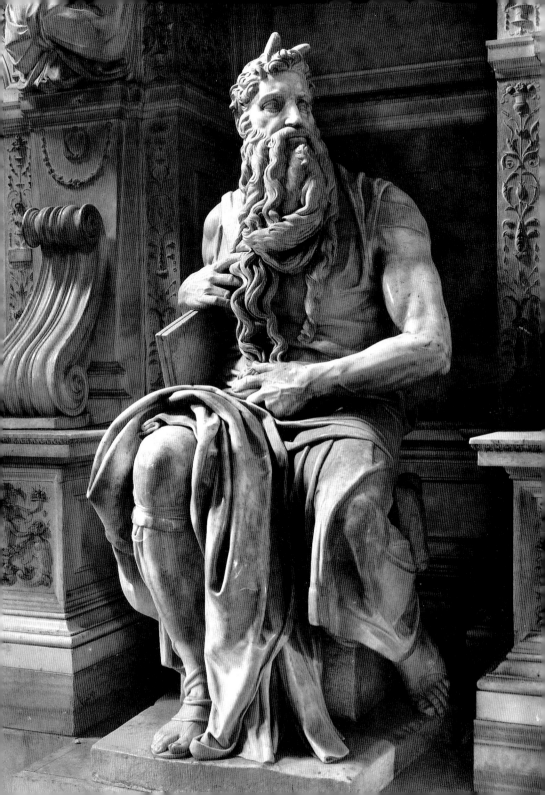

though seized by the will of God, and his cascading beard derive from
Donatello's *Abraham and Isaac*, while the protrusions on his head depict
a Vulgate mistranslation as 'horns' of the Hebrew for 'rays of light'.

The two other sculptures from the 1513 project are the so-called
'Slaves' (Louvre), meant to be bound to pilasters flanking niches with
victory figures. They are fettered and in torsion like the seated *ignudi* of
the Sistine ceiling and thus also depend on the *Torso Belvedere*, another
antiquity in the Pope's collection. The *Dying Slave* appears to be
awakening from a deep sleep. The bands across his chest symbolized for
Michelangelo weight oppressing the soul. These captives are sometimes
identified as prisoners of provinces Julius had captured, reflecting their
origins in sarcophagi and triumphal arches, or as the liberal arts that the
Pope's death fettered. Thus the *Dying Slave* with the roughed-in ape as
a support, holding the convex mirror used by artists, could represent
painting, while the other could be sculpture. A third contract for the
Julius Tomb was negotiated in 1516, from which time date four
additional unfinished 'Slaves' (sometimes allied to the S. Lorenzo
facade, begun by Pope Leo X in 1516 but cancelled in 1520). These
assisted works, later installed in the Boboli Grotto, Florence, are taller
and heavier in physiognomy than the Louvre 'Slaves'. They are
architectonic and, like caryatids, seem to be weight-bearing. They
reflect the sculptor's own aging body and greater pessimism. Still
within the matrix of the primordial block, they evoke humanity bound
to its earthliness. Perhaps the most galvanizing is the *Atlas Slave*,
intended for an angle of the tomb. The figure sits astride an object and
clutches its head, which is buried in a block of stone. Examination
reveals a small face traced next to the forearm, in an unusually
unfinished state. Work continued sporadically on the Julius Tomb with
legal threats by the heirs until a compromise was reached and the more
modest but spiritual tomb was installed in 1545, not in St Peter's but in
S. Pietro in Vincoli.

During his last Florentine sojourn and as part of the fourth contract
(1526), Michelangelo had produced another statue for the Julius Tomb,
the *Victory*, intended for a niche between 'Slaves'. It had a profound
effect on sixteenth-century art, playing a seminal role in the develop-
ment of *Maniera*, the court style of Mannerism. Forming a corkscrew, it
is an extreme essay on the *figura serpentinata*. The languid but tense
youth is poised over the less finished older man as victor-over-
vanquished. Comparing the young man with his haunting blank eyes
with the *David* shows how Michelangelo's art had evolved towards a
more graceful, effete and abstract type. Perhaps it represents Virtue
triumphant over Vice (as in later sculptures derived from it). The

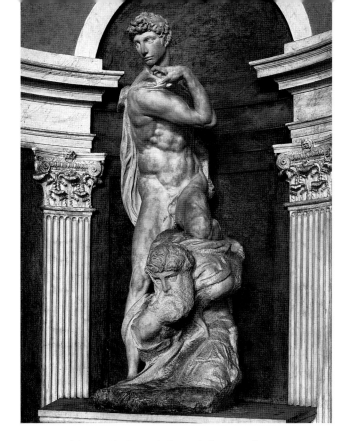

132 Michelangelo
Victory, c. 1527–30
(marble, 261 cm, 102¾ in)

features of the older man may resemble Michelangelo's and the youth has sometimes been identified as Tommaso Cavalieri, a handsome Roman from a distinguished family, who became Michelangelo's beloved friend during the 1530s. They first met in 1532, when the artist was fifty-seven. This idea must be rejected because it is too biographical and the sculpture is dated stylistically to before 1532. He was drawn to Cavalieri by his beauty but it is more probable that Michelangelo's desire was sublimated in his art rather than physically expressed. They remained friends until his death and it was Cavalieri who oversaw the posthumous installation of Michelangelo's Capitoline project in Rome.

The Medici Chapel, or the New Sacristy, in S. Lorenzo, Florence, is Michelangelo's greatest ensemble. The idea for this interplay of sculpture and architecture was first broached by Leo X in May 1519 as a family funeral chapel. It is the realization of many projects and interprets Brunelleschi's nearby Old Sacristy in an iconoclastic manner: Vasari says that Michelangelo deviated from all the rules established by

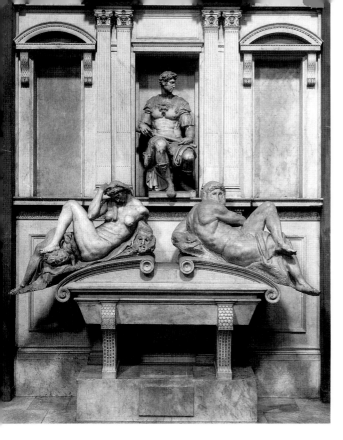

133, 134 Michelangelo *Tombs of Giuliano and Lorenzo*, Medici Chapel, *c.* 1519–34 (marble and *pietra serena*, *c.* 600 cm, 236¼ in). S. Lorenzo, Florence

Vitruvius. Here and in the adjacent Laurentian Library he pioneered his highly experimental architecture, his metaphysical ideas transferring easily into the non-representational idiom. As with the Julius Tomb, Michelangelo initially envisioned a freestanding monument, abandoned in favour of three wall tombs in a triumphal arch format. Four Medici were to be commemorated, the two *Magnifici* – Lorenzo and his brother Giuliano – in the double tomb. Two single tombs were planned for the *Capitani* who died without male issue, dashing the dream of a Medici dynasty (Leo X said 'Henceforth we belong no more to the house of Medici but to the house of God') – Giuliano Duke of Nemours (died 1516) and Lorenzo Duke of Urbino (died 1519), to whom Machiavelli's *Prince* is dedicated. The Chapel's theme was the Resurrection of the Soul and its dome was modelled on the Pantheon to suggest that it was not only a mausoleum. In 1521 Michelangelo was in Carrara selecting marble but the project was delayed by Leo's death. Work did not proceed until 1523, under Pope Clement VII, the illegitimate son of Giuliano. The double tomb facing the altar was

133
134

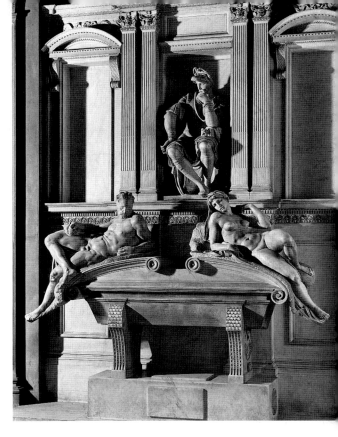

incomplete when Michelangelo left for good in 1534; what remain are a
Madonna and Child by him and two Medici saints by his workshop.

The single tombs on opposite walls are divided into three bays,
before which stand sarcophagi, indebted to an ancient one in the
Pantheon. From Michelangelo's drawings, the lunettes were intended
for frescoes and the two side niches for statues. He also planned four
reclining river gods below the sarcophagi, known from drawings and
an over-life-size model. His inventive architectural licence is seen in the *135*
masks forming part of the capitals. The central niches contain seated

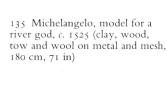

135 Michelangelo, model for a
river god, *c.* 1525 (clay, wood,
tow and wool on metal and mesh,
180 cm, 71 in)

figures of consummate grace (Lorenzo and Giuliano), which Bronzino's later *Maniera* portraits resemble. They wear pseudo-Roman armour, referring to the 1513 ceremony that granted them Roman citizenship. Growing out of the *Moses* and Sistine prophets, they are not portraits but rather types, embodying the Neo-Platonic opposites of the Contemplative and Active Life. Giuliano looks towards the Madonna and Child, holding a baton as Captain of the Church and coins, signifying either his liberality or the coins of departed souls. Lorenzo, who died insane, is depicted in the Classical thinker's pose, his face thrown into dark shadow by his zoomorphic helmet. He holds a money box with a bizarre mask which may be another allusion to the coins of the dead or to the Medici profession of banking. The smallness of their niches makes these figures appear proportionately larger. Below, strange sarcophagi support pairs of separately carved female and male figures, representing the times of Day, symbols of the corrosive effects of time and the transience of the world. They appear to be sliding off the curved, split lids, giving the illusion that the sarcophagi will open to release the souls of the deceased. 'Night' and 'Day' below Giuliano, 'Dawn' and 'Dusk' below Lorenzo derive from the Sistine spandrels and resemble figures on Etruscan funerary urns. Their *ennui* may reflect the artist's own doubts and frustrations. 'Night', wearing a diadem with a crescent moon and star, is in troubled sleep. Her body is from a male model (as was typical practice), while her breasts, which appear pasted on male pectorals, reveal that Michelangelo had little knowledge of female anatomy (although her abdomen suggests she has borne children). A night owl is situated between her legs as though just born and altogether her pose is generative (it depends on an ancient copulating Leda). The *non-finito* wreath of poppies and the mask symbolize Sleep and Dreams, children of Night. 'Day', based on the *Torso Belvedere*, is earthbound and his face is unfinished to convey that day is yet forming. 'Dawn' seems imprisoned in sleep by the bands across her torso. Younger than 'Night' she has not borne children. The head of 'Dusk' is thought to be a self-portrait of Michelangelo in the late afternoon of his life.

Political troubles prevented the original plan's completion. Little was done between 1527 and 1530, when Florence reverted to a republic. After helping to fortify it against the reconquering Medici, Michelangelo became *persona non grata*. He was eventually pardoned and continued work until he departed for ever in 1534. The Giuliano and Lorenzo statues and *pietra serena* mouldings had been installed and some of the details, such as the novel string course of continuous masks and funerary motifs, carved to his design. Most of the partly finished statues

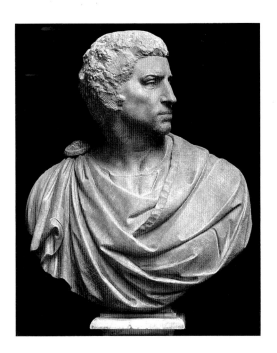

136 Michelangelo *Brutus*,
c. 1534? (marble, 95 cm,
37⅜ in with base)

left around the Chapel and the Madonna and Child found in his studio were installed by 1545. The issue of *non-finito* is important in Michelangelo's oeuvre. When, if ever, did he intend to leave a work unfinished? His difficulty in delegating to assistants, compounded by his slowness and perfectionism, prevented him completing large projects, a frustration to himself and his patrons. His increasing abstraction also accompanied the *non-finito*: the problem rather than the finished work interested Michelangelo.

The pontificate of Paul III Farnese (1534–49) presided over the beginning of the Counter-Reformation, with the confirmation of the Jesuit order in 1540 and the convocation of the Council of Trent in 1545. Michelangelo painted the Sistine *Last Judgment* during this time, when he was spiritually tormented, as were his friends. One of them, Donato Giannotti, planned to write a play on Brutus, the tyrannicide and republican hero of Florence and, according to Vasari, encouraged Michelangelo to carve a *Brutus*. He was now an ardent republican and the sculpture became a patriotic tribute, perhaps after the assassination of either Alessandro de' Medici in 1537 or Lorenzino in 1548. The *Brutus*, in togate format like imperial busts, is placed on a socle in the ancient mode, a departure from the fifteenth-century form. He looks out to the left, the side of one's body open to evil and danger (the right was protected by God). On the fibula Michelangelo carved a sketchy

136

profile which has been tentatively identified as portraying his patron. *Brutus*'s heavy features resemble those of figures in the *Last Judgment*, although the hand of Michelangelo's pupil Calcagni has been detected here. The face suggests a kind of heroic vision and scorn for all those who tamper with liberty.

Now Michelangelo began to descend into despair. To this time belongs his friendship with Vittoria Colonna, the widowed poet Marchioness of Pescara, one of the outstanding women of the Renaissance. The friend of Castiglione and Ariosto, she had been a faithful wife in a loveless marriage. Michelangelo met her in 1536, while she was in a convent, and they continued to be close until her death in 1547. Her poetry (published in 1540) and religious dedication helped him strengthen his faith in God and pursue the salvation of his soul. His passion for the corporeal and Cavalieri was replaced by devotion to Colonna and the life of the spirit. He wrote her exalted sonnets and called her perfect after Dante (Beatrice) and Petrarch (Laura). An enlightened Counter-Reformation individual, Colonna belonged to a group that relied on the ideas of the Spanish reformer Juan de Valdés. They adopted a new concept of salvation – justification by faith – which was very close to Protestantism.

The late works of Michelangelo are exceedingly pessimistic, especially after the deaths of Colonna and Luigi del Riccio (who had wanted to publish his sonnets). The *Duomo Pietà*, carved for his own tomb according to Condivi and Vasari (a related work is the so-called *Palestrina Pietà* in the Accademia), must date to 1547–50 since it was included in Vasari's 1550 edition. Still an indefatigable worker, Michelangelo carved it at night, inventing a special hat with a candle. In 1555 he attacked the piece out of anger at a flaw and general frustration. Calcagni rescued it, repairing some areas and reworking others. The flaw probably existed in the broken elbow region and where the left leg of Christ crossed over the Madonna's thigh. (Today a hole marks that area.) The slung leg, based on an antique motif for a divine marriage, signified Christ's mystical union with Mary and the Church. After years of work and a change to a less tolerant pope (the Inquisitor Paul IV), Michelangelo suffered a period of doubt. The union of Mary Magdalen, the Virgin and Christ – which he hoped to suggest through their physical intertwinings – no longer seemed acceptable. It is also clear that the septuagenarian was having difficulty with carving (late drawings likewise have blurred contours and limp figures). The pyramidal *Pietà* consists of a prominent, hooded figure identified as Nicodemus or Joseph of Arimathea, holding the broken body of Christ with Magdalen at the left and Mary at the right. There is a symbolic

137

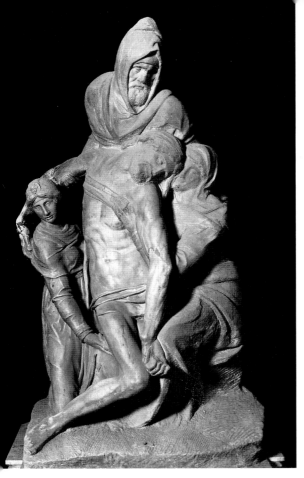
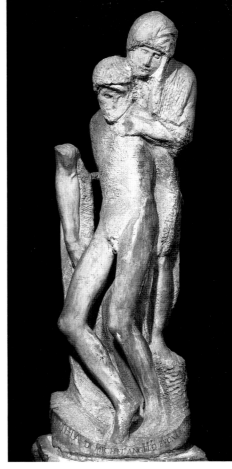

137 Michelangelo *Duomo Pietà*, c. 1547–55 (marble, 226 cm, 89 in)

138 Michelangelo *Rondanini Pietà*, c. 1552–64 (marble, 195 cm, 76¾ in)

sense of movement: the figures in the front weighed down towards the grave, that at the apex pointing upward. The Magdalen was finished by Calcagni, while the faces of the Virgin and Christ are close to Michelangelo, their forms emotionally united. Around Christ's chest are bands, perhaps the cloths used to lower him from the cross. The figure supporting Christ is a self-portrait (recognized by Vasari in a letter of 1564), suggesting Michelangelo's Counter-Reformation identification with the death of Christ. As he embraces the loving triad, he depicts the transcendence he craved. He hoped to be saved through his faith but vascillated between burning faith and chilling doubt, threatened by the void. A sonnet of 1554 reflects his attitude:

The course of my life already attained, over a tempestuous sea, in a
fragile boat the common port where all must land to give an account
of every good or evil deed. So now I recognize how laden with error
was the passionate fantasy that made art an idol and a monarch to me,
like all things men desire in spite of their best instincts. What will
become of my amorous thoughts, once gay and vain, that now two
deaths [body and soul] approach me? Of one I am certain, and the
other menaces me. Neither painting nor sculpture will be able to
quiet the soul, turned to that divine love that opened its arms on the
cross to enfold us.

By the time the Florentine Academy was formed in 1563 and
Michelangelo was elected a member, his antipathy towards Florence
had disappeared. He worked on the *Rondanini Pietà*, his final sculpture,
until six days before his death. It is overwhelmingly vertical and, like
the *Duomo Pietà*, displays some mutilation. The lack of physical weight
and beauty, subordinating all to the expressive soul, contrasts
drastically with his early sculptures. All that remains of its first state is
the right forearm of Christ, while both Virgin and Christ were carved
from what remained of the Virgin. (In 1973 a head and part of a
shoulder, which some believe is a lost fragment of the earlier Christ,
some a modern work, was found in Rome.) At the same time
Michelangelo was working as architect of the new St Peter's without
pay 'for the salvation of my soul'. In the final version Christ and his
mother are fused; finally united, they appear to rise, as in a resurrection,
a proof of his victory over doubt. The sculpture is as close to abstraction
as any representation could be, yet is related to established types: a
standing God the Father with his dead Son; certain depictions of the
Trinity; the Throne of Grace. This *Pietà* is a highly unconventional
image of the triumph of the spirit, as the soaring arc of the back
indicates. Michelangelo died on 18 February 1564. In his will he left his
soul to God, his body to the earth and his belongings to his relations,
and asked his friends to remember in his death the death of Christ.

The Sixteenth Century and the Legacy of Michelangelo

By the 1520s Michelangelo's fame had spread and other sculptors had to contend with his inspiring but intimidating works. They tended to adopt his visual ideas in form rather than in spirit in their Mannerist search for variety – imitation with variation was respectable for artists such as Baccio Bandinelli (1493–1560). Michelangelo's departure in 1534 coincided with the unveiling of Bandinelli's *Hercules and Cacus*, intended to balance the *David*. This designated him the principal Florentine/Medici sculptor for the next twenty years. Trained as a goldsmith by his father, he later entered Rustici's workshop. Through Duke Giuliano he received his first major commission, a St Peter for the Duomo, continuing the work Michelangelo and Sansovino had failed to complete. An *Orpheus*, for the triumphal entry of Leo X in 1515, was installed in the Medici Palace to replace Donatello's *David*. Symbolizing the harmony between Florence and its Medici ruler, it was the first of many allegories associating the Medici with mythological figures. Around 1529 he was made a knight of the order of S. Iago and sources relate he was vain, aggressive, jealous and pretentious. Vasari, who studied with and despised him, was responsible for much of this bad reputation but he was also Cellini's *bête noire*. Bandinelli in turn wrote a defence of his life, the *Memoriale*.

The genesis of *Hercules and Cacus* dates to 1508 when a marble block _{*139*} was ordered for Michelangelo to carve as a counterpart to the *David* (a *bozzetto* may preserve his idea). However, the marble was not delivered until 1525 and was given to Bandinelli as Michelangelo was working on the Medici Chapel. His first model proved incompatible with the block but he continued on the project through the 1527 expulsion of the Medici. In 1528, with the republicans in control, Michelangelo was given the block for a Samson and Philistine (an allusion to the Medici) but after the Medici return in 1530 he was instructed to resume work in the Chapel and Bandinelli to continue the *Hercules and Cacus*. Once again the statue became pro-Medici as their rule was equated with Hercules, a traditional founder of Florence and Rome, and his clemency to Cacus. After seeing it installed as a pendant to the *David* in the vast Piazza, Bandinelli concluded that the muscles were 'too sweet'

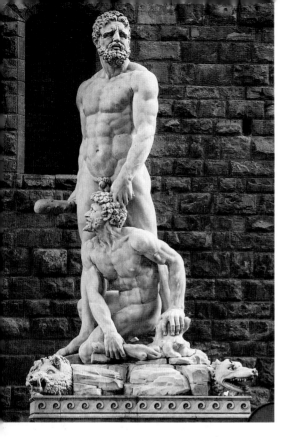

139 Baccio Bandinelli *Hercules and Cacus*, c. 1525–34 (marble, 505 cm, 198⅞ in). Piazza della Signoria, Florence

140 Bandinelli *Pietà* 1554–9 (marble, over life-size). SS. Annunziata, Florence

and further exaggerated it; still it was lampooned and Cellini later described its anatomy as a 'sack of melons'. The basic theme of victor over vanquished seems forced and devoid of tension in comparison to Michelangelo's *Victory*. In trying to outdo the *David*, it is rigidly posed and the facial grimaces are like deeply drilled caricatures. Strangely enough, Bandinelli's base (intended to surpass the *David*'s), not the sculpture, is signed, like the Dioscuri of Monte Cavallo. Bandinelli has been credited with the invention of the historiated pedestal. His earlier drawing for a monument to Andrea Doria included reliefs, as did his *Monument to Giovanni delle Bande Nere* near S. Lorenzo. Praising relief above other forms of sculpture, he became its most proficient Florentine practitioner and much of his work has a flatness akin to relief.

In 1536 Bandinelli secured the sculpture on a pair of tombs for the two Medici popes, Leo X and Clement VII (erected in S. M. Sopra Minerva, Rome), although when he returned to Florence in 1540, much remained incomplete. Vasari relates that when he heard Michelangelo was carving a *Pietà* for his tomb, he immediately began

to plan his own, which he finished shortly before he died. Like
Michelangelo's, it includes an idealized self-portrait as Joseph of
Arimathea or Nicodemus and was to be a four-figure group with St
Catherine of Siena and John the Baptist (Bandinelli saints and the
patrons of Siena and Florence). Whereas Michelangelo's group forms
an equilateral triangle, Bandinelli's makes an isosceles. Michelangelo
depicted himself looking down at the holy group and sharing their
union, while Bandinelli leans forward, devoid of emotion, his haunted
visage seeking the viewer's approval. Both have been interpreted as
concerned with loneliness but Bandinelli's stresses the survivor and his
mortality (note the large skulls) rather than transcendence of the spirit.
His contemporaries sensed some of the incongruities and considered his
Christ too physical and indecorous. Strangely proportioned, he rests
awkwardly on a block signed by the artist, which resembles a small altar
as well as Michelangelo's blocks. The Christ may be a portrait of his son
Clemente, who ran away to Rome in 1555 to escape his rage and died
shortly after. The sculpture could be interpreted as a guilt offering by a
father whose own father was reburied in the same tomb. It is filled with
personal allusions, such as coats-of-arms and two reliefs of the sculptor
and his wife, on the back. The amount of marble carved out of the
block is astounding yet this anti-Michelangelesque practice became the
wave of the future.

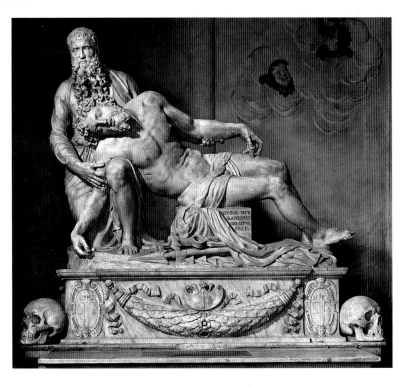

Other significant commissions include reliefs for the Holy House of the Virgin at Loreto. In 1540 Bandinelli embarked on a project for the Palazzo Vecchio and in 1547 began decorations for the Duomo altar and choir, assisted by his pupil Giovanni Bandini. When he asked Duke Cosimo to visit the unfinished choir in order to silence criticism, the Duke refused, annoyed by his dilatoriness – thus ended Bandinelli's relationship with the Medici. He converted some of the criticized figures for the altar into other subjects: for example, Adam evolved into Bacchus, revealing his superficial approach to subject matter as opposed to Michelangelo's profundity. Bandinelli excelled as a draughtsman and was proud of his adherence to *disegno*, prized by Florentine theorists. Except for Bandinelli and Michelangelo, few sculptors were prolific draughtsmen; most preferred to model in clay, plaster, terracotta or wax. A famous print (*c.* 1550) by Enea Vico after Bandinelli depicts his informal 'academy' of drawing with students sketching small casts. It predates the Florentine Academy of 1563 and shows Bandinelli's belief in an art with a clear intellectual foundation.

From his boastful and often entertaining autobiography (not published until the eighteenth century) we know more about Benvenuto Cellini (1500–71) than any other sculptor. Trained as a goldsmith, he also wrote treatises on sculpture and goldsmithing. In 1519 he moved to Rome, his principal centre until 1540. He remained there during the Sack of 1527, described in frighteningly vivid detail in his *Vita*, and was imprisoned with the Pope in the Castel S. Angelo. On periodic visits to Florence he worked as a medallist for Alessandro de' Medici but he also went to Venice and Mantua. He was prolific, working for aristocrats as well as Popes Clement VII and Paul III, for whom he made innovative liturgical vessels and jewelry. Above all, Cellini was a gifted designer always extending the range of his craft. As Goldsmith to Francis I of France from 1537 to 1545, he completed his
145 first sculpture, the *Salt Cellar*, which had been started for Cardinal Ippolito d'Este. To a goldsmith's design he imparted the monumentality of sculpture. The two langorous somatic types reflect the plethora of stucco work (polished like marble to imitate Roman techniques) produced by Rosso Il Fiorentino and Francesco Primaticcio at Fontainebleau. The style of the School of Fontainebleau and Italian *Maniera* is characterized by an elongation and abstraction of the poised rather than moving body, creating an unnatural elegance and sophistication. The poses of Cellini's figures also derive from those in Michelangelo's Medici Chapel, unencumbered by their philosophical content. The cellar's iconography reads like a programme for sculpture. The goddess of earth, holding her breast and a cornucopia to

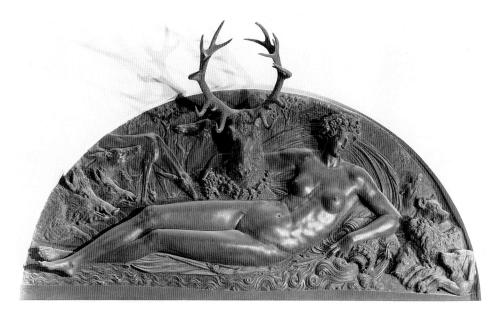

141 Benvenuto Cellini *Nymph of Fontainebleau, c.* 1542–4 (bronze, 205 × 409 cm, 80¾ × 161 in)

signify her nutritive powers, is flanked by a miniature Ionic temple for
pepper corns (with Abundance posed as Michelangelo's 'Dawn'). The *134*
god of the sea (Neptune), with trident and shell chariot, is flanked by a
boat for salt. Practical yet capricious, the cellar is a Mannerist
masterpiece and a nascently scientific conversation-piece. During
dinner the interaction of water and land to make salt and pepper
(echoed by the intertwined legs) could be discussed. The elaborate
ebony base is decorated with cartouches of reclining figures, reminis-
cent of Ghiberti's doors. They represent the four times of day
alternating with four winds or seasons (from Ovid's *Metamorphoses*). It
also contains a heraldic salamander and other allusions to the French
king, enlivened by coloured enamelling.

The first surviving monumental piece by Cellini is a bronze lunette,
the *Nymph of Fontainebleau* for the Porte Dorée at Fontainebleau. The *141*
relief, the only extant part of his portal decoration, illustrates a variant
of the legend of Fontainebleau (a hunting dog discovered a spring and
its goddess in the forest) from a lost fresco by Rosso. A nymph reclines
like a Classical river god – her arm round a stag (one of the emblems of
Francis I) with a three-dimensional head – flanked by hunting dogs and
boars (appropriate for a hunting château). Her large form, against a foil
of intricate detail, demonstrates that articulating the body on a large

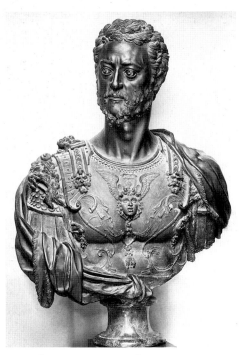

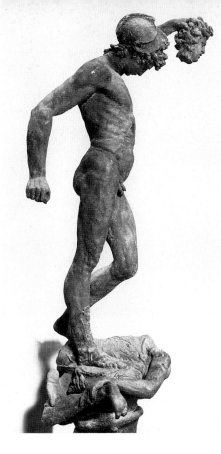

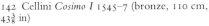
142 Cellini *Cosimo I* 1545–7 (bronze, 110 cm, 43⅜ in)

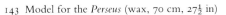
143 Model for the *Perseus* (wax, 70 cm, 27½ in)

scale was not Cellini's forte. Replacements and repatination after eighteenth-century vandalism now mar the work. A gifted animal sculptor, Cellini claimed that he always based his works on nature, as in the sympathetically rendered animals. After returning to Florence in 1545, suspected of embezzling precious metal from the king, he sculpted an oval relief of a *Saluki* (the shape itself is Mannerist, imitating antique gems). This elegant hunting dog was synonymous with royalty and popular at the Medici court. It equalled in canine terms the fashionable proportions of the day preserved in Bronzino's portraits. Cellini boasted that he tossed it off to demonstrate his proficiency before casting *Perseus* and indeed Duke Cosimo preempted it.

 In his autobiography Cellini describes the Duke's commission for
144 *Perseus and Medusa*. Like the *Nymph*, the *Perseus* was cast directly, a decision that caused Cellini anxiety. A number of models in various
143 media, including one in yellow wax, document his struggles with it. After casting a large bust of the Duke, the Medusa was cast, then the

144 Cellini *Perseus and Medusa* 1545–54 (bronze and marble, 320 cm, 126 in without pedestal). Loggia dei Lanzi, Florence

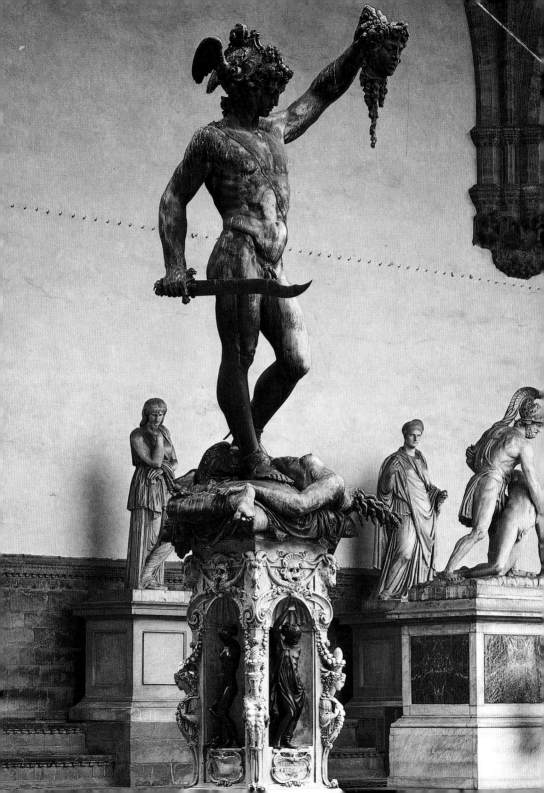

Perseus successfully in one piece except for damage to the right foot, as detailed in his *Vita*. The group was unveiled in the Loggia dei Lanzi to popular acclaim in 1554. Based on an Etruscan statuette conflated with the victor-over-vanquished pose, it was a pendant to Donatello's *Judith*. In the model, Perseus stands on a capital and column, the solution of a goldsmith, whereas in the sculpture Cellini adopted a rectangular base with a cushion (borrowed from Donatello's wine-skin) in place of the capital's abacus. The detailing is extremely refined, with an imaginative zoomorphic helmet whose human face at the back is possibly a self-portrait.

The figure of Perseus in the final work is stronger than in the lither model. Cellini relates that he studied a live model to understand the problems in executing a large figure. Clearly, he also studied Michelangelo's *David*, whose parallels did not escape him. The scale of Cellini's figure is, nevertheless, difficult to judge due to the precious modelling and it seems artificial rather than dramatically gripping. In contrast to the horror of Donatello's *Judith*, it is anaesthetized, even the body of Medusa carefully arranged. The blood spurting from her neck and dripping from her head is beguilingly decorative rather than revolting. Her face has the sensuous beauty of Classical representations rather than the apotropaic qualities of earlier works, creating a much more psychologically sinister monster. Its composition invites the viewer to walk around (which the installation impedes), for Cellini intended it to have eight points of view (Mannerist variety).

The fantastic bronze and marble base of the group is pure *Maniera*. The choice of materials was influenced by ancient authors and Cellini's 1546 trip to Venice, where he saw Sansovino's Loggetta. Like an antique altar covered with organic ornament, the base's decorative masks metamorphose into motifs, as did the *grotteschi* of ancient and *cinquecento* Roman painting and stucco work. The niches contain small-scale bronze figures of Danae, the child Perseus, Jupiter, Athena and Mercury, all from Ovid's story of Perseus. The caryatids at its corners in the form of many-breasted Diana of Ephesus are taken from Benedetto Varchi's theory of generative nature. Goat-heads of Capricorn, the ascendant sign of the Duke, are one of several motifs referring to Cosimo more blatantly than the encoded symbolism of Bandinelli's *Hercules and Cacus*. The ensemble is an affirmation of Medici rule, alluding to the safety and abundance provided by Cosimo, the new Perseus. A bronze relief of Perseus liberating Andromeda beneath the base adds height. This slick monument is also about artistic virtuosity. One of the Latin couplets associated with its unveiling sums up its importance: 'Nature was once the archetype of art; but since Cellini cast

his Perseus, art has become the archetype of Nature.' The Mannerist inversion epitomizes the age. Art became a refuge from political and religious controversy and flamboyant form was frequently stressed above content. The *Perseus* fittingly draws an aesthetic rather than ethical response.

In the *Vita* Cellini mentions that his *Portrait of Cosimo I* was a technical experiment in casting, executed for his own pleasure. Actually it was a transparent bid for patronage, competing with a marble bust by Bandinelli. The over life-size fierce portrait is his most charged work, notable for neurotic energy and intensity of expression (his version of Michelangelo's *terribilità*). It was modelled *all'antica* after busts in armour, rather than fifteenth-century reliquary types, and after a print executed by Niccolò della Casa (from a drawing by Bandinelli). But its heroic proportions, which aggrandize Cosimo, are rarely encountered in ancient busts. Cellini may also have been influenced by a full-length portrait of Julius Caesar in Rome. The leonine tousled hair and furrowed brow refer to the *Marzocco*. Cosimo gazes over his shoulder as if alerted to danger. His fantastic cuirass conflates Medici and civic symbolism in a pedantic yet elegant display of motifs worthy of the finest goldsmith, including a winged Gorgoneion with a harp to designate Cosimo as the new Orpheus. In addition there is the emblem of the order of the Golden Fleece, conferred on Cosimo in 1545. Described in the sixteenth-century as touched with gold, its deeply drilled eyes may also once have been silvered or enamelled. In its aloof coldness it too is the equivalent of Bronzino's portraits. The brilliant work did not enjoy great success and Cellini consequently failed to become court portraitist. It was replaced in 1557 by Bandinelli's more conventional sculpture based on a portrait bust of the emperor Hadrian in Cosimo's collection. Perhaps Bandinelli's seemed to Cosimo more peaceful, an image he wished to cultivate, as opposed to Cellini's aggressive portrayal, which reflects the colossal Mars on which he had been working in France. Cellini continued his attempts to become a court artist, cultivating Cosimo's wife, Eleonora of Toledo, and restoring artefacts for the Duke.

The first known transition from bronze to marble by Cellini was the *Apollo and Hyacinth* (1546), hewn from a faulty block offered by Bandinelli. It was followed by the *Narcissus* and the *Ganymede*, whose torso was antique. After 1553, however, Cellini's fortunes changed, for his old enemy Vasari returned to Florence and became the Duke's arbiter of taste. Between 1556 and 1562 Cellini carved a *Crucifix*, a Christ in white marble on a black marble cross, that he later claimed was intended for his own tomb and corresponded to a vision he had had

142

in the Castel S. Angelo. He had wanted to have it carved by another sculptor but could not afford this after a series of imprisonments for physical assault and sodomy (he was bisexual). Needing money, he sold the work to Cosimo; Cosimo's son Francesco I gave it to Philip II of Spain and it is now in the Escorial.

The focal point for sculpture in mid-century Florence was the return of Bartolommeo Ammanati (1511–92), who enjoyed not only the backing of Michelangelo, his true master, but also the sponsorship of Vasari. Born at Settignano, he had trained in Bandinelli's shop. With the 1527 Medici expulsion, he fled to the Veneto where he found refuge with J. Sansovino, fresh from Rome. In 1533 Ammanati began a life-size *Neptune* in Padua and between 1536 and 1538 he worked on the *Sannazaro Monument*, S. M. del Parto in Naples, with the Florentine sculptor Giovanni Angelo Montorsoli. Ammanati revisited Venice around 1540, joining Sansovino in decorating the Library of S. Marco and the Loggetta and sculpting a now-lost *Neptune* (1542–4) for the

145 Cellini *Salt Cellar*, c. 1540–4 (gold, enamel and ebony, 26 × 33.5 cm, 10¼ × 13¼ in)

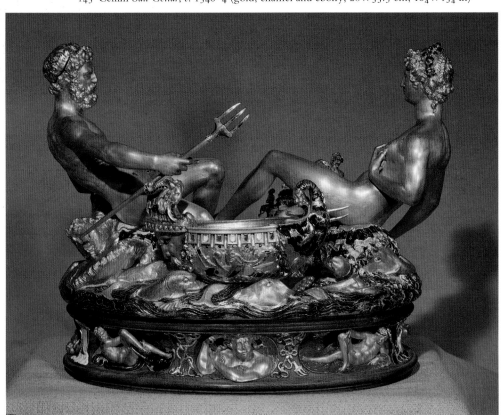

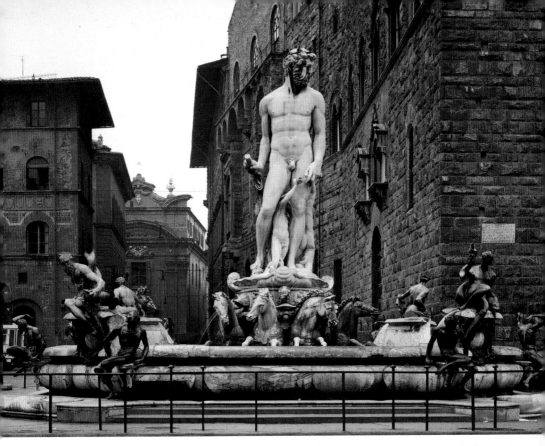

146 Bartolommeo Ammanati *Fountain of Neptune, c.* 1559–75 (marble and bronze). Piazza della Signoria, Florence

Piazza S. Marco. Other commissions drew him to Vicenza and Padua, where he was employed by Marco Mantova Benavides, the wealthy humanist and teacher at the University. In 1548 he was in Rome for several projects, including construction of the Villa Giulia and a pair of tombs. He married the poet Laura Battiferri in 1550 and after the death of Julius III (1555) returned to Florence, becoming Bandinelli's most serious rival.

Ammanati adapted to the Medici court style and was awarded the *Fountain of Juno* (an allusion to Eleonora of Toledo whom Vasari characterized as 'Juno of the Air') for a room of the Palazzo Vecchio whose iconography deified Cosimo in the guise of Jupiter, her husband, as ruler of Florence and the cosmos (it was the death blow to Bandinelli's near-monopoly on Medici patronage). A later drawing 147

189

preserves the fantastic design, an allegory on the generation and 'cosmic' role of water (a pun on Cosimo exploited throughout the palace). At the base, the river god Arno with the *Marzocco* held a Medici ball, while the spring *Parnassus*, draped in ivy sacred to Bacchus and seated on Pegasus, held a laurel crown symbolizing the city's poetry. From their backs issued a marble rainbow arch, the firmament, which supported a Michelangelesque *Juno* flanked by peacocks. Abundant Ceres, who stood at the centre with the rainbow resting on her head and water spouting from her breasts, has a court artist's veneer, resembling types painted by Vasari and Francesco Salviati. Despite the stylized forms, the fountain shows astounding boldness and its theatricality and fantastic use of water were indebted to Ammanati's experiences in Rome. Even though all the components were complete by 1563, the fountain was never erected as planned. It was installed first at the Medici Villa of Pratolino and later behind the Pitti Palace and is now partly reconstructed in the Bargello. Both eclectic and radical, it anticipated Bernini's fountain in the Piazza Navona, Rome, which seems to float on thin air. It was the first of several thought-provoking works by Ammanati alluding to the Medici quest for water and power.

Public fountains had been relatively rare but were used increasingly by rulers in the Cinquecento to evoke grandeur. They became an art form, evolving from simple rustic, private types. As in Roman times, the beneficent effect of water and its necessity for existence rendered the fountain an ideal symbol of good government. Many *cinquecento* innovations are due to Niccolò Tribolo who, assisted by his pupil Pierino da Vinci (Leonardo's nephew), created fountains for Cosimo's villa at Castello, such as the *Fountain of Hercules* (1550–9), whose Hercules and Antaeus were sculpted by Ammanati after Tribolo's designs. Here an intimate relationship between the jets of water and the sculpture was established. Around this time Cosimo decided to commission public fountains to further his propagandistic ends.

A fountain in the Piazza della Signoria is first mentioned in a 1550 letter from Bandinelli, who secured the commission and wished to surpass the *Fountain of Orion* (1550–1) by Montorsoli which he had seen in Messina. Intense rivalry was engendered by the commission. Around 1558 Bandinelli inspected the block for the central figure and obtained permission to make models for the fountain. In 1559 Cellini and Ammanati, resenting this opportunity, decided to challenge Bandinelli by asking to compete. The Duke consented, which so upset Bandinelli that he defaced the block. When Bandinelli died in 1560, Cellini and Ammanati both sought the commission, which Michelangelo and Vasari ultimately secured for Ammanati, an experienced carver. In

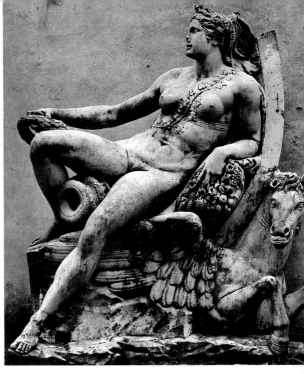

147 Giovanni Guerra, drawing after Ammanati's *Fountain of Juno*

148 Ammanati *Parnassus* (Arbia) from the *Fountain of Juno*, c. 1563 (marble)

1565 Ammanati's model for the giant was set up for the wedding of Francesco de' Medici and Giovanna d'Austria, although the marble was only completed in 1570 and the fountain unveiled in 1575. Ammanati's *Neptune* stands on a sea-shell chariot, pulled by four horses rising out of the water, and carries a general's baton. His stance has been credited to Bandinelli's damage and is also related to Ammanati's earlier Paduan colossal Hercules, Sansovino's Venice *Neptune* (1554) and Michelangelo's *David*. Neptune is presented as a civic protector, alluding to Cosimo's efforts to increase the water supply and to establish a viable port at Livorno. The chariot wheels are decorated with signs of the zodiac, particularly Capricorn and Aries, signs of the Duke and Francesco respectively, illustrating the transfer of power when Cosimo abdicated to Francesco in 1564. In the final installation, Aries is depicted above water with Capricorn below. Neptune wears a crown of metal fir cones, symbolizing the tree sacred to Neptune for building ships.

The eight-sided marble basin seems small compared with the figure of Neptune. Four bronze figures representing Thetis, Douris and two gigantic sea-gods perch on the short sides, below which sit eight fauns and satyrs. These later bronze statues, cast by assistants, represent the high *Maniera* in vogue under Francesco I in contrast to the *Neptune*,

165
1

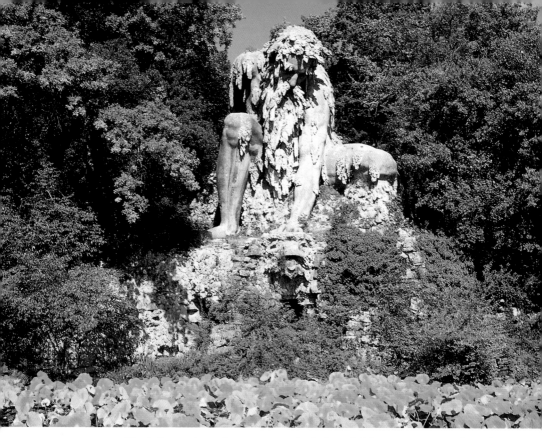

149 Giambologna *Appennine*, *c.* 1570–80 (rock, lava, brick, etc., 10 m, *c.* 33 ft). Villa Medici garden, Pratolino

giving the fountain a disjointed quirkiness which works in spite of itself (not all the jets are integrated with the sculpture). Neptune towers over the others in absolute power, a disparity emphasized by the bronze of the subsidiary figures which tends to make them look even smaller. He competes with the Piazza and the Palazzo Vecchio, while the smaller figures ingeniously harmonize with the scale of the viewer. The theme was significant in *cinquecento* Italy, a time of contest for supremacy in maritime trade and exploration, with Venice and Genoa the prime contenders and Florence anxious to increase its influence through Livorno. Bandinelli had treated the theme in his Andrea Doria monument (1528), where the admiral was depicted as Neptune; Montorsoli followed with a *Neptune Fountain* (*c.* 1551–7) and Sansovino with his (1554). Ammanati continued working for the Medici, which included completing Michelangelo's Laurentian

Library. At the end of his life, he fell under the influence of the Counter-Reformation and gave up sculpture altogether.

Vincenzo Danti (1530–76), one of the competitors for the *Fountain of Neptune*, was born in Perugia and trained as a goldsmith. He joined the artists at the court of Cosimo I in 1557, having created a powerful bronze portrait of Pope Julius III. With Giovanni Bologna and Ammanati, Danti was one of the major sculptors after the death of Bandinelli. He designed the catafalque for Michelangelo's funeral and structures for weddings and triumphal processions. His full-scale model for the *Fountain*, praised by a correspondent of Michelangelo, was followed by *Honour Triumphant over Falsehood*, his first Florentine sculpture. The quickly carved work impressed Vasari because it was from a single block; it led to a series of commissions from Sforza Almeni, the chamberlain of Cosimo I. Another essay on the victor-over-vanquished theme, it resembles Michelangelo's *Victory* and Pierino da Vinci's *Samson and the Philistine*. The opening premise of Danti's *Trattato delle perfette proporzioni* (*Treatise on Perfect Proportions*, published in 1567 and dedicated to Cosimo I) was that Michelangelo surpassed all modern and perhaps even all ancient artists. Yet Danti's sculpture is distinctive, for the taut musculature is far more realistic than Michelangelo's abstractions. The arm of Falsehood, whose physicality was adopted by the Baroque, is perversely contorted to keep it in the orbit of Mannerism. This pose and the high finish are related to a painting by Salviati, illustrating the interaction of *Maneria* artists at the Medici court.

The *Beheading of St John the Baptist* over the Baptistry's south door, installed in 1571, marks a high point in Danti's career. The central St John kneels awaiting his martyrdom, while on the right the elegantly poised executioner holds his sword aloft and on the left is Salome, Herod's daughter. Her elongated form and elaborate costume are emphasized at the expense of the cruelty and horror in her face, anaesthetized as in Cellini's *Perseus*. Danti was also accomplished in reliefs, such as a bronze *Moses and the Brazen Serpent* (Bargello) and marble reliefs. One of his last works is a small bronze *Venus Anadyomene*, ordered for the Studiolo of Francesco, the precious room that epitomizes the court *Maniera* of Florence. The iconography of the room, which included eight statuettes, explored the relationship of nature/science and art. Danti's bronze was influenced by Giambologna's *Apollo* for the same room, testifying to the increasing importance of the younger man. Perhaps his success encouraged Danti to return to his native city, where he became head of the Guild of Goldsmiths and a founder of the local academy.

Without a doubt, the most influential sculptor in the second half of the century was Giovanni Bologna (1529–1608). Referred to more frequently as Giambologna, he emerged during the *Neptune* competition. Born Jean Boulogne in Douai, Flanders, he travelled to Italy in 1554 after training with Jacques Dubroeucq, who worked in an Italianate style. His biographer Filippo Baldinucci relates that after two years in Rome, Bernardo Vecchietti persuaded him to settle in Florence and introduced him to Francesco I. Not much early work is known, although his first Medici commission was a coat-of-arms of Cosimo I for the Palazzo di Parte Guelfa and he carved a Venus (perhaps crouching) for Vecchietti, which remains a controversial sculpture to this day. Many pieces were related to fountains, such as his bronze Florence on the *Fountain of the Labyrinth* (now at Petraia), based on a model of Tribolo's. His first major work was the *Neptune Fountain* at Bologna (now restored). Several models in clay and bronze record its evolution, which seems to be a critique of Ammanati's fountain (it also reflects Montorsoli's *Neptune Fountain*). With a vertical rather than horizontal emphasis, the format is pyramidal and architectonic. Consistent proportions and the use of bronze throughout create the unity lacking in Ammanati's. The fantastic lower figures allow the viewer's eyes to ascend to the Neptune, silhouetted against the sky,

155

146

150, 151 Vincenzo Danti *Honour Triumphant over Falsehood* 1561 (marble, 187 cm, 73⅝ in)

152 Danti *Beheading of St John the Baptist* 1569–71 (bronze, c. 243 cm, 95⅝ in). Baptistry, Florence

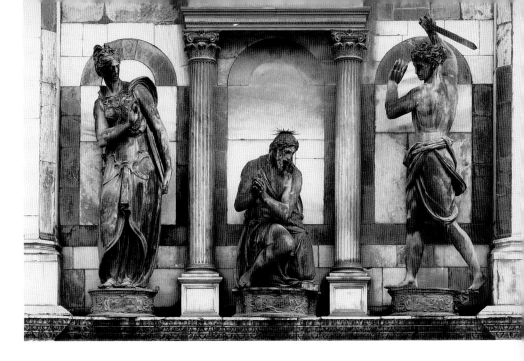

depicted in a striding pose unlike Ammanati's static figure. His trident certifies his identity. Mermaids whose breasts spout water rise from the basin at the corners. Since the jets are integrated with all the figures, the play of water unifies the fountain, the most sophisticated in Italy and anticipatory, therefore, of the Baroque.

The most celebrated sculpture by Giambologna is the *Mercury*, known in four versions whose chronology is uncertain. His first design, a heavy wingless figure, is preserved in a model in Bologna and is related to a Mercury commissioned for a pedestal in the courtyard of the Archiginnasio there. When Giambologna returned to Florence, he referred to his earlier work in a second version, a flying Mercury, now lost or identical to one in Vienna. This bronze was sent by Cosimo as a diplomatic gift to the Holy Roman Emperor Maximilian II, when they were negotiating the marriage of Maximilian's sister Giovanna to Francesco de' Medici. The messenger god was Maximilian's protector and the pose was based on a medal of Maximilian by Leone Leoni (1551). A flying variant in Florence was completed by 1580, when it became a fountain figure at the Villa Medici, Rome. Mercury balances on a bronze column of air issuing from the mouth of Zephyr, over which flowed water, increasing the illusion that he was floating. The work shows a study of Verrocchio's *Putto and Dolphin* and Rustici's *Mercury*, both for the Medici, and is indebted to the Mercury on the

base of Cellini's *Perseus* but has more dynamism. The god assumes an arabesque, balanced precariously on his toes, and points upward to Jupiter. It is Mannerist in that it can be appreciated from all angles and is elongated and elegant; yet these features contrast with its amazing physicality and an evident study of weights and balances. The preciosity of *Maniera* is blended with what became Baroque illusionism and the freedom derived from wax.

Work on the Bologna fountain was interrupted by a gesso group of *Florence Triumphant over Pisa* (translated into marble in 1570), a pendant to Michelangelo's *Victory* for the wedding of Francesco de' Medici in 1565. In this confrontation with Michelangelo, Giambologna pierced his block with voids like the Hellenistic models he studied – the so-called Farnese Bull (*Punishment of Dirce*), discovered in 1546, and the *Laocoön*. This approach is more pronounced in *Samson and a Philistine*, a commission from Francesco I (*c.* 1561–3), which was also based on a Michelangelo *bozzetto*. The physicality of Giambologna's figures is forcefully articulated here for the first time. He also sculpted the *Fountain of the Ocean* for Cosimo I, crowned by another Neptune standing over seated river gods who pour water into a basin (for the Pitti Palace). Giambologna was a great modeller in wax, as seen in his bronze birds (peacock, owl, eagle) from the late 1560s for the volcanic rock grotto of Francesco's Villa at Castello. They manifest an interest in nature and the nascent scientific experiments encouraged by the Medici. Perhaps the *Turkey* is the most original of the group; the textures of its wonderful neck, ruffled feathers and fanned tail all derive from the wax model, which was directly cast. In order to achieve the subtle effects, he manipulated dripped and sliced wax to look uncannily like feathers. As in bestiaries, Giambologna's animals are often endowed with slightly human traits, here a pompous strut and expression, revealing Giambologna's humour. Perhaps his northern heritage enabled him to become one of the finest bronze animaliers. A similar approach occurs in his bronzes of Morgante, the Medici court dwarf. Giambologna also created genre figures, such as birdcatchers and bagpipe players, with parallels in German and Flemish wood sculpture and Italian Adoration scenes.

Capable of chameleon changes, Giambologna produced coldly sensual bronzes, such as the *Apollo* for the Studiolo of Francesco (*c.* 1573–5). Destined for a niche, its *figura serpentinata* was concentrated to a single viewpoint. Not so with the fire-gilt bronze *Astronomy*, identified in old inventories as Venus Urania (the armillary sphere at her feet is inscribed *VENNVS. SOL. LVNNA.*). It is related to other works by him, exhibiting not only his preferred 'v' form of limbs but

156

196

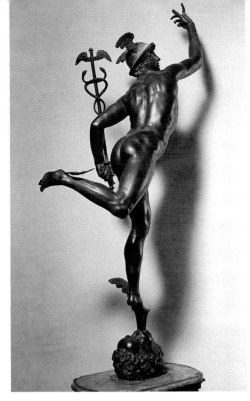

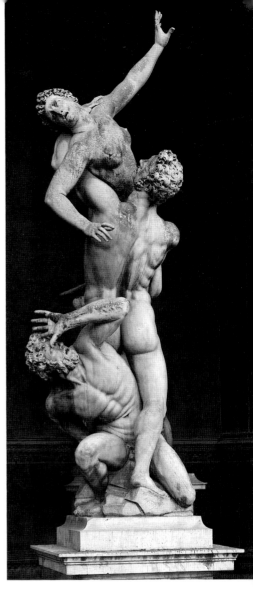

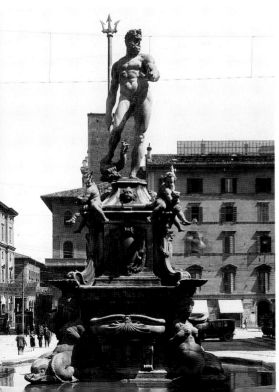

153 (*above left*) Giambologna *Mercury*
1564–80 (bronze, 180 cm, 70$\frac{7}{8}$ in)

154 (*above*) Giambologna *Rape of the
Sabines*, *c.* 1581–3 (marble, 410 cm, 161$\frac{3}{8}$ in).
Loggia dei Lanzi, Florence

155 Giambologna *Neptune Fountain*,
c. 1563–6 (bronze and marble, central figure
c. 335 cm, 131$\frac{7}{8}$ in). Piazza del Nettuno,
Bologna

also pleasurable multiple views and is a sophisticated outgrowth of earlier figures, especially his *Venus* (*c.* 1570–2, today in the Boboli Grotto), installed on a fountain with a basin surrounded by leering fauns who spout water from their mouths.

149 Around 1570–80 Giambologna designed the *Appennine*, a fountain of sorts set in a garden of titillating marvels at the Medici Villa at Pratolino. The theatrical work combined several Mannerist themes: the colossus, the fountain, Michelangelo and the interaction between art and nature. It was carved partly out of living rock and embellished with dripped stucco, lava and other materials to appear organic. Initially,
157 Giambologna envisioned the River Nile in a more canonical pose, as in a model. Two other models record a mountain god, appropriate to the villa's hilly setting north of Florence. The elemental quality, fore-shadowed in the models and retained in the sculpture, departed from Giambologna's usual practice. It was an essay in extravagant dream-like fantasy, perhaps influenced by the hydraulic engineer Bernardo Buontalenti, the inventive architect of the gardens and its automata. Here the Mannerist fountain-grotto is taken to its definitive conclusion, the grotto turned inside out to form the giant whose hoary locks were compared to icicles. He appears to emerge out of the mountain, his shoulders originally covered with a rocky canopy to make him more part of the earth. His hand is over a monstrous head like a turtle's, which spouted water to the pool below. Inside the once painted giant, there

156 Giambologna *Turkey* 1560s
(bronze, 62 cm, 24¾ in)

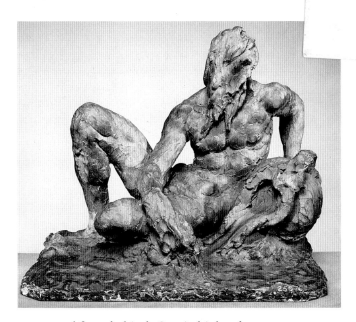

157 Giambologna, model
for a river god,
c. 1570–80 (terracotta,
30.3 × 39.4 cm, 11⅞ × 15½ in)

are small rooms and a grotto, entered from behind. One in his head was
used by Francesco I for fishing, a line dropped from one eye, while
others were embellished with water tricks. *Appennine* symbolized the
genius loci of the garden in the foothills of the Appennines, a water
source of Tuscany, and favourite Medici allusions to their rule – the
golden age and spring, when the ice of the Appennines melted. The
rustic image is part of a dialogue between art and nature, akin to that
explored in the northern court of Rudolf II and the art of Arcimboldo,
and catered to Francesco's obsession with alchemy, magic and the
nascent sciences.

Giambologna executed a number of important religious commis-
sions reflecting Counter-Reformation ideas, although his most am
bitious secular sculpture, the *Rape of the Sabines*, marked the climax of
his career as an official Medici sculptor. In a letter from him to the Duke
of Parma he refers to a small bronze of two figures in a pose reminiscent
of a *pas-de-deux* (today in Naples). For the larger work, Giambologna
inserted a third figure, incorporating the victor-over-vanquished
theme. This great marble triad was unveiled in the Loggia dei Lanzi in
January 1583 in place of Donatello's *Judith*. The group is indebted to
Giambologna's study of Hellenistic sculpture, particularly in the voids
which penetrate the three interlocked figures. On a technical level it
represents the fulfilment of an aspiration from antiquity. Ancient
sources record sculptures made from a single block, a claim which the
Renaissance discovered was not true. Giambologna intended to surpass

154

antiquity by sculpting a large group from a single block that also involved a complicated lift. In his *Riposo* (1584), Raffaello Borghini explains: 'solely to prove his excellence in his art, and without selecting any subject, he represented a proud youth seizing a most beautiful girl from a weak old man.' If Borghini was correct, the work would represent an early example of art for art's sake, although it is clear that the general subject, a seizure/rape had been established. Later, the title was applied and a clarifying narrative relief placed on its base. The real theme was artistic virtuosity in competition with the antique. The triad has been interpreted allegorically as the Medici (the youth) taking Florence (the woman) from the previous government (old man) and establishing a new Rome. The first sculpture with no principal viewpoints, it forms a spiral that is the culmination of the *figura serpentinata*. Such multiple views achieve on a large scale the effect of turning a statuette in one's hands. The abrupt extension of the female's hand into space is a physical release, developed by Bernini's *Pluto and Persephone*. The robust interaction of the athletic figures saves the work from preciosity and *Maniera*; instead it becomes a pivot in the transition to the Baroque. Nowhere can this be seen more graphically than in the woman's derriere, vehemently impressed by her attacker's hands, again foreshadowing Bernini's pictorial sculpture. After completion, the *Rape* was universally celebrated, stimulating tremendous international demand for small replicas by his workshop.

Giambologna made numerous equine studies before he was commissioned for an equestrian. There is evidence that Francesco I contacted him about an equestrian of Cosimo I but Francesco's own projects took precedence. In 1587 Ferdinando I, his brother and successor and a more practical man, commissioned the bronze equestrian in the Piazza della Signoria. Latent republican sentiments ensured that such an equestrian was not viable before the late Cinquecento. Giambologna relied on Antonio Susini for its execution, Giovanni Alberghetti probably with many assistants for its casting and the painter Il Cigoli for its design. He was given a studio with a foundry for the project where the horse and rider were cast separately. Three reliefs on the base depict political events in Cosimo's reign in the unadulterated propaganda of absolutism. This was the first time in Florence that a sculpture praising a leader was displayed publicly and treated historically rather than allegorically. Cosimo found Florence a weak town in 1537 and left it the stable capital of Tuscany, a model for later monarchies. He knew the power of art harnessed to the state, again a model for future rulers, and his regime established a unity in the arts which prefigures that of the Baroque age.

158

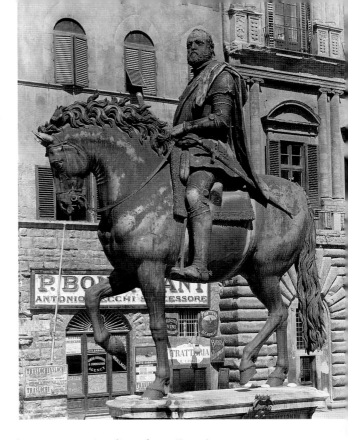

158 Giambologna *Equestrian Portrait of Cosimo I* 1587–94 (bronze, 450 cm, 177⅛ in). Piazza della Signoria, Florence

The statue is closer to the *Marcus Aurelius* than Renaissance prototypes. It is not, therefore, coincidental that it stands in the Florentine Campidoglio, facing the *Fountain of Neptune, David, Hercules and Cacus*, the Uffizi and the statues in the Loggia dei Lanzi, encompassing their symbolism. The horse's billowing mane contrasts with its static body, while the Duke governs his horse and implicitly the state. Cosimo's portrait is idealized but lacks the hyperbole of antique symbolism in Bandinelli's and Cellini's portraits. The statue influenced all subsequent equestrians of sovereigns. Giambologna started another equestrian of Ferdinando I, intentionally a mirror image of Cosimo I in the Piazza SS. Annunziata, finished by Pietro Tacca. Working for the Medici until his death, he began in 1594 a *Hercules and the Centaur* for Ferdinando. Giambologna's influence was widespread largely because of the mass production of small bronzes by his studio. Assistants were often responsible for casting and finishing, accounting for changes in quality and patina. His pupils continued to produce variations of their master's compositions after his death. This mass production and the

146,1

139

international background of his assistants, who had perfected the use of piece-moulds, helped to spread Mannerism throughout Europe. Susini and Tacca, his most distinguished pupils, worked into the next century. Consequently, Giambologna in later life enjoyed great prestige and was the most important Italian sculptor of the century after Michelangelo. He linked Michelangelo and Bernini, who would carve marble as though it were wax.

NAPLES

Giovanni da Nola (*c.* 1488–1558) was active in Naples and is first noted for his *Nativity* for the poet Jacopo Sannazaro in S. M. del Parto, Naples. An unorthodox work is the *Monument of Don Pedro of Toledo* in S. Giacomo degli Spagnuoli, erected around 1570. Don Pedro, Viceroy of Naples and father-in-law of Cosimo I, died in Florence and was buried in the Duomo after he had commissioned the monument for himself and his wife, Maria Osorio Pimentel. Vasari relates that he had intended to transport it to Spain. It includes three reliefs depicting his military and diplomatic accomplishments and at the corners four cardinal virtues. They are reminiscent of Florentine court sculpture – via the *Sannazaro Monument* carved by Montorsoli and Ammanati in Tuscany and shipped to Naples – and have a slight Spanish accent.

159 Giovanni da Nola *Monument of Don Pedro of Toledo* after 1544–70 (marble). S. Giacomo degli Spagnuoli, Naples

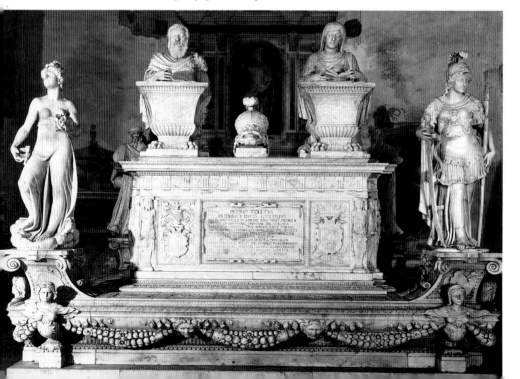

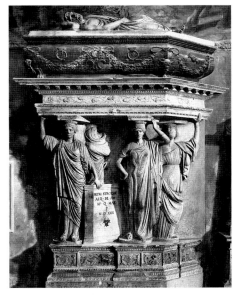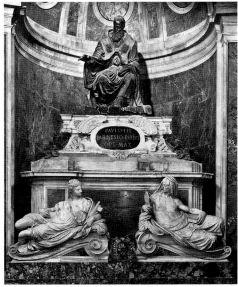

160 Giulio Romano (designer) *Tomb of Pietro Strozzi, c.* 1529 (marble). S. Andrea, Mantua

161 Guglielmo della Porta *Tomb of Pope Paul III* 1549–75 (bronze and marble). St Peter's, Rome

LOMBARDY

Another unusual monument is the *Tomb of Pietro Strozzi* (died 1529) in S. Andrea, Mantua, where it was moved in 1805. Its design is attributed to Giulio Romano (1492–1546). The four caryatids usurp the traditional place of virtues and support a heavy entablature carrying a sarcophagus with the Strozzi crescent moons and the effigy of the deceased dressed in toga and sandals. Each caryatid, similar except in pose, has a basket on her head, like the echinus of a capital. The front two are freestanding; those against the wall carved in relief (the one in profile at the left drawing a chiton round her head appears to be pivoting). That on the right was derived from an antique Venus (Vienna, formerly in the Palazzo Ducale); the figure on the left from a Roman copy of a Greek original (in the ducal collection). The caryatids can be traced to the Erechtheum in Athens, known through prints.

Leone Leoni (1509–90), of Aretine stock, first worked in Rome as an engraver at the mint and was the dominant sculptor in Milan during the latter half of the century. He eventually took charge of the imperial mint in Milan and developed an international reputation, entering the service of Charles V. With his son he worked on the High Altar of the

160

Escorial for Philip II of Spain. One of Leoni's most interesting works is his own Casa degli Omenoni, Milan, with eight caryatid captives on its facade. The palace and its collection of ancient casts were praised by Vasari, a fellow Aretine, for their capricious fantasy and symbolism. Pompeo Leoni (c. 1533–1608), trained by his father, spent a great portion of his career in Spain and after being imprisoned by the Inquisition settled in Madrid. In 1591 he began the monumental sepulchral groups of Charles V and Philip II in the Capilla Reale. These theatrical works synthesize Spanish and French tombs and his father's portrait style.

ROME

Many of the *cinquecento* sculptors discussed worked in Rome, the greatest from the second half of the century being Guglielmo della Porta (c. 1490–1577), the son of a sculptor. He worked in Milan and Genoa and is first documented in Rome in 1546 in the Vatican. He sculpted a number of busts of the Farnese Pope Paul III and worked his way into the papal hierarchy, securing the commission for the Pope's 161 tomb. An antique sarcophagus and other features had been predetermined by the Pope. Della Porta originally envisioned a freestanding tomb in a funeral chapel in the manner of Michelangelo's Julius Tomb but changed to a wall type on account of Michelangelo's criticism. Its colourism – a combination of coloured marbles, bronze and gilding – arises from the northern Italian tradition and proved influential on the Baroque. The bronze effigy of the Pope was cast and chased by 1553 when Della Porta turned to the reclining allegorical figures. In 1628 the tomb was transferred and modified by Bernini to become a pendant to his *Tomb of Pope Urban VIII*. Della Porta's commanding Pope is depicted alive and seated on a diagonal in an engaging manner, a less formal pose than the benediction adopted by Bernini.

VENICE

Unlike the cities of central Italy, Venice with no autocrat engendered no court style. After the Sack of Rome, artists from the papal court spread throughout the peninsula. One of the greatest, the Florentine Jacopo Sansovino, stopped in Venice on his way to France and never left. The Doge immediately employed him in architectural projects and in 1529, after the death of Bartolomeo Bon, he was appointed Protomagister of S. Marco. He became a friend of the writer Pietro Aretino and Titian, forming a formidable cultural triumvirate. Jacopo developed a link between painting and sculpture, stronger than that of Tullio Lombardo, which is characteristic of Venetian *cinquecento*

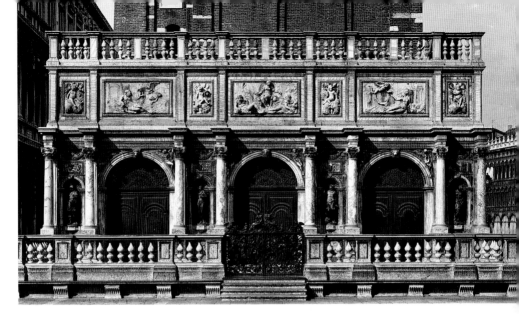

162 J. Sansovino, Loggetta of the Campanile, c. 1537–45 (red, white and green marbles and bronze). Piazza S. Marco, Venice

sculpture and close to the Baroque. A contemporary was the architect Andrea Palladio, who was working in the Veneto and with whom he shared many stylistic traits. Sansovino worked on a relief for the Chapel of S. Antonio in Padua (1528–34), resurrecting the tradition of the Lombardo family. In 1536 he was awarded the contract for a second, the *Miracle of the Maid Carilla*, which had been assigned to Tullio but was not funded until 1562. Sansovino signed this relief as sculptor, architect and Florentine citizen. In it, he rejected the classicism of Antonio in favour of the emotional approach of Tullio, tempered by stronger realism.

Sansovino's art of the 1530s shows an adept integration of Venetian and central Italian elements. His fertile imagination and classicism satisfied diverse clients and transformed Venice with architecture liberally decorated with sculpture. An experimenter, he never consciously set out to break rules like the Mannerists. Throughout his career he maintained a classical equilibrium between sculptural and architectural elements, as in the Library of S. Marco and the Loggetta of the Campanile. This small structure was set in an architecturally diverse square, called by Napoleon 'the most beautiful drawing room in the world'. To Sansovino's credit he produced a work distinctive yet in harmony with adjacent buildings. Like the original edifice it replaced (destroyed by lightning in 1489 and by an earthquake in 1511), it served as a civic meeting place or patrician clubhouse. Constructed at the end

162

205

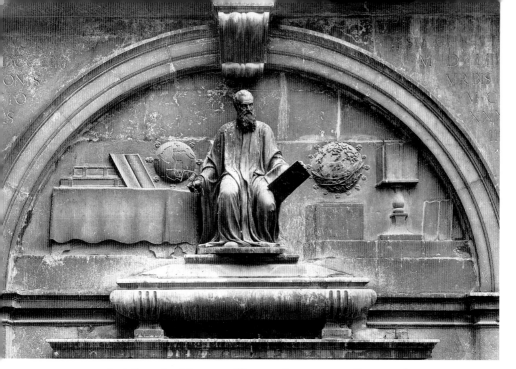

163 J. Sansovino *Monument of Tommaso Rangone* 1553–7 (bronze and stone, *c.* 241 cm, 94⅞ in). S. Giuliano, Venice

of Doge Andrea Gritti's time, it expresses the self-confidence of the Venetian republic and its power at sea. The entire structure is based on the triumphal arch with three openings and an entablature in imperial Roman style. It is sumptuously decorated with composite columns in coloured oriental marbles and seems more like a large sculptural screen than architecture. The dominant warm tonality – red Verona and white Carrara marble with thin strips of green marble and bronze – is typically Venetian, integrating the Loggetta with its surroundings. In 1545 the four bronze figures (Pallas, Apollo, Mercury and Peace) were installed in their niches, thereafter influencing the development of Venetian statuettes. There are also 8 reliefs of mythological subjects above and below the niches, 5 in the attic (2 are later) and 6 victory figures in the spandrels, all in a lyrical style. The structure was later modified by the terrace and rebuilt in 1902 after the Campanile collapsed.

The first of Sansovino's two major commissions for S. Marco involved the singing galleries of the choir in the 1530s, part of his modernization of the interior with High Renaissance elements. Each

contained eight bronze reliefs, some amazing pictorial effects and great skill in low relief. The second commission (1546–72) was the curved bronze Sacristy Door, depicting the Resurrection and the Entombment, and subservient reliefs influenced by Ghiberti's Paradise Doors. The vogue for *colossi* can be seen in his *Mars* and *Neptune* for the Scala dei Giganti, the staircase leading to the Ducal Palace (1554–67). Neither exhibits Mannerist variety, being conceived with a single viewpoint. The way in which the weathered *Neptune* holds a dolphin by the tail is a gentle, light-hearted treatment of the victor-over-vanquished theme, underlining some of the differences from Florentine *colossi*. A distinctive monument was commissioned by Tommaso Rangone, a physician and expert on hygiene, an astrologer, philologist and patron of the arts from Ravenna (also depicted by Tintoretto in the Scuola di S. Marco). He had wanted his monument on the facade of S. Geminiano in the Piazza S. Marco but it is found above the central portal of S. Giuliano, a ruined church reconstructed by Sansovino for the purpose. Executed in collaboration with Alessandro Vittoria, it departs from the Venetian practice of honouring only patrician naval heroes on church facades (Rangone was a private citizen). Above a simplified sarcophagus is a seated bronze statue of the patron, who is portrayed as a scholar in his study in a highly pictorial setting equivalent

165

163

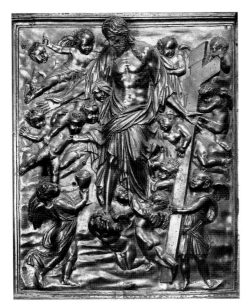

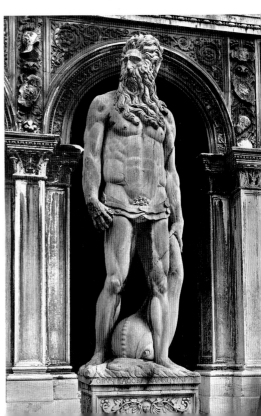

164 J. Sansovino *Allegory of Redemption*, c. 1546–65 (bronze gilt, 43 × 37 cm, 16⅞ × 14½ in). S. Marco, Venice

165 J. Sansovino *Neptune* 1554–67 (marble, 305 cm, 120 in). Palazzo Ducale, Venice

to portraits by Titian. Surrounded by humanist accoutrements illusionistically carved in low relief, Rangone is pursuing his love of learning for all eternity.

In the *Tomb of Francesco Venier* in S. Salvatore, Sansovino applied the principles of the Loggetta to the sepulchral monument. Although it *112* follows the *Vendramin Monument* by Tullio, its simplicity and colourism belong to the Venetian High Renaissance. Sansovino's works were the friendly rivals of Titian's paintings, always evolving, direct and naturalistic. Venetian artists were interested in sensuous *colore* versus the intellectual *disegno* of central Italy and they seem to have had little theoretical interest in sculpture (this area is still unexplored). Nevertheless, there are references in Aretino's letters to the sculpture versus painting *paragone* and he admits that sculpture is unique because it can be touched. Sansovino, a friend of painters and thus sensitive to their concerns, was able to combine the colour and light important to them with the tactility of sculpture. This quality is seen best in his bronze reliefs where light patterns create impressionistic effects. In the *164* *Allegory of Redemption*, reflected light stands for the divine light that painters rendered in pigment, a feat even Titian could not match. According to Vasari, Sansovino combined the best of both worlds, creating 'the true form' (like a sculptor) while 'giving to the fire so much warmth and light that one actually sees things living and flames that, almost flickering, make bright the darkest shadows of the night' (like a painter). Such concerns were directly pursued by Baroque artists.

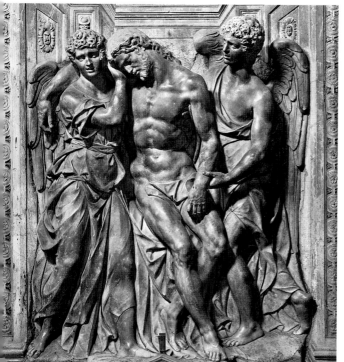

166 Girolamo Campagna, 'Man of Sorrows' from the Altar of the Sacrament, *c.* 1577–8 (marble, 85 × 115 cm, 33½ × 45¼ in). S. Giuliano, Venice

167 Campagna, High Altar, 1591–3 (bronze and copper gilt, 350 cm, 137¾ in). S. Giorgio Maggiore, Venice

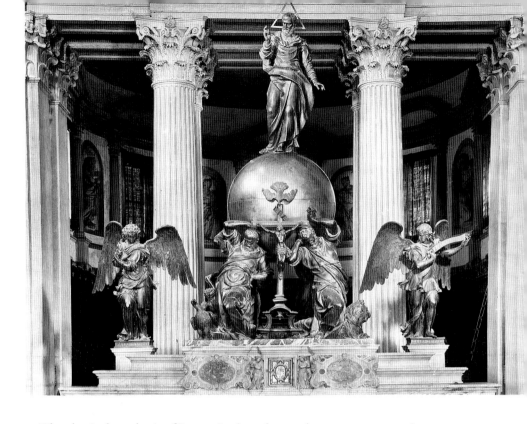

The classical synthesis of Sansovino's sculpture does not appear to the same degree in his pupils' work. One of his finest, Danese Cattaneo, worked with him on the decoration of the Library and the Loggetta, as well as in Padua, but created a more artificial and decorative style. After Cattaneo's death, several of his commissions were completed by his pupil Girolamo Campagna (1549/50–1625?), born in Verona and active in Venice. Indebted to Sansovino, an early relief depicts Christ *166* supported by two angels, a favourite image in Venetian painting. It contains a dexterous manipulation of sources – ancient, central Italian and Venetian. The lyrical forms are grounded in nature, whereas the drilling of the angels' hair is from the antique. Its elegance and serenity recall the tone of Veronese's paintings. The High Altar for Palladio's S. *167* Giorgio Maggiore, however, reveals Campagna's potential. The complex, based on a drawing by the painter Vassilacchi, expanded the conventions of the altarpiece. In unprecedented fashion, Campagna transformed the pictorial design into three dimensions (but retained its painterly qualities), which allowed a view of Palladio's magnificent double colonnade behind the altar. The pyramidal structure consists of

a gilded copper globe supported by bronze Evangelists as Atlas figures. Their poses echo Michelangelo's four late 'Slaves' but they are individualized and finished. The Dove of the Holy Spirit descends to a crucifix in front of the globe, on which stands God the Father, completing the Trinity on the central axis. This Counter-Reformation image, whose metal surface reflects the light in the sanctuary, is worthy of the intense visions of Tintoretto and the physicality of Veronese. Its illusionism (missing in Giambologna's sculpture) anticipates Bernini's, especially his *Cathedra Petri*.

One of the unsuccessful competitors for this altar was Alessandro Vittoria (1525–1608). Born in Trent, he moved to Venice in 1543 and entered Sansovino's workshop. The greatest Venetian sculptor of the late century, he is documented in Vicenza in 1551, where he remained intermittently until 1553, developing an interest in portrait busts. He decorated the Sala dei Principi of the Palazzo Thiene with eight stucco busts of emperors and Romans with an unprecedented sense of movement. By the 1550s Vittoria was producing medals and was employed by Benavides in Padua but continued working on architectural projects with Sansovino and Michele Sanmicheli. He also collaborated with Palladio on the decoration of the Villa Barbaro at Maser, where he was responsible for, among other things, the Nymphaeum. At some time during this period serious differences arose between him and Sansovino. Although he never travelled outside the Veneto, he knew ancient and pseudo-ancient objects – for example, at the Statuario Pubblico, the first public museum of ancient sculpture, donated to the Republic by Cardinal Giovanni Grimani (the nucleus of the Museo Archeologico). Much of the work of this underestimated sculptor is documented in his *Memorie*. A Michelangelesque influence is apparent in a sculpture of *St Sebastian* in S. Francesco della Vigna, modelled after a reproduction of Michelangelo's *Dying Slave*, which had been sent to France in 1544. His *St Jerome* for the Frari, the earlier of two, was also indebted (albeit less literally) to Michelangelo.

Above all, Vittoria was a talented portraitist, although the chronology of his portraits has only recently been studied. He popularized the new type of portrait bust on a socle (as opposed to the type truncated at mid-torso), which descended naturally from Antico's small copies of Roman busts, Cattaneo's busts *all'antica* executed in Padua around 1540 and other influences unique to the Veneto. A signed bust in marble portrays *Ottaviano Grimani* (died 1576) in contemporary dress, with a Roman echo in the cloak to ennoble the work. The separate socle may indicate a public position, perhaps balancing the bust of his father (*c.* 1561) in the family chapel in S. Sebastiano. The ancient type is modified

168

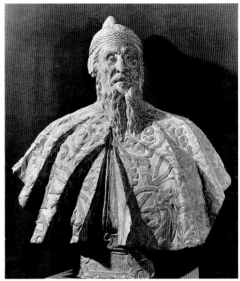

168 Alessandro Vittoria *Ottaviano Grimani*, c. 1571–6 (marble, 80.5 cm, 31¾ in with socle)

169 Vittoria *Doge Niccolò da Ponte* 1582–4 (terracotta, 100 cm, 39⅜ in with socle)

by flattening and broadening to give greater substantiality. Vittoria's realism and descriptive powers were extraordinary. Grimani's contemplative nobility and sensitive mouth contrast with the intensity of his eyes below heavy brows, his physical presence so real he appears to breathe or speak, as in Bernini's portraits. The bust seems to embody Leonardo's dictum that a portrait should reveal the motions of the sitter's mind. In the terracotta of *Doge Niccolò da Ponte*, Vittoria's *169* masterpiece, the sculptor's great freedom – resembling the impasto technique of late Titian paintings – is displayed in the painterly beard. The interest in texture and in capturing the outward pomp of Venice is reflected in the patterned brocade of the Doge's garment. It is his only depiction of a doge in ducal regalia: the rich robe undulates to impart a sense of movement and its massiveness lends grandeur and power. Designed for the Doge's tomb, it marks a departure from the customary ducal full-length portrait. It was also a drastic change from durable marble to perishable terracotta (perhaps an acknowledgment of Vittoria's prowess in the medium). The wisdom of old age (celebrated in the gerontocracy of Venice) is successfully captured in a poetic but powerful portrayal that ranks with Titian's of elderly people.

Vittoria continued to work in stucco, contributing decorations to the Library and the Ducal Palace and in the 1570s to S. Giorgio Maggiore. He also worked in bronze, as in the *Annunciation* (Chicago). A friend of

211

the painter Palma Giovane, he had a deep interest in the works of Parmigianino as well as Venetian painters. This sensuous and painterly relief depends on a model by Titian, now known only in a print. The light flooding its surface, the dramatic gestures and windblown drapery convey the excitement of his style and a forthright Counter-Reformation spirit for depicting sacred subjects. His art was very influential on Tiziano Aspetti, a pupil of Campagna, whose sculpture in Padua and Venice parallels that of Pietro Bernini in Rome. The finest

170 statuette securely attributed to Vittoria is the *St John the Baptist*, which has Michelangelesque influence but whose active pose, elasticity and fluid forms lead into the virtuoso carving and high drama of the work

171 of Pietro's son Gian Lorenzo Bernini (1598–1680) and the Baroque. As the curtain went up on a new century, the patronage of the papacy established Rome as the centre of Italian sculpture and Bernini as its presiding genius. He built on the fecund foundation of Renaissance sculpture but, beyond the physicality expressed in the works of Giambologna, Campagna, Vittoria and others, forged a style with spontaneity and illusionism so seductive that the hardness of marble is forgotten.

170 Vittoria *St John the Baptist*, c. 1583–4 (bronze, 71 cm, 27⅞ in). S. Francesco della Vigna, Venice

171 Gian Lorenzo Bernini *Apollo and Daphne*, c. 1622–5 (marble, 243 cm, 95⅝ in without base)

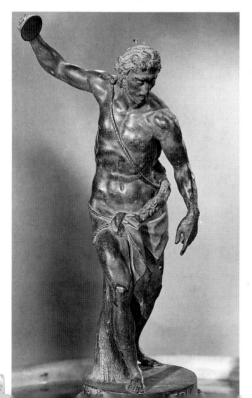
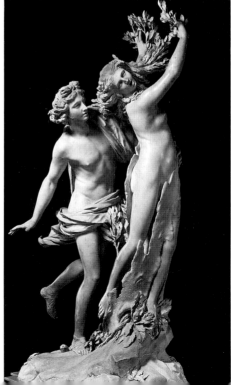

Select Bibliography

I am indebted to the rich and varied scholarship in the field and to many scholars (much of this research was accomplished at Watson Library of the Metropolitan Museum of Art, New York). For additional bibliography, the three volumes by Sir John Pope-Hennessy (*see below*) are indispensable.

General

Andres, G., Hunisak, J. M., and Turner, A. R. *The Art of Florence.* 2 vols, New York, 1988, and London, 1991. Avery, C. *Florentine Renaissance Sculpture.* London, 1970. Becherucci, L., and Brunetti, G. *Il Museo dell'Opera del Duomo a Firenze.* 2 vols, Venice, n.d. Bober, P. P., and Rubenstein, R. *Renaissance Artists and Antique Sculpture.* London, 1986. Bode, W. von *Florentine Sculptors of the Renaissance.* (J. Haynes, trans.), London, 1908. — *Italian Bronze Statuettes of the Renaissance.* 3 vols (J. D. Draper, ed.), New York, 1980. Bravo, Carlo Del *Scultura senese del Quattrocento.* Florence, 1970. Connell, S. *The Employment of Sculptors and Stonemasons in Venice in the Fifteenth Century.* New York and London, 1988. Cox-Rearick, J. *Dynasty and Destiny in Medici Art.* Princeton, NJ, 1984. Crichton, G. H. *Romanesque Sculpture in Italy.* London, 1954. Glass, D. F. *Italian Romanesque Sculpture: an annotated bibliography.* Boston, MA, 1983. Hill, G. F. *A Corpus of Italian Medals of the Renaissance.* 2 vols, London, 1930 (enlarged 1978). McAndrew, J. *Venetian Architecture of the Italian Renaissance.* Cambridge, MA, 1980. Panofsky, E. *Tomb Sculpture.* New York, 1964. Pincus, D. *The Arco Foscari.* New York and London, 1974. Planiscig, L. *Die Italienische Bronzestatuette der Renaissance.* Vienna, 1925. — *Venezianische Bildhauer der Renaissance.* Vienna, 1921. Pope-Hennessy, J. *An Introduction to Italian Sculpture.* 3 vols, New York, 1985 (3rd edn). — *The Study and Criticism of Italian Sculpture.* Princeton, NJ, 1980. Radcliffe, A. *European Bronze Statuettes.* London, 1966. Schuyler, J. *Florentine Busts: Sculpted Portraits in the Fifteenth Century.* New York and London, 1976. Seymour, C., Jr *Sculpture in Italy 1400–1500.* New Haven, CT, 1973. Smith, C. *The Baptistry of Pisa.* New York and London, 1978. Vasari, G. *Le Vite de' più eccellenti pittori, scultori ed architettori.* 1550 (1st edn) and 1568 (2nd edn). Venturi, A. *Storia dell'arte italiana.* 11 vols, Milan, 1935–7. Wackernagel, M. *The World of the Florentine Renaissance Artist.* (A. Luchs, trans.), Princeton, NJ, 1983. Weil-Garris, K. *The Santa Casa di Loreto.* New York and London, 1977. White, J. *Art and Architecture in Italy 1250–1400.* London, 1966. Wilk, S. B. *Fifteenth Century Central Italian Sculpture: an annotated bibliography.* Boston, MA, 1986. Valentiner, W. R. *Studies in Italian Renaissance Sculpture.* London, 1950. Wolters, W. *La Scultura Veneziana Gotica.* 2 vols, Venice, 1976.

Monographs (by sculptor)

The Early Sculpture of Bartolomeo Ammanati. P. Kinney, New York and London, 1976. *Bambaia: Catalogo completo.* M. T. Fiorio, Florence, 1990. *Benedetto da Maiano, ein florentiner Bildhauer des späten Quattrocento.* L. Dussler, Munich, 1924. *Bertoldo di Giovanni.* J. Draper, Columbia, MO, forthcoming. *The Sculpture of Giovanni and Bartolomeo Bon* A. M. Schultz, Philadelphia, PA, 1978. *La Porta di Bonanno nel Duomo di Pisa.* W. Melczer, Ospedaletto, 1988. *Girolamo Campagna.* W. Timofiewitsch, Munich, 1972. *Cellini.* J. Pope-Hennessy, New York, 1985. *The Sculpture of Vincenzo Danti.* D. Summers, New York and London, 1979. *Andrea della Robbia and his Atelier.* A. Marquand, 2 vols, Princeton, NJ, 1922. *Giovanni della Robbia.* A. Marquand, Princeton, NJ, 1920. *Luca della Robbia.* J. Pope-Hennessy, Oxford, 1980. *Luca della Robbia.* A. Marquand, Princeton, NJ, 1914. *Desiderio da Settignano.* L. Planiscig, Vienna, 1942. *Donatello.* B. Bennett and D. G. Wilkens, Oxford, 1984. *Donatello and His Sources.* M. Greenhalgh, New York, 1982. *The Sculpture of Donatello.* H. W. Janson, Princeton, NJ, 1957. *Lorenzo Ghiberti nel suo tempo.* Istituto Nazionale di Studi sul Rinascimento, Florence, 1980. *Lorenzo Ghiberti.* R. Krautheimer, 2 vols, Princeton, NJ, 1970 (2nd edn). *Giambologna: The Complete Sculpture.* C. Avery, Oxford, 1987. *The Sculptor Giovanni Bologna.* J. Holderbaum, New York and London, 1983. *Jacopo della Quercia.* J. H. Beck, New York, forthcoming. *Jacopo della Quercia's Fonte Gaia.* A. C. Hanson, Oxford, 1965. *Niccolò and Piero Lamberti.* G. Goldner, New York and London, 1978. *Leonardo da Vinci.* M. Kemp, Cambridge, MA, 1981. *Leone Leoni et Pompeo Leone.* E. Plon, Paris, 1887. *Guido Mazzoni e la rinascita della terracotta nel Quattrocento.* A. Lugli, Turin, 1990. *Michelangelo e l'arte classica.* G. Agosti and V. Farinella, Florence, 1987. *Michelangelo.* H. Hibbard, New York, 1974. *Michelangelo.* C. de Tolnay, 5 vols, Princeton, NJ, 1943–60. *Donatello and Michelozzo.* R. W. Lightbown, 2 vols, London, 1980. *Michelozzo.* H. M. Caplow, 2 vols, New York and London, 1977. *The Sculpture of Andrea and Nino Pisano.* A. F. Moscowitz, Cambridge, 1986. *Giovanni Pisano.* M. Ayerton, New York, 1969. *Giovanni Pisano.* G. L. Mellini, Milan, 1970. *Giovanni Pisano a Genova.* M. Seidel, Genoa, 1987. *La Scultura lignea di Giovanni Pisano.* M. Seidel, Florence, 1971. *Nicola Pisano and the Revival of Sculpture in Italy.* G. H. Crichton and R. Elsie, Cambridge, 1938. *Nicola Pisano: architetto sculptore.* M. L. T. Cristiani, Pisa, 1987. *Antonio and Piero Pollaiuolo.* L. D. Ettlinger, New York, 1978. *Andrea Riccio.* L. Planiscig, Vienna, 1927. *Bernardo and Antonio Rossellino.* L. Planiscig, Vienna, 1942. *The Sculpture of Bernardo Rossellino and his Workshop.* A. M. Schulz, Princeton, NJ, 1977. *Jacopo Sansovino: Architecture*

and Patronage in Renaissance Venice. D. Howard, New Haven, CT, and London, 1975. Tino da Camaino. G. Kreytenberg, Florence, 1986. The Sculpture of Verrocchio. C. Seymour Jr, Greenwich, CT, 1971. Alessandro Vittoria. M. Leithe-Jasper, Ph.D. thesis, University of Vienna, 1963. The Portrait Busts of Alessandro Vittoria. T. E. Martin, Ph.D. thesis, Columbia University, 1988.

Exhibition catalogues

There are many exemplary catalogues of permanent collections. Other recent catalogues, in chronological order, include:

Siena, Palazzo Pubblico. Jacopo della Quercia nell'arte del suo tempo. (Florence) 1975. Florence, Museo dell'Accademia e Museo di San Marco. Lorenzo Ghiberti: materia e ragionmenti. 1978. London, Arts Council of Great Britain, et al. Giambologna 1529–1608. Sculptor to the Medici. (C. Avery and A. Radcliffe, eds) 1978. Northampton, MA, Smith College Museum of Art. Antiquity in the Renaissance. (W. S. Sheard) 1978. London, Victoria and Albert Museum. Splendours of the Gonzaga. (D. Chambers and J. Martineau, Milan) 1981. Detroit, Institute of Arts. Italian Renaissance Sculpture in the Time of Donatello. (A. P. Darr, ed.) 1985. Washington, DC, Smithsonian Institution. Renaissance Master Bronzes from the Collection of the Kunsthistorisches Museum, Vienna. (M. Leithe-Jasper) 1986. Siena, Pinacoteca Nazionale. Scultura dipinta: Maestri di legname e pittori a Siena 1250–1450. (Florence) 1987.

Museum Locations and Acknowledgments for Photographs

Index